SHARK

SHARK

A Visual History

RICHARD ELLIS

LYONS PRESS
GUILFORD, CONNECTICUT
An imprint of Globe Pequot Press

To buy books in quantity for corporate use
or incentives, call **(800) 962-0973**
or e-mail **premiums@GlobePequot.com**.

Lyons Press is an imprint of Globe Pequot Press

Text design: Sheryl Kober
Layout artist: Nancy Freeborn
Project editor: Ellen Urban

Library of Congress Cataloging-in-Publication Data is available on file.

ISBN 978-0-7627-7797-6

Printed in the United States of America

10 9 8 7 6 5 4 3 2 1

CONTENTS

FOREWORD

As far as I know, this is the first time that an exhibit about sharks is being held in an art museum. In a way, that's exactly as it should be. It is fitting that we are celebrating sharks, as beautifully "designed" for their myriad jobs as any group of animals on earth. And just as there is no single creature that we can call "the shark," there is no single way of looking at the vast variety of species. There are some five hundred species of sharks. Some artists see them as threatening or menacing, others as interpretations of nature's sleekest and most graceful forms. To some, sharks are the ultimate predators; to others they are integral parts of the great web of life in the ocean. In their infinite variety, sharks obligingly lend themselves to any number of interpretations.

I have been involved with sharks for—oh dear!—more than seventy years. I have dived with them; trained them; taught courses about them; published books, scientific papers, and magazine articles about them; founded a research laboratory to study them; and lectured all over the world about them. In this exhibition, with the help of the contributing painters, sculptors, writers, designers, filmmakers, divers, curators, and collectors, I can see sharks for what they really are: nature's triumphant masterpieces.

Eugenie Clark, PhD
Senior Research Scientist and Founding Director
Mote Marine Laboratory
Sarasota, Florida

INTRODUCTION

When I was a staff lecturer at the National Gallery of Art in Washington during the early 1980s, one of the most popular works in the American galleries was *Watson and the Shark,* a large canvas by Revolutionary-era painter John Singleton Copley that told the dramatic story of fourteen-year-old Brook Watson, who was attacked by a shark while swimming in Havana Harbor in 1749. Painted in London, the oil established Copley's reputation in England and its success led the artist, as well as a few of his contemporaries, to create additional versions of the original composition—one of which, on loan from the Metropolitan Museum of Art, is included in this exhibition. When I spoke about the painting in Washington, my focus was on the story of Brook Watson, the orphan serving as a crew member who lost a leg in the incident. But Richard Ellis, the curator of our exhibition, Shark, and the author of this accompanying book, is encouraging us to appreciate the shark as well as the victim.

Richard notes that Copley probably never saw a shark firsthand because his "imagined" shark is anatomically incorrect. Sharks don't have lips, nor do they have eyes that are forward facing. Much has been learned about sharks since Copley's time, and Richard Ellis has been at the center of writing about those advances. Author of numerous books and articles about the sea as well as a noted painter of marine life, Richard has continued compiling these investigations for this exhibition. We thank him for the excitement he brings in sharing this new material with us. It no doubt will lead many to approach the complex subject of sharks with an even greater understanding.

Florida is a natural locale for such an undertaking, and we are fortunate to have Nova Southeastern University's Oceanographic Center as our ally in this effort. The topic of sharks initially arose out of a conversation I had with Richard E. Dodge, dean of the Oceanographic Center, and Professor Mahmood Shivji, director of the Guy Harvey Research Institute and Save Our Seas Shark Center. The shark has long been a major area of study and research at the university, where textbook-changing, scientific breakthroughs have been made on shark biology, highlighting the urgent need for conservation of these critically important but rapidly declining animals. With these issues in mind, we all felt it was time to address the shark's place in art and in the public imagination.

For this project, we have had the enthusiastic support of the university, including the encouragement of President George L. Hanbury II and Chancellor Ray Ferrero. At the museum, much appreciation goes to our head registrar Rachel Talent Ivers and collections manager Stacy Slavichak, who coordinated this exhibition along with curatorial assistant Rachel Diana, all of whom kept up with Richard Ellis's quest for being as inclusive as possible. Last but not least, I would like to thank the participating artists, whose vision and creativity are what make this an exciting and stimulating exhibition. In particular, I call attention to two artists long associated with the university, Guy Harvey and Kent Ullberg, both of whom endorsed the selection of Richard Ellis as our guest curator. It was the most fortunate of decisions.

The exhibition and this accompanying publication present multiple portraits of the shark that help us to better understand these magnificent fish—not simply as portrayed by Copley as the perpetrator against the hapless Watson—but rather as one of nature's most impressive, advanced, thrilling, and beguiling creatures that, sadly, is also one of the more vulnerable inhabitants of the sea.

Irvin M. Lippman
Executive Director
Museum of Art | Fort Lauderdale
Nova Southeastern University

THE ART OF THE SHARK

Sometime in 1972, I got a call from the editors at the *Encyclopedia Britannica*, who were planning to revise their multi-volume product, and were looking for people to illustrate various animals. They sent me a long list of the ones they needed, and because the time frame was extremely tight, I agreed to do only those with which I was completely familiar, or for which I had the necessary reference material on hand. There was not enough time to go to libraries for additional research material. (This was long before Google image search.) That meant I would do the whales, sharks, some fishes, and a motley assortment of mammals, including the numbat, the dhole, the fisher, and the Tasmanian tiger. (That you may not have heard of many of these creatures only points up the inadequacy of the conservationists' campaign to make people aware of their plight; all are endangered except the Tasmanian tiger, which is extinct.) I worked around the clock, sometimes cranking out three or four paintings a day, and managed to complete my assignment. During the painting, however, I became fascinated by the shape of sharks.

I thought they were beautifully designed, and I was always a sucker for good design. They seemed streamlined and efficient, and were obviously good at what

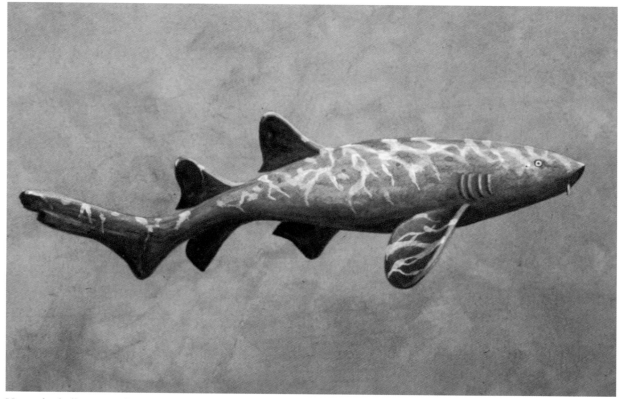

Nurse shark illustration by Richard Ellis for the *Encyclopedia Britannica*, 1972

they did. After all, they've been doing it for 300 million years, haven't they? For the encyclopedia, I had done some of the larger and more dramatic species—the white, mako, porbeagle, blue, tiger, hammerhead, nurse, thresher, and whale shark—but while the encyclopedia people were satisfied with my illustrations, I wasn't. I thought I could do them better, so with nothing more in mind than an homage to the graceful beauty of sharks, I began painting them. At this time, there were very few photographs of sharks in the water; most photographs showed a dead shark strung up next to a beaming fisherman. But in 1970, Jacques and Philippe Cousteau's *The Shark: Splendid Savage of the Sea* was published, containing many photographs of blues, tigers, oceanic whitetips, and various reef sharks in their element. I used this book for a reference, and also Peter Matthiessen's *Blue Meridian*, the chronicle of Peter Gimbel's round-the-world expedition in search of the great white shark. With the exception of those that I saw in aquariums, and one that I had spotted while snorkeling in Hawaii, I had never seen a live shark.

When the *Britannica* paintings were completed and sent off to Chicago, I retained a strange feeling of unfulfillment. I had painted pictures of some of the better-known sharks, but the paintings were quite small: The largest was ten inches long, including the background. I felt that the subject required more than these little renderings, and, besides, I knew I hadn't done the sharks justice—I just didn't know enough about them. The image of the shark stayed with me, like some disturbing, primordial memory. I didn't know it, but I was becoming a shark painter.

Painting animals involves at least as much research as skill, probably more. One has to know the characteristics of one's subjects, their attitudes, biology, size, shape, habitat—in short, their natural history. Most animals are visible in one way or another, either in zoos, aquariums, or in the wild. The artist can observe the animal in its natural habitat or in captivity, or he can rely on photographs, taken by himself or others. Most wildlife painters, therefore, choose as their subjects creatures they can see. This is not what one would call an abnormally restrictive criterion. One can easily see sharks in any public aquarium. There are probably sand tigers, dogfish, nurse sharks, and even an occasional sandbar or tiger shark. Other species have been maintained in captivity, but the frequency with which this occurs and the survival rate of the sharks is low. Besides, seeing a shark in an aquarium tank is not the same as seeing a shark in its natural habitat. There are those who would argue that to encounter a shark in the wild is to court disaster, but this is not necessarily so.

My introduction to sharks was representational: I was primarily concerned with their shape and form. When I began painting them regularly, I realized

that I had to "put them in the water," since that is the way they can best be understood—as creatures that are part of the undersea world, not as fishermen's trophies or as man-eaters showing lots of teeth. I have not meant to imply that there are no good photographs of free-swimming sharks. Of course there are. Among the photographer-divers who have produced some excellent shots of sharks in the water are Peter Gimbel, Ron and Valerie Taylor, Hans Hass, Jerry Greenberg, Doug Seifert, David Doubilet, and the Cousteaus. However, like the written information about various species, these pictures are not to be found in any one volume. A book that is rich in biological information is often short on illustrations; one with lots of pictures is usually accompanied by a proportional amount of misinformation.

I was originally fascinated by the complexity of the elements that comprised the silhouette of the shark. Each fin is a study in itself—a complex and graceful design, made up of curves and recurves that add up to a spare, efficient animal, powerful and primitive, yet part of our life today. The tail, or caudal fin, is an example of this superb design, since it is the sole source of the propulsive power of the shark. Some species have a long upper lobe ("heterocercal" tail fin), while others have upper and lower lobes that are almost the same size ("homocercal" tail fin). In one species, the thresher, the upper lobe of the tail is as long as the rest of the shark, and has been described as one of the toughest flexible structures in the animal kingdom. The sharks' fins are also powerful graphic images, the most abused of which, in a literary sense, is the dorsal fin. It always seems to be "slicing" or "knifing" through the water, presaging doom to the hapless swimmer, seal, or other creature. But the other fins, the curving pectorals, the flaring pelvics, the anal fins, and the second dorsals—all of these incorporate delicate, intersecting curves that I believe are unequaled in the animal kingdom.

So far I have dealt only with the gross morphology of the shark, its exterior form—no mention of skin like sandpaper, razor-sharp teeth, voracious appetite, man-eating, 300-million-year evolution. While working on the paintings, I began to truly appreciate the sharks. The more I learned about them, the more I wanted to know. Predators have always fascinated me, and the more effective the predator, the greater the degree of my fascination. I am aware that this obsession with hunters indicates something particularly revealing in my psychological profile, but this neurosis notwithstanding, I have been painting big cats, birds of prey, bears, and wolves for years. Now I have discovered perhaps the most intriguing hunters of all, the sharks, spellbinding masters of the seas.

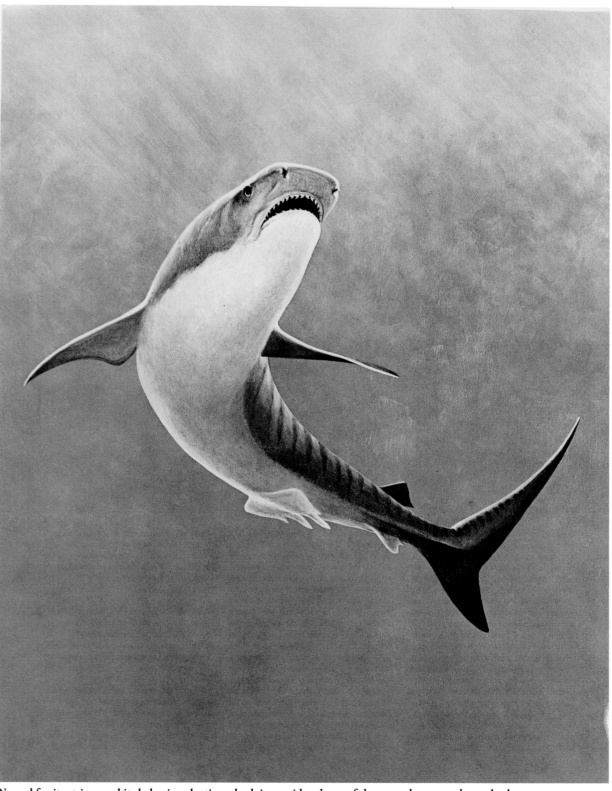

Named for its stripes and its behavior, the tiger shark is considered one of the more dangerous large sharks.
Painting by Richard Ellis

In my paintings, I have tried to show the sharks in settings that suggest their pelagic *modus vivendi*. This means that the background is often featureless, with only a suggestion of the surface or the bottom. Without any reference points, the subject of scale comes up: How can I demonstrate the size of these creatures? I tried everything, but the only object that everyone knows the size of is a human being. Coral, boats, other fishes—all these are variables, and there is no way of guaranteeing that the viewer will know their size. In a couple of instances, I put a human being in the painting, because I felt it was absolutely imperative to show the size of a particular species. In the rest of the paintings, I can just hope that the big sharks *look* big, and that the small sharks look small.

Gimbel's film, *Blue Water, White Death*, was released in 1971 to great critical acclaim. It chronicled the search for the great white, from South Africa to the Seychelles and ultimately to South Australia, where the filmmakers finally found their quarry. The film, shot by Gimbel, Stan Waterman, and Ron and Valerie Taylor, was described by Peter Matthiessen (in *Blue Meridian*) as "surely the most exciting film ever taken underwater [that] had been obtained without serious injury to anybody." In South Africa, the filmmakers had descended in a cage alongside the carcass of a sperm whale that had been harpooned by a whaler, and then, with the sharks ripping huge bites out of the dead whale, they left the safety of their cage and filmed the sharks while swimming among them. When they got to South Australia (where Ron Taylor had already filmed great whites), they finally got the footage they had traveled around the world for a year to get. I saw the film several times, and tried to burn the images of *Carcharodon carcharias* into my mind, but I also had a copy of *Blue Meridian*, which had some beautiful stills of great whites in action. Probably because they were the most infamous of all sharks, the largest predatory fishes in the world, and the stars of *Blue Water, White Death*, and also because I thought they were beautiful in a menacingly graceful way, I began to paint great white sharks.

With the exception of John Singleton Copley's *Watson and the Shark*, which shows a naked man in the water with a strange-looking shark with its jaws outside its lips, and Winslow Homer's *The Gulf Stream*, with its sharks hungrily circling a dismasted schooner with a disconsolate sailor aboard, few people have approached the shark as a subject for art. But I didn't care; I thought they were beautiful, and I wanted to paint them. First I did some midwater images, with the shark hovering in the gloom, but like the little encyclopedia paintings, these didn't seem to capture the awesome size and power of the white shark. I decided to paint the shark's portrait—only the head, arguably the quintessence of white shark-ness. When the

half-finished painting was up on my easel, the mother of a friend of my seven-year-old daughter came into the studio and asked what it was. I said "It's a great white shark," and she said, "That's interesting. I have a friend who's working on a novel about a shark or a whale or something. Can I have him call you?" I said sure, and shortly thereafter, the phone rang, and a voice said, "Hi. This is Peter Benchley. I hear you're painting a shark." I said indeed I was, and Benchley asked if he might come over to have a look at it. When the painting was finished he came to the apartment, and liked the painting so much that he bought it on the spot. (It was the first shark painting I ever sold.) Benchley said that in a couple of weeks there was going to be a publication party for the novel he had written, and because he lived in Princeton, perhaps I could bring the painting to the party, which was going to be in the Doubleday office on 53rd Street and Fifth Avenue, and he would take it home from there.

On the night of the party, I wrapped the painting in brown paper, and off we went in a taxi. When I offered the painting to Benchley, he said, "Let's unwrap it and exhibit it here," but I thought that it was his party and it didn't need my painting. "But the book is about a great white," he said, "let's put it over there." We propped the painting on the back of a sofa, and I must admit, it looked pretty good there. Peter Gimbel and I were standing in front of the painting, commenting about the great white shark, its implacable black eye, razor-sharp teeth, and other sharky topics, when Benchley's wife Wendy came over, tugged on my elbow and said, "Oscar Dystel wants to talk to you." I said, "Okay, just a minute; I'm talking to Gimbel." (Gimbel's German-born wife Elga always referred to him as "Gimbel," so many of us picked that up.) "No," said Wendy, "*OSCAR DYSTEL* wants to talk to you." I hadn't the faintest idea who Oscar Dystel was, but if Wendy thought talking to him was so important, I'd go. She led me to a short, bald fellow, who asked me what I was working on. This was a publishing party—the first I'd ever been to—so I told him I was working on a book about sharks. I wasn't, but it seemed like an appropriate response, and besides, I had no idea who Dystel was. When he said, "I may have a publisher for you," I put it down to inconsequential cocktail-party chatter.

I went back to my discussion with Gimbel, and then began to bug Benchley about my copy of *Jaws*. I assumed that at a party like this, the guests were all supposed to receive a copy of the book, and I kept asking Peter for a copy. I've since learned that it is the exception rather than the rule for authors to hand out copies of their books, but finally, an exasperated Benchley handed me a copy of the

book. When I opened it, I saw that he had inscribed it, "*Here, Goddammit. Peter Benchley.*" With my lovingly inscribed copy of *Jaws* in hand and the painting safely delivered, I headed home and forgot all about Oscar Dystel.

Until 9:00 the next morning, when my phone rang and a voice said, "My name is Harold Roth. I'm the publisher at Grosset & Dunlap. Oscar Dystel told me to call you. He said you were writing a book about sharks." "Who is Oscar Dystel?" I asked him. He told me that Dystel was the president of Bantam books, the largest paperback publisher in America. "Oh, is that all," I thought. "When can we have a look at an outline of your book?" asked Roth. There was no outline of course; there was nothing but a couple of shark paintings, but fortune was smiling on me in the form of jury duty. I told him I couldn't meet with him for at least a week, because I was due to begin jury duty the next Monday, but as soon as my civic duties were discharged, I would bring him an outline. I never made it onto a jury, so I spent the entire week being interviewed by lawyers, and then scurrying back to my table so I could write the outline. I didn't have much of an idea of what a book outline was supposed to look like, but by the time of our scheduled meeting at Grosset

& Dunlap, I had something that resembled a term paper about sharks, and a bunch of black and white photographs of my paintings. Roth was at the meeting along with an editor named Bob Markel, and they seemed to feel that my presentation was satisfactory, because I left with the feeling that I was going to write a book about sharks for them.

I didn't know exactly what that meant, and furthermore, because we had not discussed money, I didn't know if they were going to give me $500, $5,000, or nothing at all until I delivered a completed manuscript. And after the meeting, I couldn't

think of how to find out. I couldn't just call up Harold Roth and say, "Um, excuse me. I think we forgot to talk about money. How much did you say you were going to give me?" Again Lady Luck appeared, this time on a bus stop. Every school morning I would take my daughter Elizabeth downstairs to get the school bus, and one of the mothers who waited at the same bus stop was the novelist Anne Roiphe, the author of *Up the Sandbox*, among other things. While waiting for the bus on a cold February morning, I told her my story, and she said, "Why don't you call my agent, Carl Brandt?" After putting my daughter on the bus, I went back upstairs and called him immediately. I told him the story of Wendy Benchley and Oscar Dystel, about how Harold Roth had called me, and how I had to write an outline in the jury waiting room at 100 Center Street. I agreed to send him a copy of the outline I had given to Roth, and after he got it, he said, "Leave everything to me."

I had pretty much forgotten about my meeting with Grosset, and a couple of months later, I found myself in Trinity Bay, Newfoundland, where I had been invited to do some whale-watching. One day, after flensing the carcass of dead minke whale (and burning the clothes we had worn), we ended up in the bar at the Trinity Inn. Someone announced that there was a phone call for me, and I was told to pick up the wall-mounted pay phone. It was Brandt. He said, "This is your agent calling." My agent! (I had completely forgotten that I had an agent.) He said, "How does $xxxx sound to you?" I said, "Wow," and bought a round for everyone in the bar. In the saloon bar of a remote Newfoundland inn, I had become an author. Now all I had to do was figure out how to write a book.

In that same year, by a fortuitous coincidence, *Audubon* magazine sent me to Florida with Gary Soucie, who was planning to write a big article on sharks. I was to provide the illustrations, so the trip would give me the opportunity to see some of the sharks and also talk to some of the shark people. In Sarasota, Gary and I both interviewed scientists Stewart Springer, David Baldridge, and Perry Gilbert (as an extra bonus, Beulah Davis of the Natal [South Africa] Anti-Shark Measures Board was there when we visited the Mote Marine Lab), and I got to see some sharks up close and personal. Perry Gilbert was showing us around the Mote Lab, which then consisted of little more than a cinder-block office building and a couple of big open shark tanks. Gary and I wanted to look at the sandbar and dusky sharks that were swimming in one of the tanks, so we got on a sort of wooden walkway that bisected the tank, and looked down as they slowly circled below us. About halfway across, the boards gave way, and we were dumped into a tank of what we assumed were ravenous, man-eating sharks. We'd both read *Jaws*, so we thought that the

end had come, but the sharks were probably more frightened than we were as two huge, flailing objects splashed into their pool, and they took off faster than we did. We really had nothing to worry about because in our haste to escape, we probably redefined the term "walking on water." Gary's article, which was called "Consider the Shark," ran in the September 1976 issue of *Audubon*, and contained a painting of each of the better-known large sharks, including a hammerhead, white, tiger, blue, whale shark, basking shark, thresher, and one little fellow called a chain dogfish.

Seems that *Audubon* editor Les Line had found an article in the *New York Times* about some "rare treasures" that had been caught in the Gulf of Mexico, and brought to the New York Aquarium at Coney Island. He suggested that I head for Coney Island and have a look at these rare and unusual creatures, with an idea of painting one for the magazine. The chain dogfish (*Sciliorhinus retifer*) is a 15-inch-long shark that is cream-colored with reddish-brown chainlike markings and emerald-green eyes. It would provide a nice counterpoint to all those nasty man-eaters, so off I went to Coney Island, sketchbook in hand. It was probably the first time in *Audubon*'s history that an artist was sent *by taxi* to observe and draw a wild creature.

During the summer of 1975, when I was living in Rhode Island, I received a call from one of the local fishermen, telling me that they had brought a shark to the dock. (I had asked that they call me if any sharks were brought in.) When I asked what kind of shark it was, he said, "It's just a gray shark." At that time, I was working on the text for *The Book of Sharks*, and I was interested in all types of sharks, but I must confess that I was not too interested in seeing a blue or a sandbar, sharks that were fairly common in Rhode Island waters. I almost didn't go to the docks at all.

But because I had asked them to call me, I did go, and when I got there, I recognized the fish immediately as a white shark, although it was certainly not great. It was four feet two inches long, a perfectly formed miniature of the adult it would have become had it not drowned in the fishermen's nets. I told the fishermen it was a great white, and they assumed I was joking—this was, after all, the summer of the release of *Jaws*, and it can be said that most of the country (certainly most of the country where people swam in the ocean) was in the grip of what can only be described as "shark hysteria." When they asked me to get serious and *really* identify it, I assured them that it certainly was a great white and proceeded to point out its salient characteristics: conical snout, black eyes, lunate tail with almost equal lobes, black spots at the axil, and finally, its triangular, serrated teeth.

The chain dogfish (*Scyliorhinus retifer*), painted from a live specimen in the New York Aquarium, Coney Island. *Painting by Richard Ellis*

A baby white shark is a miniature version of an adult, and even in death it exudes strength, power, and menace. It doesn't look like a baby shark—it doesn't look like a baby *anything*. At four feet in length, a newborn white shark is larger

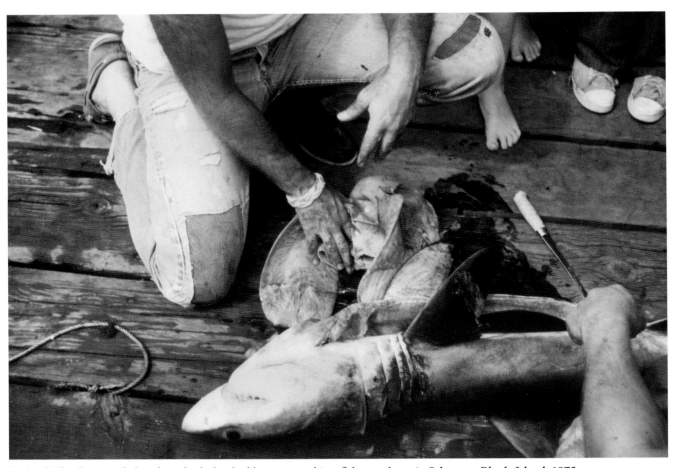

Richard Ellis dissects a baby white shark that had been trapped in a fishermen's net in Sakonnet, Rhode Island, 1975.
Photo by T. A. Kneeland

than most other species of sharks full-grown. A crowd gathered as I proceeded to dissect this four-foot-long baby. (I had called my colleagues at the Narragansett Lab of the National Marine Fisheries Service, and asked them what they wanted, and they told me, "stomach contents"), and after I told them it was indeed a baby white shark, people gathered around nervously asked me, "Where's its mother?"

The Book of Sharks had a section called "The Shark People," which included scientists, divers, fishermen, photographers, writers (fiction and non-), victims of shark attacks, and the man who developed the commercial market for shark leather. Since the book appeared in 1975, many of the original shark people have died. Zane Grey was long dead when I wrote the book, as was "Sharky Bill" Young. Perry Gilbert, Stewart Springer, Scott Johnson, Jack Garrick, Beulah Davis, Art Myrberg, and Don Nelson died after 1975. John McCosker and I dedicated our 1991 *Great White Shark* to Peter Gimbel, who died in 1987. The 1975 party for

Jaws was the genesis of *The Book of Sharks*, and in that book, I included Peter Benchley in my profiles of the "shark people" who had contributed to our understanding—if that's really the word—of sharks. Later, McCosker and I wrote *Great White Shark*, which featured Benchley as one of the seminal figures in the intertwined destinies of *Carcharodon carcharias* and *Homo sapiens*. Never mind that some of what he wrote was exaggerated or just plain wrong—the important thing was that people believed it. By 2003, when I wrote *The Empty Ocean*, Benchley had become an advocate for shark conservation, and I was pleased to include him in that context. He wrote *Shark Trouble* (his last book) in 2002, about his longtime affiliation with sharks, in which he said:

> *Sharks are perfect predators whose form and function have not changed significantly in more than thirty million years. I'll try to pass on what I've learned about sharks and about keeping safe in the sea, to show you what sharks are like, and why they don't want to hurt or eat you, why they would like nothing better than to be left alone to do what nature has programmed them to do: swim, eat, and make little sharks.*

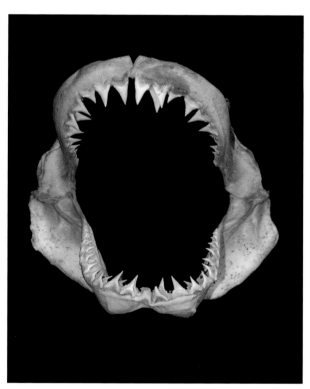

The jaws of the little white shark on the previous page, showing that even the babies can be dangerous.
Photo by Richard Ellis

Benchley never apologized for all the trouble he caused, particularly for sharks. (The title of his book can be interpreted as trouble for the sharks, not as Benchley himself getting into trouble. Indeed, sharks never really got him into trouble, unless his chronic back problems were brought about by carrying sacks of money to the bank.) The *Jaws* phenomenon—novel, movie, and sequels—spawned any number of dime-store imitations, but more important, portrayed sharks as dangerous man-eaters, and therefore creatures that ought to be eliminated from the face of the earth. Sharks actually do not want to hurt or eat you, and as Benchley said, they would like nothing better than to be left alone. In this book, I hope to be able to demonstrate that, and also that sharks constitute the most fascinating and misunderstood group of animals on land or in the sea.

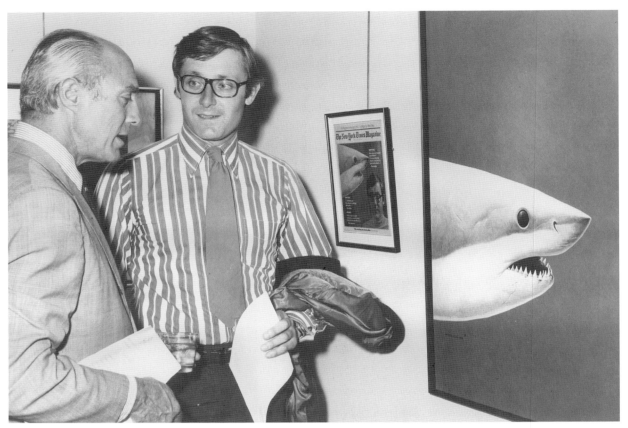

Stan Waterman (left) and Peter Benchley checking the accuracy of Richard Ellis's portrait of a great white shark, 1976.
Courtesy of Sportsman's Edge Gallery

What is it about sharks that so intrigues us? Is it that they are so disdainful of us that they swim silently offshore, ignoring the tasty legs often dangled right in front of them? (Wherever you swim off an ocean beach, there are probably sharks not very far away. If sharks were the voracious man-eaters that some people think they are, no beach in the world would be safe.) They come in all shapes and sizes, from minute to monstrous. There are angel sharks, basking sharks, blacktip sharks, blue sharks, bramble sharks, bull sharks, carpet sharks, catsharks, cigar sharks, cow sharks, crocodile sharks, dogfish, epaulette sharks, frilled sharks, goblin sharks, gray sharks, horn sharks, kitefin sharks, lemon sharks, leopard sharks, mako sharks, monk sharks, nurse sharks, reef sharks, salmon sharks, saw sharks, sharpnose sharks, silky sharks, sleeper sharks, soupfin sharks, swell sharks, thresher sharks, tiger sharks, whale sharks, whaler sharks, white sharks, whitetip sharks, zebra sharks, bonnetheads, hammerheads, porbeagles, and wobbegongs.

The world of sharks is amazingly diverse. Not only are they found in every ocean (and occasionally in rivers or lakes), but they are with us everywhere—in our museums, aquariums, books, magazines (there is a magazine called *Shark Diver*), sports arenas, movie theaters, restaurants, television screens, jewelry, clothing, toys, dreams, nightmares, folktales, and mythology. The early Polynesians told of the shark-god Kauhuhu, who lived inside a great cavern from which no one ever emerged. In Australian aboriginal mythology, the tiger shark Bangudja attacked a dolphin-man in the Gulf of Carpentaria, leaving a large red stain on the rocks of Chasm Island that can still be seen today. Dancers in the islands of the Torres Straits (between the Cape York Peninsula of northeastern Australia and Papua New Guinea) often wear elaborate shark head-dresses, and the Solomon Islanders, whose religious life consists of ghosts, spirits, and other manifestations of the supernatural, believed that the ghosts of the departed inhabited the bodies of sharks. In the art of the Northwest Coast Indians of North America, the dogfish was often used decoratively as a reminder of the woman who was carried off by a shark and then became one. Except for the peoples of the Pacific, however, the shark was generally ignored as a symbol. European legends contain few references to the shark—there are no sharks in Aesop's *Fables*, for instance. These fish appear only in natural histories or seafarers' journals, where it was fairly common to write about and occasionally identify these often mysterious, always threatening creatures. It was not until fairly recently that the shark insinuated itself into our collective consciousness, figuratively and literally.

We "advanced" folk of the twenty-first century probably think of ourselves as being beyond pagan mysticism, but as I hope to demonstrate, we are actually in the grip of an even stronger mythology. We have elevated the shark to a position in our pantheon that transcends that of any other animal. Only the whale has achieved a comparable mythification, but there we have fabricated a benevolent spirit, as contrasted with the shark as the embodiment of evil, the representative of the Underworld. Perhaps it is the mysterious nature of the strap-gills that has been responsible for their enthronement. After all, we know very little about them, and we tend to fear that which we do not understand.

There are many creatures in the oceans that we know little about, but none fascinates us or holds us in thrall as does the shark. From the foot-long dogfishes to the forty-foot-long whale shark (the largest fish in the world), all the four-hundred-odd species have succeeded in withholding some of their secrets from the prying eyes of the scientists. Consider the great white shark, surely the most fearsome of all the sharks: We know little about its breeding habits, its swimming

speed in the wild, its food preferences, its abundance, range, or ancestry. For all our ignorance about this fish, perhaps the most disturbing aspect of its behavior is its predilection for attacking people and occasionally devouring them. This inclination might prove to be nothing more complex than a big, carnivorous fish trying to eat what appear to be edible objects, but the simplicity of this interpretation does not diminish the terror—it may even intensify it.

The painting that Benchley bought in 1975 was generously loaned to this exhibit by his widow, Wendy Benchley. My friend Peter Benchley died in February 2006. This book is for him.

What Is a Shark, Exactly?

When I write of "curving pectorals" and "flaring pelvics," I am trying to discuss sharks in general. But this turns out to be almost impossible. Most sharks have the requisite number of fins, but they do not all curve gracefully. Many species are lithe and graceful, but some are not, and others are downright funny looking. Almost nothing can be said about sharks that is categorically applicable to all species. After many attempts and blind alleys, the best I can come up with is this: Sharks are vertebrate animals that have multiple gill slits, cartilaginous skeletons, placoid scales, numerous teeth, and they live in the water. All other generally accepted concepts, while not necessarily false, have to be modified, qualified, or disclaimed to such a degree that they become useless.

Take for example the question of what a shark *is*. It is not exactly a fish, since many of the criteria used to define fishes do not apply to sharks. For instance, all fishes have bony skeletons; no sharks do. It is this particular characteristic that is used to separate the fishes from the sharks (and from the skates, rays, and chimaeras). *Osteichthyes* is the name applied to the class of bony fishes; *Chondrichthyes* is the name used for all the cartilaginous fishes. There are, of course, many similarities between sharks and fishes: They both live chiefly in a watery habitat, and both use gill structures to extract oxygen from the water. (Some fishes actually breathe air, but not many.) However, similarities of habitat and method of oxygen intake are hardly sufficient to warrant the common classification of two types of creatures. If they were, people and rattlesnakes would be in the same class.

Bony fishes and cartilaginous fishes are different in a number of ways. (Even though we are discussing the question of whether or not sharks are fishes, I shall continue to call them cartilaginous fishes. That is the literal translation of the word

Chondrichthyes, and "cartilaginous animals" sounds peculiar. Besides, calling something a fish does not necessarily make it a fish. [Is a shellfish a fish? A jellyfish?]) Bony fishes have only one gill aperture on each side of the head, while sharks have from five to seven, depending on the species. (Most species have five.) Many species of sharks have a placental relationship with their young, a condition lacking in all bony fishes. The skin of a shark is comprised of placoid scales (also called "dermal denticles"), which are toothlike in character, and usually microscopic in size; the scales of the bony fishes are completely different in structure, shape, and function.

So, a shark is not exactly a fish. Neither is it a man-eating, voracious, omnivorous killer, attacking boats, swimmers, whales, and anything else foolish or edible enough to enter its domain. A shark is a vertebrate animal, usually found in an oceanic habitat, with five to seven gill slits and a cartilaginous skeleton. The rhapsodic veneration of intersecting curves presented earlier is reserved for the larger pelagics, such as the mako, the white, the thresher, and the whitetip. It is creatures like these that first come to mind when the word "shark" is mentioned. They, and many other large sharks, are all you ever thought a shark was supposed to be: They are large, fast, and dangerous, and one therefore thinks of them in that special way reserved for the large predators. It is fear, mixed with admiration and envy—they do their job so well. Any predator large enough to attack a human being, with the added ability to eat him, conjures up this morbid fascination. (When a mosquito "attacks" a human being and "eats" a minute amount of human blood, no one thinks to call a mosquito a man-eater.) Sharks have the ability (although, as we shall see, not the inclination) to eat a person alive, and this is surely one of the most horrible deaths imaginable.

Man-eating lions, tigers, and crocodiles have been extensively treated in historical and fictional literature, and elaborate attempts have been made to halt their anthropophagous habits. This is not to say that all lions, tigers, and crocodiles are man-eaters; in fact, very few of them have been known to engage in this grisly practice. It is only when humans interfere with these creatures, or when they become too old or sick to pursue their usual prey, that the notorious conflicts occur. Trespass is most clearly seen in the case of the shark, since it can be argued that a human's place is on the land, whether it be African savannah or Indian jungle, and, therefore, conflict with the land-based predators is inevitable. (On land, we have resolved the problem rather neatly by eliminating most of the lions and tigers, or relegating them to reserves where contact with people is controlled and minimal. For obvious reasons, we cannot treat the shark in the same way.) The

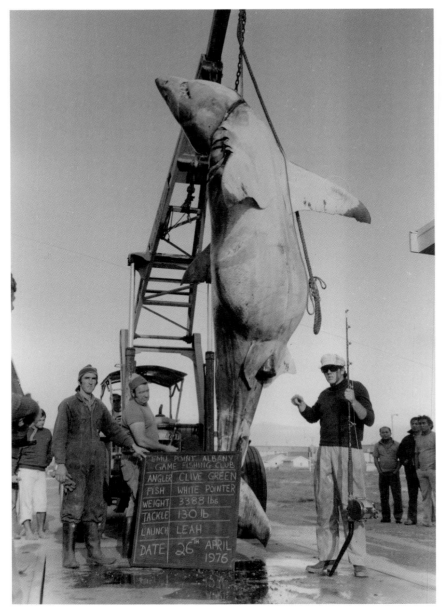

After the release of *Jaws*, everybody wanted to catch a man-eater.
Courtesy of the International Game Fish Association

shark's domain is not the human's. The human is a land animal, not an aquatic one, and he is therefore a trespasser in the water. He can swim in the ocean, he can fish in the ocean, and he can sail on the ocean, but he does not belong in the ocean. Only through the use of complicated technologies can the human even enter the world of the fish, and then he is merely a temporarily transposed land animal, fated to look at the watery world through a facemask or a window. The human is

so poorly designed for aquatic adventures that he cannot see in the water without artificial aids. If we had been meant to be in the water, we would have been given better eyes for the job, at least.

Painters and sculptors (usually on dry land) admire the sharks for their grace and power, and for their place at the pinnacle of the food chain—sharks are the chasers, rarely the chased. Divers enter the shark's deepwater domain to photograph these sleek predators, and surface with images that astonish us: *So close to those fearful jaws and teeth!* And sharks can pervade our everyday existence; we wear their teeth as jewelry, as if to demonstrate that we are the earth's predominant predators; shark T-shirts are worn by kids of all ages to incorporate these toothy images into our secure terrestrial lives. When the Monterey Bay Aquarium first exhibited a juvenile white shark that had been trapped in a fishermen's net, two hundred thousand people came to see it.

The great white shark has become a totem for our times: the embodiment of evil and terror. From its first, shadowed appearance in our collective consciousness, the white shark has been threateningly larger than life. In the summer of 1916, as French and German soldiers were fighting the terrible, bloody battle of the Somme, a series of shark attacks in New Jersey effectively displaced the war from the headlines. (As it turned out, the attacker was probably not a white shark, but people thought it was.) After a succession of white shark attacks in South Africa and Australia had amplified the terror in the 1960s, Peter Gimbel decided to look that terror in the eye, and made *Blue Water, White Death.* The white shark was on its way to the pantheon of legendary beasts, and when Peter Benchley published *Jaws* in 1974, its place in the front rank was assured.

In the new mythology of the shark, there looms a single great presence, *Carcharodon carcharias.* The great white shark swims alone in cool waters—in science, in literature, in infamy. It is the selachian definition of *sui generis*, but it has come to represent all sharks, because in a sense it is all sharks: It is big, powerful, dangerous, unheeding, and frightening to behold, and it is equipped with all the fixtures of the quintessential shark: rows of razor-sharp teeth in a gaping maw, a soulless black eye, a bullet nose, and the great triangular dorsal fin, always "knifing" through the water. Of all large, predatory animals, the white shark is probably the most dangerous to humans. Various smaller predators—cobras in Asia and scorpions around the globe—kill vastly more people each year than all the sharks in the seas, *but they do not eat their victims*, and they assuredly have not acquired the same reputation, at least not in Western countries.

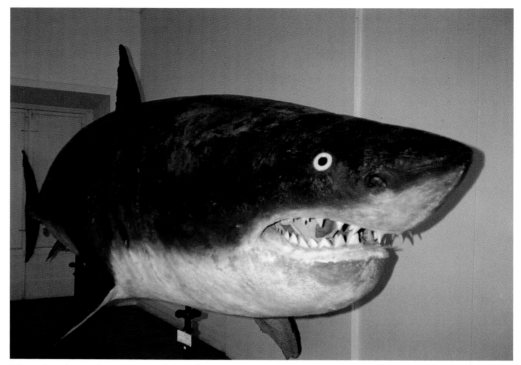

The only *tiburão branco* I was able to find in the Azores: a twelve-footer in the museum in São Miguel.
Photo by Richard Ellis

Since the cartilaginous skeletons of sharks lend themselves poorly to fossilization, we have only fragmented evidence regarding their evolution. (Only the teeth and the vertebral centra have been preserved, and as we shall see, these often cause more problems than they resolve.) There is no question that sharks are amongst the oldest of the vertebrates, and we can trace their lineage back some 300 million years. (*Homo sapiens* can claim at best a three-million-year-old forebear). If the origins of the sharks themselves are lost in the mists of elapsed time, so too are the origins of the legends. As mentioned earlier, we can easily identify some of the early folktales, but today, sharks hold the unchallenged top position in our pantheon of marine monsters.

In this new mythology, there is an emphasis on one species, *Carcharodon carcharias*, the great white shark. In the chapter on the "whiteness" of a certain whale, Melville acknowledges that there are other creatures whose lack of color "causes the thought of whiteness, when divorced from more kindly associations, and coupled with any object terrible in itself, to heighten that terror to the furthest bounds." He singles out the polar bear ("were it not for the whiteness, you would not have that intensified terror"), and of course, the great white shark. Never mind that the white

shark isn't really white, but mostly dark gray with white underparts—Melville, who probably never saw one, thought it was, and wrote, "the white gliding ghostliness of repose in that creature, when beheld in his ordinary moods, strangely tallies with the same quality in the Polar quadruped." Forget that there are an additional 450 species of sharks, most of which are harmless to man. Forget also that there are no authenticated reports of white sharks over nineteen feet in length. (The shark in *Jaws* was never measured, but the ichthyologist suggests that it might be twenty-five feet long.) There continue to be reports of monster sharks, ranging in length from 30 feet to 115 feet.

In 1982 I went to the Azores to track down reports of a twenty-nine-foot-long shark that was supposed to have been harpooned there by sperm whalers. I spent the better part of two weeks in the islands, interviewing scientists, fishermen, newspapermen, and administrators. I found no evidence at all that a white shark of such a size had ever been seen in the Azores. Of course, that does not conclusively prove that such a creature does not exist, only that a dedicated investigator who spoke only two words of Portuguese (*tiburão branco*) was unable to document its existence.

During a twelve-day period in July 1916, no fewer than five men were attacked by sharks in New Jersey waters, four of them fatally. On July 1, twenty-three-year-old Charles Vansant, playing in the surf some fifteen yards from shore at Beach Haven, was bitten on the left thigh. Although companions dragged him ashore and quickly applied a tourniquet to his leg, he had suffered a massive loss of blood, and he died less than two hours after the attack. On July 6, at the beach resort of Spring Lake, some forty-five miles north of Beach Haven, Charles Bruder was attacked while swimming four hundred feet from shore, and both his feet were bitten off. Although a lifeboat was launched immediately when he began to scream, and he was taken quickly to shore, he died within minutes. Six days later, at Matawan, thirty miles north of Spring Lake, an eleven-year-old boy named Lester Stillwell was swimming with friends when he was pulled under. (Although a "large dark gray shark" had been spotted earlier in Matawan Creek, nobody actually saw the shark that attacked Stillwell.) Would-be rescuers dived into the creek searching for Stillwell's body, and one of them, a twenty-four-year-old tailor named Stanley Fisher, was savagely bitten on the right thigh, and even though he was rushed to a hospital, there was no way to reverse the massive tissue and blood loss and he died on the operating table.

By this time, the news of the Matawan Creek attacks had spread, and even as a group of boys were climbing out of the water some four hundred yards from

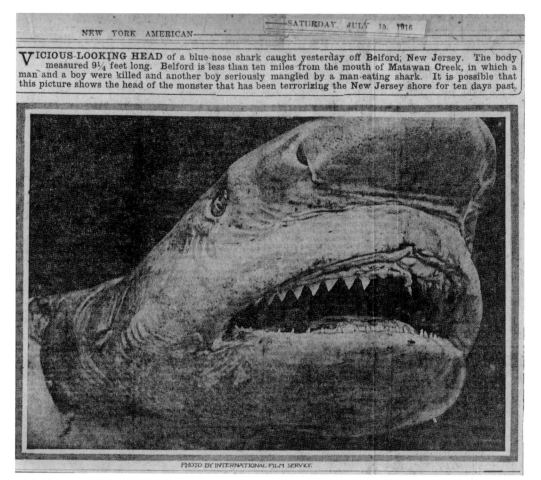

SATURDAY, JULY 15, 1916

NEW YORK AMERICAN

VICIOUS-LOOKING HEAD of a blue-nose shark caught yesterday off Belford, New Jersey. The body measured 9¼ feet long. Belford is less than ten miles from the mouth of Matawan Creek, in which a man and a boy were killed and another boy seriously mangled by a man-eating shark. It is possible that this picture shows the head of the monster that has been terrorizing the New Jersey shore for ten days past.

PHOTO BY INTERNATIONAL FILM SERVICE

Nobody really knew what kind of shark (or sharks) were responsible for the 1916 attacks.
Richard Ellis collection

the site of the Stillwell-Fisher attacks, twelve-year-old Joseph Dunn was bitten on the lower left leg. But although he was severely lacerated, no bones were crushed and no arteries were severed, and Dunn made a full recovery. Using dynamite, guns, harpoons, spears, and nets, the residents of Matawan assaulted the waterways, hoping to capture or kill all of the sharks in the vicinity. Although many sharks were thus dispatched, it was never proved that any of them was responsible for the attacks in Matawan Creek. For two days, the newspapers were full of shark reports and stories of "monsters" caught in the region. Then, on July 14, a 7.5- to 8.5-foot white shark was trapped in a drift net in Raritan Bay—just four miles northeast of the mouth of Matawan Creek—and bludgeoned to death by a man named Michael Schleisser. When this shark was cut open, it was found to contain fifteen pounds of flesh and assorted bone fragments, which may or may not have

been human. (One of those who "positively" identified the remains as human was Dr. Frederick A. Lucas, director of the American Museum of Natural History in New York, who only a few days earlier was quoted in the newspapers as saying that sharks could not possibly inflict the kind of damage that was done to Bruder.)

On the front page of the *Home News* ("For the People of Harlem and the Heights") for July 19, 1916, is a photograph of Michael Schleisser and the white shark. The headline of the accompanying story reads, "Harlem Man in Tiny Boat Kills a 7 1/2-Foot Man-Eating Shark," and the subhead read, "Beats it to Death with Broken Oar, Directly off Matawan Creek, Where Two Brothers Were Attacked and Killed by Sea-Tiger Last Week. Examination By Director of Museum of Natural History Shows Human Bones in Shark's Stomach." Schleisser and his friend John Murphy had gone fishing from South Amboy (New Jersey), setting a small drag net that then snagged the monster. The shark towed their eight-foot motorboat on a wild, stern-first ride, but Schleisser finally killed it by repeatedly bashing it on the head with a broken oar. The 350-pound carcass was taken to the offices of the newspaper at 125th Street, where "the yawning jaws and vicious teeth" were viewed—according to an article the following Sunday—by "at least 30,000 men, women, and children." Sharks—especially those that were suspected of being man-eaters—were an unusual sight in New York City. One woman called it "cute," and a man maintained that the fish in the window was not a shark at all, because the mouth of a shark was on the side, not on the front, and he identified the fish as a porpoise.

For about two weeks in the summer of 1916, the news of the Jersey shark attacks dominated the news. But it wasn't long before another battle—even more catastrophic and with more casualties—drove the sharks off the front pages. The Battle of the Somme was fought in France between July and November 1916, on both banks of the river of the same name. It was one of the largest battles of the First World War, and by the time fighting petered out in the late autumn of 1916, more than one and a half million casualties had been recorded by both sides. It was one of the bloodiest military operations in history, more than enough to relegate the New Jersey shark attacks to the back pages, or out of the news altogether. The gruesome shark stories were mostly forgotten until around 1963, when Messrs. McCormick, Allen, and Young produced *Shadows in the Sea*, in which the opening chapter ("The Shadows Attack") contains a detailed, gory account of the New Jersey attacks. Then Dr. Richard Fernicola, a medical doctor from Allenhurst, New Jersey, picked up the gauntlet, and decided that the culprit was really the single

white shark caught by Michael Schleisser. He pounded that drum incessantly, writing books and writing and appearing in television specials (on Shark Week, of course) trying to bludgeon his conclusions across, rather like Schleisser had bludgeoned the poor little shark.

Richard Fernicola and I participated in a television show around 1990, filmed as we stood on the beach on the Jersey shore. He argued the case for the white shark as perpetrator, while I tried to explain that white sharks have never been known to enter fresh water while bull sharks do it regularly, that no single shark (of any species) would swim a hundred miles in four days just to bite people, and that juvenile white sharks are fish-eaters and do not attack large prey until they get to be ten feet long or longer. I don't think I convinced him that the attacks were caused by bull sharks, known to swim up rivers (one was taken in Illinois, one thousand miles up the Mississippi), and more to the point, known throughout their worldwide range as man-killers.

Not content with debates, TV shows, or pamphlets, in 2001 Fernicola wrote a book he called *Twelve Days of Terror*, and followed that in 2004 with a television screenplay with the same title. The book is historically accurate, and includes Dr. Fernicola's meticulous analysis of the bite wounds on the various victims, as well as a careful discussion of the teeth of great white sharks to show that only a great white could have perpetrated these attacks. (As evidence, he cites my cover illustration for *Great White Shark*.) The teleplay, however, is a shark of a different color—well, not really, for the shark in the film is a great *white*. As befits its medium, the TV version of *Twelve Days of Terror* has a romantic subplot. The hero, simply named Alex, has lost his girl Alice to a haberdasher named Stanley, who happens to be Stanley *Fisher*, the man who actually became the fifth victim as he tried to rescue Lester Stillwell in Matawan Creek in 1916. After some "warm-current" mumbo jumbo, Alex heads for the offshore spot where he knows the shark will be, but instead of a shark, he finds Michael Schleisser, who intends to kill the shark himself. But in a reversal of history, instead of Schleisser killing the shark, it kills him. Alex avenges the deaths of all those other people, kills the shark, and tows it back to town, where it is strung up, and of course it proves to be a great white. Game, set, and match to Fernicola. (TV category.)

Later in the twentieth century, shark attacks became front-page news all over the world, especially in South Africa and Australia. In 1959, the American Institute of Biological Sciences convened the Shark Research Panel, which in turn collected data on shark attacks around the world. The Shark Attack File, then maintained at

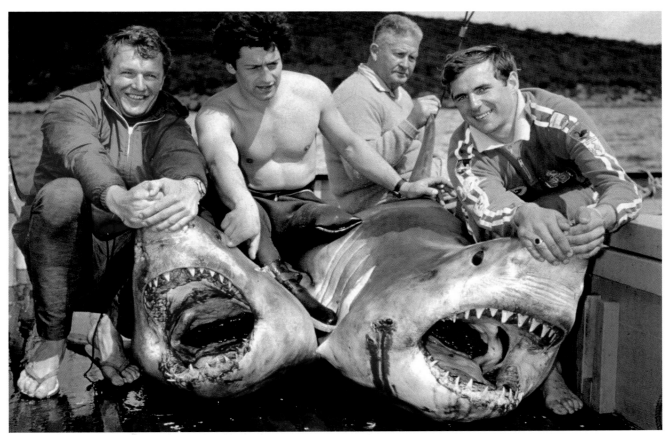

Brian Rodger, Henri Bource (who lost his left leg), and Rodney Fox, all victims of attacks by great white sharks. Behind them is Alf Dean, the shark fisherman who caught the cuties in the foreground. *Photo by Ron Taylor*

the Mote Marine Laboratory in Sarasota, Florida (now at the University of Florida in Gainesville), was reviewed by H. David Baldridge, who compiled a report on the data contained in the file, and then wrote a popular book called *Shark Attack*. Other books were written (I wrote one in 1976 and another in 1991), but the sharks did not have to rely on published material to get themselves noticed. They were doing very nicely on their own, thank you.

In South Australia, three divers were attacked by white sharks. In 1961, Brian Rodger was bitten; the next year Geoff Corner was killed; and in 1963, Rodney Fox was savagely attacked by a white pointer. It took 462 stitches to sew Fox together again. In 1967, with Henri Bource (another victim, who had lost a leg to a white shark in 1964), Ron Taylor, and Alf Dean, the fisherman who holds the record for the largest fish ever caught on rod and reel, a 2,664-pound white shark, Rodney Fox went back to Spencer Gulf to look for the fish that nearly killed him. The

photographs that Ron Taylor took on this expedition are still among the best ever taken, and they have probably been used more often than any other pictures of the shark the Australians call "white death." One of Taylor's photographs of a shark approaching the camera with its jaws agape was used on the poster advertising Peter Gimbel's 1968 film of his search for the great white shark, *Blue Water, White Death*. It was the first time that the white shark had been filmed underwater, but it was not going to be the last.

The shark occupies a habitat that is not of our terrestrial understanding. Despite the technological advances that have enabled us to enter the water, we do so as trespassers in an alien and decidedly hostile world. Even the medium is hostile; we cannot breathe it like the fishes and the sharks do, and without a facemask, we can barely see through it. In this thick, liquid environment, the shark evidently reigns supreme. Are we jealous of the ease with which the sharks move, breathe, feed, and reproduce in the water? What are the elements that make up this love-hate relationship? Is it that these big fish with the small brains have circumvented our every effort to control or even understand them? Do we admire these hunter-killers because we have lost these natural abilities ourselves? Or do we admire their lethal, graceful form; their spare economy of line and motion; their smooth, sleek, and overwhelmingly ancient efficiency? Is it something that goes even deeper into our collective psyche? Perhaps it is our atavistic fear of being eaten that simultaneously lends distance and a disturbing proximity to our relationship with the shark. It is, after all, one of the few animals on earth that we fear can—or worse, *will*—eat us, and that is the stuff of which legends are made.

Sharks existed long before there were people to fear them. Primitive sharks, looking nothing like today's familiar tigers, blues, and whites, prowled Devonian seas 300 million years ago, armed with circular-saw teeth, while others had scissor jaws armed with five-inch, serrated teeth. And then there is the (extinct) megalodon, a fifty-foot-long shark that could swallow a cow. For years, the open jaws of megalodon dominated the Fossil Fishes Alcove in the American Museum of Natural History, its gigantic gape and huge teeth a silent and fearsome testimony to the past history of dominant ocean predators. A photograph of this huge jaw, shown sometimes with six men sitting in it and sometimes with only one, appears in almost every book about sharks. However, even though the museum label said, "It is estimated that this giant shark reached a length of approximately forty-five feet," anyone using megalodon in his book adds ten, twenty, or even fifty feet to this given length. So it is that many writers who have seen the jaw and read the

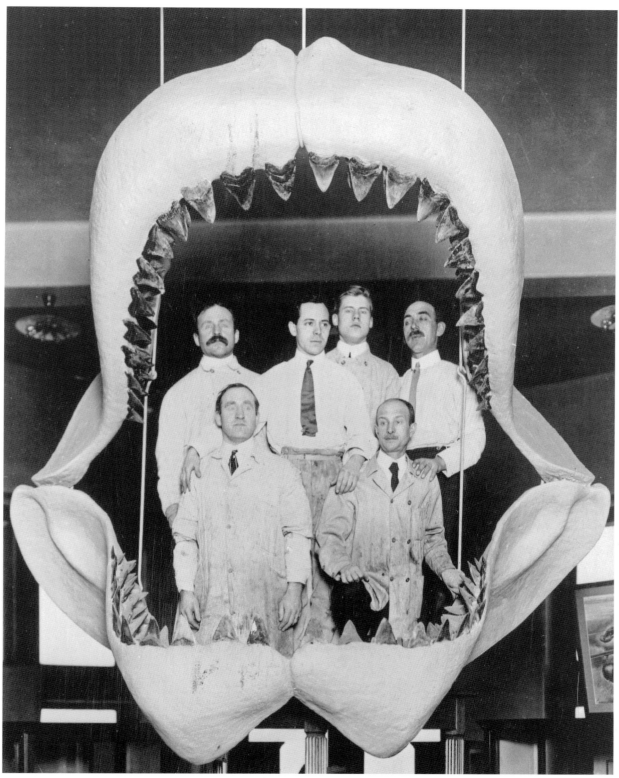

Now replaced by a smaller, more accurate version, this gigantic replica of the jaws of megalodon astonished visitors to the American Museum of Natural History for years. *Photograph: American Museum of Natural History*

The extinct megalodon, as depicted by
Charles R. Knight, painter of prehistoric
creatures. *Courtesy of Rhoda Kalt*

label conjure up giant sharks over a hundred feet long. Most popular books discuss megalodon, and since it is almost impossible to prove it was *not* a hundred feet long, or (and this is even more sensational) *that it does not exist today*, this remains the *ne plus ultra* of shark fantasies: a hundred-foot version of the great white shark, with teeth as big as your hand, large enough to swallow an ox! In an article in the journal *Science*, Dr. John Randall, an ichthyologist with a special interest in sharks, said this about the megalodon jaws:

> *A reconstruction of the jaws of* Carcharodon megalodon *at the American Museum of Natural History has provided a concept of the enormous size of these extinct leviathans. This reconstruction, however, has been shown to be at least one-third too large, because all the teeth were regarded as nearly the same size as the large ones medially in the jaw.*

Now the great megalodon jaw has been deconstructed and replaced with a much smaller—but still enormously impressive—model. As John Maisey, Curator of Fossil Fishes at the museum wrote to me when I asked him what had become of the original jaw:

> *The original reconstruction was made of plaster, with an iron internal framework, but the iron had begun to corrode with age, fracturing the plaster and placing anyone walking below it at risk! It disintegrated as we were dismantling it, but I kept one of the larger pieces. For historical reasons, I carefully documented the position of each tooth in the original reconstruction, and the teeth are stored in our collection with this information. Our current jaw on display is fiberglass with real teeth (none of the original set of teeth were used). It is smaller than the original (a) because of more accurate scaling, and (b) because all the teeth are below the maximum known size (it was the largest we could get using all real teeth . . . larger teeth would not have allowed us a complete series).*

Similar gaps exist in our knowledge of other species. We can only guess about the function of the whip-like tail of the thresher, or the pattern of spots, stripes, and ridges that decorate the whale shark. There is, of course, no such thing as "the shark," any more than there is one bird that fulfills all avian criteria. Just as all birds have feathers and lay eggs, so do all sharks have multiple gill slits, cartilaginous skeletons, and denticular skin. But there are as many differences between a mako

and a nurse shark as there are between an eagle and a duck. Legends do not usually differentiate on specific grounds, so unless I want to make a point about a particular species, I will continue to refer to "the shark."

In a 1968 paper entitled "Serpents, Sea Creatures, and Giant Sharks," Harvard student James F. Clark contended that a "giant shark of the magnitude of *C. megalodon* presently inhabits the deep sea. This beast, ranging between 60 and 120 feet, is intimately related to the living *C. carcharias*, if indeed it is not simply a gigantic representative of that species." It is not the intention of this discussion to dissect a misguided undergraduate paper, but Clark's essay came to the attention of Peter Matthiessen, who referred to it in *Blue Meridian: The Search for the Great White Shark*, his popular (and otherwise excellent) 1971 book about Peter Gimbel's search for the great white shark. Matthiessen acknowledges Clark's contribution and thanks him for "permission to paraphrase his arguments in support of the hypothesis that the white shark's giant relative *Carcharias* [sic] *megalodon* still exists." Because Matthiessen's book predates Perry Gilbert's 1973 revelation that the 36.5-foot "Port Fairy" white shark in the British Museum was a typographical error (the specimen was actually no longer than 16.5 feet), Matthiessen can be forgiven for assuming that the maximum known length of the white shark is 36.5 feet. But when he follows Clark in his arguments that "it seems much more correct to recognize but a single species of Carcharodon on the basis of tooth morphology," he makes a significant error. The teeth of the two species are different enough to classify them as distinct, so distinct that some paleontologists suggest that they do not even share the same ancestor.

Several scientists have also postulated the existence of giant man-eaters. One was the late Gilbert Whitley, an Australian ichthyologist whose 1940 publication *The Fishes of Australia, Part II: The Sharks*, contains this statement:

Large flat triangular teeth with serrated edges have long been known to geologists from the various divisions of the Tertiary formation throughout the world. They are the remnants of sharks which must have attained enormous dimensions, and which were evidently similar in general form to "The Great White Shark" (Carcharodon carcharias) *of present times. This recent species attains a length of forty feet, at which size it has teeth about three inches in length; since the fossil teeth are sometimes six inches long, it has been assumed that the extinct species reached a length of eighty feet. Fresh-looking teeth measuring 4 by 3 ½ inches have been dredged from the sea-floor, which indicates that if*

to be accidental aggregations of minerals that just happened to assume familiar shapes.) Stensen has been called the father of modern geology and paleontology, and as an ordained Catholic priest and later as a bishop, he was among the first to make science acceptable to the Church.

The only evidence we have for the existence of megalodon is its fossilized teeth. Because the teeth are replaced many times over, these cartilaginous fishes may have thousands of teeth during their lifetime. These fall out or are otherwise displaced, which makes for a whole lot of fossil shark teeth on the ocean floor. Normally, the presence of fossil teeth leads only to paleontological discussions of the previous owners, but in the case of giant sharks, which may be the perfect monsters, people are not so willing to give up on their existence. Throughout the popular literature (as opposed to the scientific), there are repeated references to giant sharks, but very few popular writers want to come right out and say that these monsters are extinct.

J. L. B. Smith, the man who identified the coelacanth in 1938 (and therefore had a vested interest in the discovery of sensational new fishes), has written, "Teeth 5 ins. long have been dredged from the depths, indicating sharks of 100 ft. with jaws at least 6 ft. across. These monsters may still live in deep water but it is better to believe them extinct. Such a shark could swallow an ox whole." In *Blue Meridian*, we read:

> *The many sightings of enormous white sharks have led a few ichthyologists to wonder if* C. megalodon *might still exist. It has even been argued that fossil teeth of small* C. megalodon *are so similar to those of living* C. carcharias *that the two may represent a single species. . . . The oceans are still supporting whales, which have a higher metabolic rate than sharks, and possibly* C. megalodon, *like the sperm whale, feeds in the ocean depths on squid, which have been found in the stomach of the white. A giant shark would not need to surface as whales must do, nor scavenge on the continental shelf, where the smaller whites are mostly seen.*

In fact, the teeth of the two *Carcharodon* species are quite different The teeth of the white shark are white, since they are composed of dentine and enamel, while the teeth of megalodon are always fossilized and range in color from beige to black. Megalodon teeth are made of stone. In addition, the teeth of the giant megalodon have a "chevron" above the root, which is lacking in the teeth of the living white shark, and much smaller serrations. Only the discovery of a fresh, white megalodon tooth would confirm the creature's current existence.

The Art of the Shark

I am prepared to argue that the most influential American novel (subsequently made into an even more influential movie) was *Jaws*. Peter Benchley's 1974 blockbuster affected a great many people's attitude toward swimming, to the extent that nearly four decades after publication, there are still people who are terrified to swim in the ocean. Contributing in no small way to this enduring terror was the paperback cover (and subsequent movie poster) of a giant shark, armed with glistening steak-knife teeth, rising hungrily beneath a tiny, oblivious swimmer. It might therefore be argued that Roger Kastel's painting is the most influential painting in American history. It is one of the centerpieces of the exhibit being brought to the Museum of Art | Fort Lauderdale, entitled The Shark in Art.

In early 2010, when I was asked to curate and design a show on sharks in art for the Museum of Art | Fort Lauderdale, I thought that it probably couldn't be much of a show because there were only three shark painters that immediately came to mind: Winslow Homer, John Singleton Copley, and me. Once I got into it, however, I realized that there were a lot more people who painted sharks, perhaps not exclusively, but occasionally and well. Stanley Meltzoff (1917–2006) was a well-known American illustrator, born and raised in New York and trained at the Pratt Institute, who painted covers and interior spreads for *Life*, *National Geographic*, *Saturday Evening Post*, *The Atlantic*, and many other magazines. He did sixty-five covers for *Scientific American*. When color photography supplanted his kind of realistic re-creations, he switched gears and began painting saltwater game fish in their undersea environments. He was the first to do so, attracting first the attention of *Sports Illustrated* and later virtually all outdoor media. He painted all the major big-game fishes, eschew-

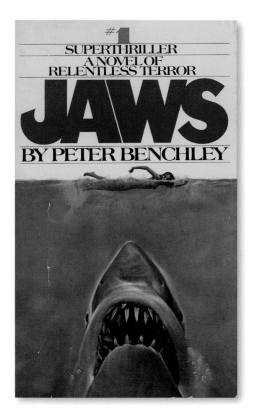

Roger Kastel's painting for the paperback of *Jaws* is probably the most famous (and fearsome) image of a shark ever painted.

ing freshwater species as being easier to see and thus less interesting to paint. An accomplished scuba-diver, Meltzoff spent a lot of time below the surface, watching his subjects and absorbing the flickering quality of underwater light. His art ran in virtually every major outdoor publication, including *Field and Stream*, *Gray's Sporting Journal*, *Outdoor Life*, *Sporting Classics*, *Sports Afield*, *Wildlife Art*, and

others. Among the dramatic paintings of tuna, marlins, and swordfish were sharks, which he painted in a fluid, painterly fashion, showing not only their grace and power, but their way of life underwater.

Because Meltzoff painted other marine life, he cannot really be called a shark painter, but rather a painter who sometimes did sharks. The same can be said for me, although there was a period when I painted only sharks. Indeed there is nobody who can be classified exclusively as a "shark painter," but there are many artists who have created paintings in which sharks were featured. For example, think of Copley's *Watson and the Shark,* where a host of boatmen try to save fourteen-year-old Brook Watson, who was attacked by a large shark while swimming naked in Havana harbor in 1749. In a discussion of the subject matter of the painting—which appeared as the cover illustration of the *Journal of the American Medical Association* in 1989—Dr. M. Therese Southgate wrote that

> *. . . the critics of 1778 found several errors of logic in it, namely that the shark does not look like a shark and its tail is not lashing the water, that the figure of the boy is too large, that the men are not rowing correctly if they are trying to reach the boy, that their fingers are not in a proper position for grasping the boy, and that the wind that blows the harpooner's hair should also affect the sails of the ships in the harbor.*

Copley had never visited Havana, and it is likely that he had never seen a shark, much less a shark attack. It is probable that he gleaned details of Havana harbor from prints and book illustrations; he includes the real landmark of Morro Castle in the right background of the painting. The reason the shark "does not look like a shark" is because Copley probably worked from a dried museum specimen, or maybe even old engravings. The only visible parts of the shark are the head and the upper lobe of the tail fin, and he gets them both wrong. Sharks do not have forward-facing eyes, nor do most species have cat-like vertical pupils. There is no shark with "lips," so we must assume that Copley saw a shark jaw somewhere and tried to incorporate it into his painting. He put it outside the shark's mouth, however, instead of inside, where it belongs.

The painting was exhibited at the Royal Academy in 1778. Copley produced a second, full-size replica for himself, which is in the Museum of Fine Arts, Boston, and a third smaller version, with a more upright composition, which is in the Detroit Institute of Arts. The original is in the National Gallery of Art, Washington, D.C.

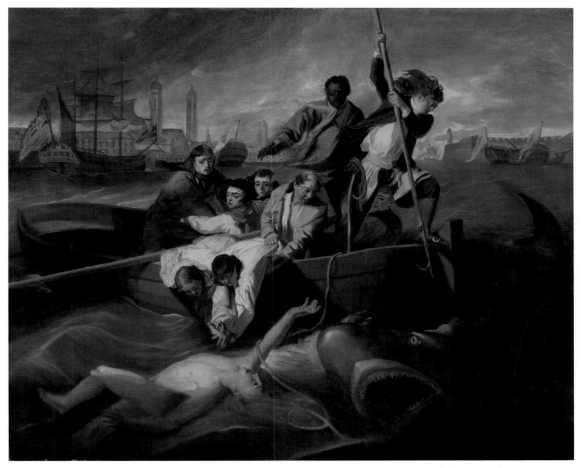

In 1778, John Singleton Copley painted *Watson and the Shark*, illustrating the moment before Brook Watson lost his leg to a ravenous shark. Watson went on to become the (one-legged) Lord Mayor of London.
Courtesy of the Metropolitan Museum of Art

In almost all pictorial representations of sharks before photographs, the shark is depicted as a menace to swimmers or sailors. The other celebrated appearance of the shark in art is, of course, Winslow Homer's *The Gulf Stream*, where a sailor gazes listlessly over the stern of his dismasted sloop, as several sharks circle hungrily, waiting for whatever happens next in this permanently arrested drama. There is a waterspout visible on the horizon, and also a full-rigged ship. Does the hurricane come and dump the hapless sailor into the sea, or is it the very hurricane that wrecked his boat in the first place? There seems to be plenty of blood in the water, suggesting that the sharks have already eaten the other crew members and are awaiting their next meal. Neither Copley's nor Homer's painting glorified the shark, but rather they embellished its already nefarious character.

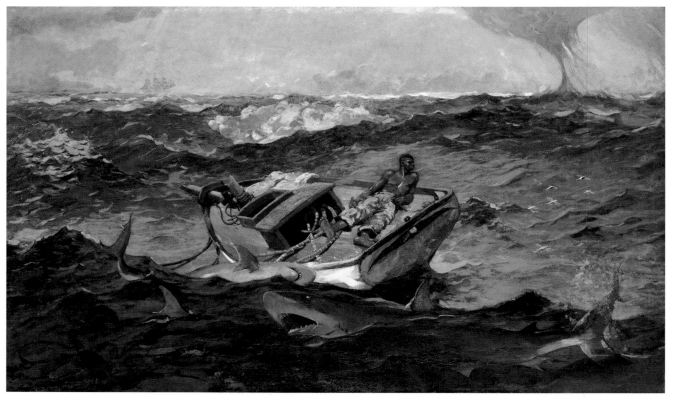

Nobody knows how this story plays out. Is the man rescued by the ship in the distance, or will the hurricane heading toward him compound his difficulties? *Courtesy of the Metropolitan Museum of Art*

Winslow Homer (1836–1910) was an American landscape painter and print-maker, best known for his marine subjects. He is considered one of the foremost painters in nineteenth-century America and a preeminent figure in American art. *The Gulf Stream* was derived from studies made during Homer's two winter trips to the Bahamas in 1884–85 and 1898–99. He painted at least two preliminary watercolor studies for his masterpiece; one in the collection of the Art Institute of Chicago shows a man on a wrecked boat with a shark in the foreground; in the Brooklyn Museum study, the man is gone and only the sharks can be seen. According to Homer biographer Alfred Ten Eyck Gardner, *The Gulf Stream* is "Homer's greatest picture . . . one of the greatest pictures ever painted in America."

The Gulf Stream was first put on exhibit in 1900 at the Pennsylvania Academy of the Fine Arts in Philadelphia. Homer later "improved" the painting. Early photographs reveal changes to the sea and to the back of the ship, which make the composition more dramatic and vivid. The painting was shown at the Carnegie Institute in Pittsburgh in 1900–1901, and then at M. Knoedler and Co. in New

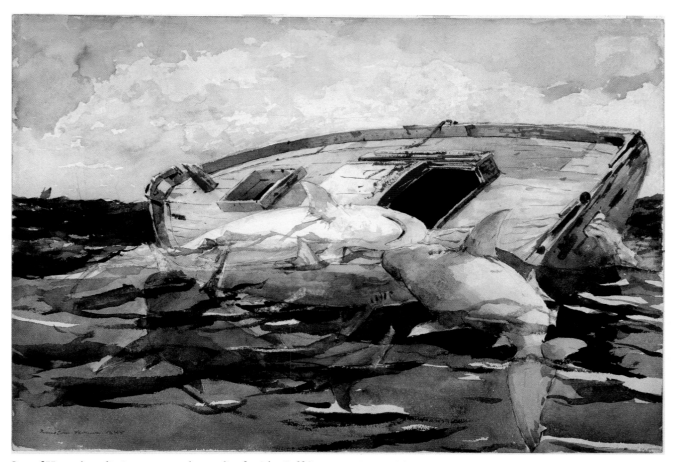

One of Homer's preliminary watercolor studies for *The Gulf Stream* *Collection of the Brooklyn Museum*

York, where the artist asked for the unheard-of price of $4,000. There were problems selling the work either because of its high price or its unpleasant subject matter. When the picture was first exhibited in 1900, so many people found the subject so depressing that Homer wrote a letter to his gallery, in which he explained, probably facetiously: "You can tell these ladies that the unfortunate negro, who is now so dazed & parboiled, will be rescued & returned to his friends and home, & ever after live happily."

Before he painted *The Gulf Stream* in 1899, we can assume that Homer actually saw at least one shark; in his watercolor *Shark Fishing*, we see almost the same creature as can be seen in the early studies and in the foreground of *The Gulf Stream*, but it is sometimes reversed, its head pointing in the opposite direction. In all versions, we can only guess as to the species of the sharks, although in the Caribbean, only the bull shark gets that large. The shark being caught in *Shark Fishing* is helpless—perhaps

dead; they wouldn't have wanted to bring a live one into that little boat—while the sharks in *The Gulf Stream* (there are three visible) are anything but. In *Shark Fishing*, Homer twists the captured shark and gives it a dead eye, showing man's conquest of nature, but the foreground shark in the final oil painting of *The Gulf Stream* rolls a malevolent eye at the sailor, emphasizing the poor man's precarious situation. Here nature, in the form of ravenous sharks, clearly dominates man.

Sculpture is another important category of art, and it soon became obvious to me that the streamlined, powerful, and graceful sharks were perfect subjects for three-dimensional representations. Victor Douieb creates polished bronzes; Stuart Peterman sculpts sharks in stainless steel; Kitty Wales hangs life-sized metal sharks in trees; Gary Staab makes lifelike replications of long-extinct species; Ptolemy Elrington assembles road-found hubcaps into startling, shiny creations; and the Korean sculptor Ji Yong Ho uses rubber tires as a sculpture medium. American sculptor Johnston Foster captures the vitality of sharks in his exuberant pieces assembled from found materials, including street pylons. The French sculptors Claude and François-Xavier Lalanne (a married couple known as "Les Lalanne") have created a body of work that includes animal-shaped furniture, including a life-sized leather rhinoceros that can be disassembled into a sofa and chairs; a safe in the form of a full-sized gorilla; a sardine-can bed (complete with stuffed fabric sardines to lie on); and a very large shark that floats serenely in its own pond.

Shark Photography

Some of the most celebrated photographers in the world spent a lot of time underwater, aiming their cameras at marine life, with sharks sometimes as their primary focus. Although the cover illustration for the paperback version of *Jaws*, drawn by Roger Kastel, is probably the most familiar shark image in the world, the photograph of the gaping jaws of a great white, originally taken by Rodney Fox in South Australia, runs it a very close second. (Rodney's shot has been replicated hundreds of times by other photographers in other places, but because Rodney was probably the most celebrated shark-attack victim [and more important, *survivor*] his photographs have acquired a cachet lacking in most others.) The fraternity of famous shark photographers includes Jerry Greenberg, Rodney Fox, Ron and Valerie Taylor, David Doubilet, Al Giddings, Douglas Seifert, and Chris Fallows. There are of course, many more excellent shark photographers, but in the interests of brevity and consolidation (not to mention personal preference), I had to make a choice.

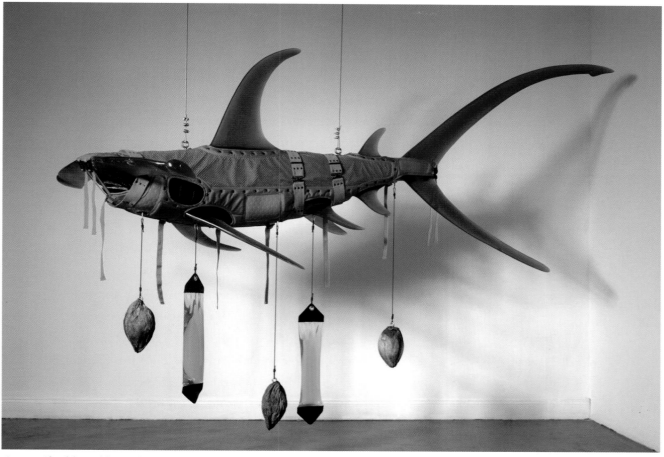

Orange Shark by **Ashley Bickerton** *Courtesy of Lehmann Maupin Gallery*

Whereas the early shark-painters had to rely on dead specimens (or their imaginations) for reference material, photographers are now able to deal with their subjects on an "up close and personal" basis. The pioneers of this undertaking were Hans Hass and Jacques Cousteau, who dived with primitive cameras (and often experimental underwater breathing equipment) in order to put themselves face to face with their quarry.

Hans Hass, born in Vienna, Austria, in 1919, is a diving pioneer, best known for his documentaries about sharks and his commitment to the protection of the environment. In 1940, Hass completed his first underwater film called *Pirsch unter Wasser* ("Stalking under Water"). He moved to Berlin in 1941, where he founded the tax-privileged society *Expedition für biologische Meereskunde* (Expedition for Biological Oceanography). Hass completed the filming of his second underwater movie, *Menschen unter Haien* ("Men among Sharks") in 1942, after several months

in the Aegean and the Sea of Crete. He was then conscripted into Nazi Germany's armed forces (the *Wehrmacht*), where he was assigned to the so-called Fighters of the Sea battalion, whose mission was to explore enemy port facilities, eliminate enemy vessels, and destroy bridges and floodgates in inland waters. The origin, equipment, and training of this unit are poorly documented because the records were almost completely destroyed, and the living veterans (including Hass) are still bound by their oath of secrecy. Hass produced more than seventy television films and twenty-five books that included his photographs, the most noteworthy of which were *Men and Sharks* (1949*)*, *Diving to Adventure* (1951), *We Come from the Sea* (1957), *Challenging the Deep* (1972), and *The Shark: Legend of a Killer* (1977).

Hans Hass, born in 1919, one of the pioneers of shark diving and shark photography.

It was Jacques-Yves Cousteau (1910–1997) who popularized recreational diving and underwater photography as no person before him. In 1943, with Émile Gagnan, a French engineer, he invented the Aqua-Lung, which made scuba diving possible for the masses. He also pioneered underwater cinematography and won an Academy Award for *World Without Sun* in 1964. With support from the National Geographic Society, he published many articles in the magazine, and wrote several enormously popular books such as *The Silent World* and *The Living Sea*. Published in February 1953, *The Silent World* included many first-time underwater photographs, identified on the cover of the paperback as "16 in full color, through the courtesy of the National Geographic Society." "By the end of the year," wrote Brad Matsen, in his 2009 biography of Cousteau, "the book had sold 486,000 copies and was being translated into French and twenty other languages." The first half of this underwater adventure story is an account of the invention of the Aqua-Lung by Cousteau and Émile Gagnan, but then we get into clearing mines, wreck diving, and encounters with sharks. A six-page sequence of black-and-white photographs is captioned thus:

1. Dumas swims toward the shark and the pilot fish.
2. Dumas gets behind the shark and touches the caudal fin.

3. The beast turns, but not towards Dumas. He comes at me.

4. The shark is ten feet away; pilot fish lose stations.

5. I keep my finger on the camera button.

6. The shark is two feet away. Then I bang his nose with the camera.

The shark in the photographs is *Carcharhinus longimanus*, the oceanic whitetip.

Filmed from the re-fitted American minesweeper *Calypso*, Cousteau's enormously popular television series, *The Undersea World of Jacques Cousteau*, first appeared on the small screen in 1967. Covering subjects that ranged from sharks and whales to underwater archaeology and Atlantis, it was based on a three-year, round-the-world cruise that Cousteau *et fils* took aboard *Calypso*, filming as they went. In the 1970 book *The Shark: Splendid Savage of the Sea*, Jacques and Philippe Cousteau introduced the heretofore unsuspecting public to these savage denizens of the deep. From the flyleaf:

What did the Cousteau team learn about the life of the shark? How does it feel to confront a shark with only a camera as protection? Is there any defense against an attack by a shark? Why are mammals superior to sharks? Why does a shark die if it is taken from the sea, if only for a moment?

They didn't answer any of these silly questions, but they did get some spectacular photographs (for 1970) of divers swimming with sharks, divers leaving the cages, sharks feeding, and various species of sharks swimming around. Perhaps to add entertainment to the narrative, the Cousteaus played favorites: They loved the blue shark, which they called "the most beautiful shark of all," but despised the oceanic whitetip, which they referred to as "the *longimanus*, the lord of the long hands":

While the brute strength of other sharks is tempered by their beauty and the elegance of their form and movement, this species is absolutely hideous. His yellow-brown color is not uniform, but streaked with irregular markings resembling a bad job of military camouflage. . . . He swims in a jerky, irregular manner, swinging his shortened, broad snout from side to side. His tiny eyes are hard and cruel-looking. . . . They will attack in spite of all the means of defense we employ and will not get discouraged as would many other species of shark. They are ugly but also quite powerful.

In fact, "the longimanus" is not really a bad-looking shark, dun-colored with broad, rounded fins tipped with white. It is a heavy-bodied, deepwater species, rarely seen anywhere close to shore, but it has been implicated in mass "attacks" on those survivors of shipwrecks who were dumped into the sea without the protection of life-rafts. With blue sharks, oceanic whitetips were the dominant species seen feeding on the whale carcass filmed by the *Blue Water, White Death* film team off Durban in 1969. In that event, Valerie Taylor didn't find these sharks attractive either, and in *Blue Meridian*, she is quoted as saying, "Several long, beautiful blue sharks glided between the heavier, uglier white-tips."

Jerry Greenberg, born in Chicago in 1927, is a Miami-based underwater photographer who specialized in

Jacques-Yves Cousteau, inventor of the Aqua-Lung, diver, explorer, and filmmaker, who opened the undersea world to millions.

sharks. In his 1971 *Manfish with a Camera*, he discussed his 1951 introduction to underwater photography: "After publication of Jacques-Yves Cousteau's bestselling *The Silent World*, magazine editors became aware of an untapped source of exciting adventure stories." In 1969 he published a little book called *Fish Men Fear . . . Shark!* and became famous for his shark photographs at a time when few people were willing to face sharks underwater. He wrote, "The idea of doing a general shark piece for *National Geographic* appealed to me. I did some artwork outlining my plans and sent them up to editor Bill Garrett. He liked the idea and after several stops and starts, I was in the shark business." One aspect of his new "business" required him to enter the water with University of Miami scientist Don Nelson as a silky shark (*Carcharhinus falciformis*) approached their boat:

Don was armed with a 12-gauge shotgun bang-stick and I had my camera ready. While I was still dangling on the surface, the silky nosed right up to me. After a

frantic splash caused it to bolt momentarily, it spun around and got so close to Don that he had to push it away with his hands. Not wishing to become a man-fish-burger, I yelled "Kill it!" The silky came around a third time. Don jammed the bang-stick into its head and the shell went off. The shark bolted off trailing blood and entrails from the wound as it spiralled uncontrollably. The episode taught me the secret of successful shark photography: a good set of nerves, a steady shutter finger, and a reliable man at your back, armed with a bang-stick.

With his wife Idaz, Greenberg founded Seahawk Press, and published several other booklets, including *The Living Reef* (1979), *Fishes Beneath Tropic Seas* (1979), and *Sharks and Other Dangerous Sea Creatures* (1980). He took many of the photographs that were used in the February 1968 *National Geographic* cover story, "Sharks: Wolves of the Sea," including the cover shot of an oceanic whitetip, and the picture of Don Nelson being attacked by the silky shark. (The *Geographic* caption reads, "Photographer Greenberg, swimming with Nelson off Florida, snapped this remarkable picture even as he himself desperately maneuvered to avoid attack.")

In the original *Jaws* movie, made in 1975, Chief Brody (Roy Scheider) is seen leafing through a book about sharks while his son plays around in a little sailboat tied up to the dock. The "book" isn't exactly a book, but rather a dummy volume assembled by the props department with bloody images of sharks and shark-attack victims inserted to make the point. The picture that causes him to panic and yell at his son is a painting of a shark smashing a boat that artist Paul Calle did for the 1968 *Geographic* article.

Many of the images that Brody looks at were from that *Geographic* article, and many of the photographs were Jerry Greenberg's. Universal Studios had asked him for permission to use his photographs, and at first he agreed, but when he balked at continuous use in all further formats of the film, they told his agent that they would simply remove the images from the film. In later DVDs of *Jaws*, the scenes with all the faked books and photos have been removed.

One of Jerry Greenberg's first publications, featuring his incredible shark photographs.
Seahawk Press

This painting, by Paul Calle, was one of the images in the "book" that Chief Brody looks at before he hollers at his kids to "get out of the boat!" *Courtesy of Paul Calle Estate*

One of the books clearly visible on Chief Brody's desk is *Sharks & Rays of Hawaii*, by Spencer Tinker and Charles DeLuca of the Waikiki Aquarium. Published a year before the movie was made, it opens with just about every shark cliché imaginable—and then some:

> *Of all the fishes in the sea, the sharks and rays hold a very special place in the attention of man because of the fear and horror which they engender. Their attacks upon swimmers and others together with their savage teeth and fearsome appearance make them the most feared of all aquatic animals. The great white shark, in fact, is considered the most ferocious of all animals. In addition to their man-eating tendencies, sharks are of interest to us because of their evolutionary background, their unusual structure and size, their habits*

and mode of life, their economic value, and because of the many stories associated with them.

Even if Peter Benchley didn't read this book, he managed to incorporate many of its wild and irrational exaggerations into *Jaws*. "Fear and horror"? Check. "Attacks upon swimmers"? Check. "Savage teeth and fearsome appearance"? Check. "Most ferocious of all animals"? Check. "Man-eating tendencies"? Double check.

In *Cousteau's Great White Shark* the "Cousteau" is Jacques' son, Jean-Michel, and the book was written with long-time Cousteau collaborator Mose Richards. In their pursuit of their eponymous subject matter, the Cousteau team first traveled to the Farallones, off San Francisco, but although they dumped vast quantities of blood and fish guts into the water, they failed to raise a single shark, so, like Peter Gimbel twenty years earlier, they headed for South Australia, where they knew the white sharks would be. And also where Rodney Fox and Ron and Valerie Taylor would be, to guide them through the process. They dived with the whites and photographed them from traditional cages, and also from clear plastic cylinders that were supposed to fool the sharks into thinking the divers were unprotected. They also built a life-sized mechanical shark so they could "see what would happen if a real great white were confronted with an artificial great white shark." When the real sharks ignored the artificial one, the experimenters pumped blood into the water, inducing the real sharks to "attack." They tore the fake shark to shreds, but the team was unable to figure out why:

> *Did Peaches [the name they gave to one of the sharks] think she was attacking a real white shark or did the blood overcome any inhibitions she might have had—either out of fear or a revulsion against attacking her own species? Did the interval between attacks, approximately five minutes, imply confusion or perhaps the attraction-repulsion conflict that many animals experience when approaching others of the same species? Did the fact that the ten-foot model was smaller suggest that Peaches—fifteen feet long—was behaving in a dominant role?*

They can't answer their own questions, and "inhibitions" is a curious word in a discussion of great white sharks, but they have produced another coffee-table book of spectacular photographs of what they admiringly call "easily the most feared of all sharks." In 1985, David Doubilet and I went to South Australia under the

auspices of *National Geographic* to write and photograph the story of fishing, that state's predominant industry. The story, which ran in the March 1987 issue, was called "Australia's Southern Seas" and covered prawn fishing, abalone diving, lobster trapping (called "crayfishing" in Australia), tuna fishing, and observing a denizen of the ocean for which, for obvious reasons, nobody was fishing. The great white shark had by this time become South Australia's most famous fish, its star marine attraction. Shark-attack victim Rodney Fox, who had been bitten so badly in 1963 that it took 462 stiches to sew him back together, had started a cage-diving enterprise, and David and I (along with Genie Clark) were going to submerge ourselves in what we hoped were sturdy enough cages to swim (or rather just stand there, breathing heavily), with great white sharks. We were among Rodney's first customers (the *Geographic* was paying the bills), so the article, while it was graced with sensational photographs of prawns, lobsters, and abalone, also included some of the first close-ups of the creature the Aussies call "white pointer"—and sometimes "white death."

By that time, David had established himself as the world's premier underwater photographer, with more than twenty *National Geographic* covers to his credit. Doubilet has photographed in the depths of such places as the southwest Pacific, New Zealand, Canada, Japan, Tasmania, the northwest Atlantic, and Scotland, where he searched underwater for the Loch Ness Monster. He has photographed stingrays, sponges, and shipwrecks in the South Pacific, the Atlantic, and at Pearl Harbor. In 1973, he photographed the "sleeping sharks" of Isla Mujeres for the article by Genie Clark. When I interviewed him in 1974 for my *Book of Sharks*, he said that sharks "are the mythical beasts of our age, like the unicorn in the Middle Ages. They seem to be a perfect combination of animal and machine . . . they're so beautifully built, they look like they're flying. Like a jet plane with eyes." After our initial dives at Dangerous Reef in '85, David has been back to South Australia several times, but as South Africa has now become the epicenter of white shark studies, he went there too.

In April 2000, Doubilet collaborated with Peter Benchley on the cover story for *National Geographic*, "Inside the Great White," which led off with one of the most sensational photos ever taken of this already terrifying creature. In the article, Benchley tried to demystify *C. carcharias*: "Back then [when he wrote *Jaws*], we thought that once a great white scented blood, it launched a feeding frenzy that inevitably led to death. Now we know that nearly three-quarters of all bite victims survive, perhaps because the shark recognizes that it has made a mistake and doesn't return for a second bite." But because Rodney Fox joined them in Gansbaai,

Benchley has to tell Rodney's story all over again, and while Rodney survived the 1963 attack, it was not because the shark thought it had made a mistake: It was because a thoracic surgeon just happened to be at the Royal Adelaide Hospital when they brought in Rodney's mangled body. As Benchley also wrote, "The sharks of False Bay were engaging in behavior that, till now, we had all believed was the stuff of extreme rarity, if not outright legend"—they were going airborne. And Chris Fallows was there.

As he tells us in the introduction to his book, *Great White*, Fallows saw his first great white shark on February 4, 1993, as he watched net fishermen pull a six-footer onto the beach at Muizenberg, Cape Town. He helped return it to the water, and noticed "this awesome creature with her bristling array of sensory organs that made her a fully fledged hunting machine. Like a fighter plane she also has a perfectly streamlined body and a pattern on her flanks that gave her a personal identity." Photographers appear to be entranced by the similarity of sharks to fighter planes [see Doubilet's remarks above], especially when it comes to *Carcharodon carcharias*.

These underwater predacious machines so fascinated Fallows that he volunteered to assist Theo and Craig Ferreira in their newly formed White Shark Research Institute (WSRI) studying the sharks at Gansbaai and Dyer Island, where the seals were.* They began a cage-diving operation, and during positioning cruises around False Bay's Seal

David Doubilet's cover shot for the April 2000 *National Geographic,* **guaranteed to sell out the issue on newsstands.** *Courtesy of National Geographic*

* In South Australia, the white sharks prey upon Australian sea lions *(Neophoca cineria),* but Dyer Island is the home of an enormous breeding colony of *Arctocephalus pusillus,* the Cape fur seal, which explains the gratuitous presence of white sharks. In a 2000 article about diving with the white sharks of Seal Island, Peter Benchley observed that "some 84,000 fur seals make their home here, and they covered every inch of the barren rock, barking, lounging, squabbling, and sliding clumsily into the water, where they metamorphosed into creatures of sleek and sinuous beauty." The Cape fur seal is found along the western and southern coasts of southern Africa. The population is estimated at 1.5 to 2 million, about two-thirds of which is found in Namibia.

Island, they noticed "with alarming regularity" what Fallows described as "large splashes, and even . . . the odd glimpse of sharks flying out of the water." It was 1997, and from that year onward, the photography of sharks (not to mention their behavior) was about to take a great leap forward. The sharks were coming up beneath the seals and bursting from the water with a seal in their jaws, often becoming completely airborne. In 1999,

Doug Seifert has dived the Seven Seas (and more) in pursuit of his subject matter. This is a hammerhead. *Courtesy of Doug Seifert*

National Geographic sent Peter Benchley, David Doubilet, and even Rodney Fox to South Africa to film a special that would, inevitably, become known as "Air Jaws." As Fallows wrote, "And so it was that the 1999 *National Geographic* film shoot launched the sharks into a new era of public recognition. The flying white sharks that had gone unnoticed next to a city of three million were now on their way to becoming justifiably, world famous." And with his spectacular photographs of the spectacular behavior of the sharks, Chris Fallows was launched into the top rank of the world's elite shark photographers.

For the past twenty years, Douglas Seifert has worked professionally as a writer and award-winning photographer specializing in the marine environment and its inhabitants. Formerly senior contributing editor of *DIVE* magazine in the United Kingdom, he has written and published more than eighty articles over the past fifteen years. Doug Seifert's photographic imagery has appeared in the *New York Times*, *Australian Geographic*, *Reader's Digest*, *Esquire*, *Outside*, *BBC Wildlife*, *National Wildlife*, *Skin Diver*, *Sport Diver*, *Mondo Marino*, *Plongeurs International*, *Mundo Submerso*, and numerous books, magazines, and newspapers around the world. His images of a family of sperm whales in the Azores were awarded a bronze medal by the United Nations Environmental Program in 2000; he was grand prize winner of the 2000 Papua New Guinea Underwater Photographic Competition. His work has been awarded many times by the prestigious British Wildlife Photographer of

the Year Competition. For the Summer 2003 "Shark" issue of *DIVE* magazine, Seifert photographed spawning whale sharks ("the first photographer to record this remarkable event"), reef sharks, bull sharks, white sharks, and hammerheads. He accompanied Ron and Valerie Taylor to the Caribbean where they were going to test a stainless steel chain-mail diving suit to ascertain if it could protect divers from shark bites. He wrote:

> So there I was. My two partners were waiting for me to do what I thought I wanted to do, and now I had to do it. . . . I turned back to an oncoming Caribbean reef shark, lifted my right forearm high and raked the tuna fillet across the rough surface of the stainless steel mesh. Particles of blood and viscera floated upward carried by the current, under the nose of the approaching shark. The shark closed in upon the origin of the scent, rolled its eye slightly as its protective nictitating membrane closed to cover the eye, opened its mouth and continued further to engulf my arm. I braced myself for pain as the shark's lower jaw struck the underside of my forearm and the upper jaw distended, gaped wide, and closed on my upper arm. As the jaws closed, the pain I felt was . . .
>
> Nothing. Just a very light pressure, like the handshake of a small child. There was no pain because the teeth had not penetrated the mesh. The shark started shaking me like a terrier holding a rat, but I followed Ron and Valerie's advice and went limp.

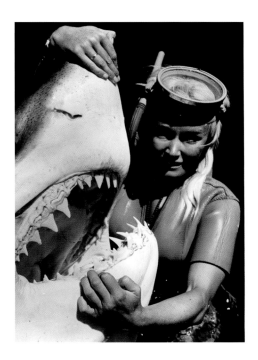

Valerie Taylor and friend *Photo by Ron Taylor*

If you had to follow the advice of anybody about what to do when a shark has engulfed your arm, it would be Ron and Valerie Taylor.

Long regarded as Australia's premier diving couple, Ron and Valerie are based in Sydney, but are likely to be found underwater almost anywhere. In 1969–70, they were part of the team that filmed the sharks for *Blue Water, White Death*, in and out of the cages in South Africa and

South Australia. In 1972, Ron and Valerie joined Italian filmmaker Bruno Vailati, who was making a documentary about *il grande squalo bianco*. During the filming, a thirteen-foot male shark got so tangled in the lines that it was unable to move, and hung, head down, about to drown if it could not be freed. It was decided to tow the shark into shallow water and release it there, even though the other crew members felt that the safest and easiest thing to do would be to let it hang until it died and then cut it loose. An excerpt from Valerie's journal for February 16, 1972:

> *All went well until we were in about six feet of water. Then the anchor caught. To my amazement, Ron jumped in, freed the anchor and swam to shore. . . . He then wrestled the shark into the shallows and started untangling the cable. He realized the Italians were only watching and shouted at them to film him. Bruno awoke as if from a trance and shouted also. Michel and Arlando ran for their movie cameras. My still camera was working overtime. Ron hung onto the shark's lunging tail until they were positioned, then took the last twist of the cable from around its tail. The great white was set free. It swam slowly in a circle before returning to Ron. He pushed it off, shouting, "Deep water, sharky, deep water." The dark grey shape swung around slowly and glided away.*

In pursuit of their subject matter, there is hardly an ice-free body of water into which Ron and Valerie haven't taken their cameras. They have worked in the tropical waters of the world, especially their own, where their published photographs have revealed the marine wildlife of the Great Barrier Reef and other unique Australian locations. Off Western Australia in April 1991 they joined Peter Benchley and filmmaker Stan Waterman, to make a film about the decline of white sharks there. In 1997 Ron and Valerie published *Blue Wilderness*, a spectacular collection of their photographs, which won the 1998 Gold Palm Award at the 25th World Festival of Underwater Photography in Antibes, France. They are also renowned underwater cinematographers, having directed, filmed, and produced numerous documentaries including the 1993 *Shadow Over the Reef*, an adventure of swimming with whale sharks at Ningaloo Reef, Western Australia. This film was instrumental in preventing the test-drilling for oil inside the Ningaloo Marine Park. In 1999, they released *Shadow of the Shark*, which reviewed their intimate relationship with sharks and their efforts to change public opinion of them as mindless predators. Still, says Valerie, the making of *Blue Water, White Death*, which took place some four decades ago, was the best thing they ever did:

We would dive from Durban to Mozambique, to the Comoros, from Madagascar to the St. Lazarus Bank to Sri Lanka, from Astove to Europa to a dozen named unknown reefs. We would finally take some superb footage of great whites of South Australia's Dangerous Reef. When this adventure finally ended, Blue Water, White Death *had established Ron and me among the best-known divers of the world, and would lead Steven Spielberg to use us for* Jaws . . . *The filming of* Blue Water, White Death *stands alone in the annals of diving history. Nothing I did before and nothing I have done since can compare. It was and still is the pinnacle of my life.*

Probably the best-known shark image in the world was painted by illustrator Roger Kastel: It is a gigantic, missile-nosed shark with a mouthful of steak-knife teeth rising ominously through the water beneath a unsuspecting swimmer. It first appeared on the cover of the paperback version of *Jaws*, but then around the world as the movie poster. When I talked to Kastel about this painting, he told me to look closely at the swimmer. She is nude, he said, which caused the book to be banned in Boston. This of course, increased the book's sale everywhere else, rocketing it to the top of the best-seller list.

The original illustration for the hardcover version of *Jaws* was considerably less threatening, with a blunt-nosed shark with insignificant teeth. If any danger could befall the swimmer in this version, it would probably come from the shark ramming her.

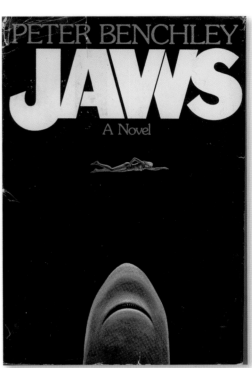

The not-so-menacing first edition of the hardcover novel. Later, the book jackets would be much toothier and much more frightening.

Other Sharks in Art

It is safe to say that it is the reputation of the shark that appeals to artists. Tiger sharks are known to be aggressive, but that is probably not why contemporary British artist Damien Hirst (b. 1965) chose to put one in a tank of formaldehyde and call it art. In October 2007, Hirst's conceptual tank piece, *The Physical Impossibility of Death in the Mind of Someone Living*—which features a thirteen-foot tiger shark floating in formaldehyde in a glass tank—went on view in the Lila

British artist Damien Hirst at the Oceanographic Museum of Monaco in front of _The Immortal,_ his great white shark in a tank of formaldehyde. _Courtesy of Valery Hache/Getty Images_

Acheson Wallace Wing for Modern and Contemporary Art at the Metropolitan Museum of Art in New York. The work was on a three-year loan from the Steven and Alexandra Cohen Collection, and as of 2010, has been returned to its owners.

The twenty-two-ton work was created in 1991 and was displayed as part of the collection of its previous owner, Charles Saatchi, in the 1997–2000 London/Berlin/New York exhibition Sensation: Young British Artists from the Saatchi Collection. Because the original shark was beginning to deteriorate, the artist has replaced it with a new one, using a modified process of preservation. The new version of the work was exhibited for the first time at the Kunsthaus Bregenz, Austria, in 2007. When the work came to New York, Philippe de Montebello, director of the Metropolitan Museum, said, "Damien Hirst's iconic shark will be an arresting sight in the Metropolitan's modern art galleries. . . . It should be especially revealing

and stimulating to confront this work in the context of the entire history of art, an opportunity only this institution can provide."

Hirst is known for the wide variety of materials he utilizes. His *Spot* paintings, whose titles are made up of references to pharmaceutical chemicals, are arrangements of colors on white ground, while his *Spin* paintings rely on centrifugal force to distribute paint over canvas. His medicine cabinet pieces are arrangements of drugs, medical supplies, and surgical tools; the tank pieces, which contain dead animals preserved in formaldehyde, are sculptures encouraging confrontation with the mortality of all living things. Hirst has pickled cows, sheep, zebras, and the like, but his real achievement was to break the power of London's traditional galleries. Initially sponsored by the dealer and collector Charles Saatchi, Hirst soon became an art entrepreneur in his own right. He still pickles animals in formaldehyde, but he also sells enlarged anatomical figures, butterfly-wing collages, and now, a life-size platinum skull encrusted with 8,601 fine diamonds, including one fifty-two-carat diamond that sits on its forehead. The sculpture, titled *For the Love of God*, will likely sell for as much as $100 million, making it the priciest contemporary artwork ever made.

In Cornucopia, a major exhibition held at the Oceanographic Museum of Monaco during the summer of 2010, Hirst added two more pickled sharks to his body of work: a hammerhead he called *Fear of Flying,* and a great white entitled *The Immortal.* Hirst then created another shark image. Making a cast of a tiger shark jaw in resin, he then painted (or had painted) the teeth in rainbow colors. The piece, in an editon of forty, is called *Dark Rainbow.* Perhaps intentionally (but perhaps not), the jaws are mounted upside down. (See catalog illustration.)

The Shark in Literature

The number of papers, books, notes, letters, and articles on sharks is almost incalculable. This is not surprising when one considers the fascination that these creatures have held since humans first became aware of them. We can assume that the earliest seafarers saw the sinuous shapes following them near the surface, and were quick to learn that these shapes could prove dangerous. The first reference to the shark is lost in antiquity; but there is an aboriginal drawing in Australia that shows a sharklike creature in the act of eating a man, probably made thirty thousand years ago. Pliny, Aristotle, and Herodotus wrote of sharks, and by the middle of the sixteenth century, the word "shark" had entered the English language. (Prior to

that, even in England, sharks were called *tiburón,* from the Spanish.) The *Oxford English Dictionary,* after declaring the word to be "of obscure origin," says that it seems to have been introduced by the sailors of Captain (later Sir John) Hawkins' expedition, who brought home a specimen that was exhibited in London in 1569. The source from which they obtained the word has not been ascertained.

By 1599, the word was used to signify "a dishonest person who preys on others," but it was soon applied to large, voracious marine fishes, its common usage today. The term also appears in mostly pejorative references to lawyers, and to those who would victimize others, such as loan sharks and pool sharks. Men who lured returning whalers into saloons to help them dispose of whatever money they had earned on the voyage were called "land sharks." In 1828, in the first American dictionary, Noah Webster told us that the word comes from the Latin *carcharias,* from the Greek *carcharios,* from *carcharos,* sharp, and the Cornish *skarkias.* Wherever the name came from, "the shark," with its dorsal fin slicing through the water and its multiple rows of teeth bared, is a common fixture in adventure fiction. But because there are some four-hundred-odd species, how do we know what sort of shark the writers are talking about?

The great white shark was originally known as *Canis carchariae,* which can be loosely translated as "dog shark," and throughout the early history of popular ichthyology, sharks of all kinds were known as dog-fishes or seadogs. (In *Vingt mille lieues sous les mers,* the original, Verne called this shark *grand Chien de mer,* which can be translated as "great dog of the sea," not much help in determining the species.) Concurrent with the problems of shark naming, there are even more complex problems affiliated with the question of how to define shark *literature.* When referring to a body of work about a particular subject, science calls this "the literature," as in "few mentions of a living megalodon can be found in the literature." The literature of sharks includes *Twenty Thousand Leagues Under the Sea,* and even such dopey novels as *Megalodon* or *Meg.* For the moment, we will eschew (a nice term when talking about sharks, isn't it?) the *scientific* literature, those works of ichthyology and related sciences that deal with the biology and natural history of sharks. Because of their ancient and enduring reputation for malevolence, sharks have been part of our literature—and therefore, part of our lives—for millennia.

From the time man first put to sea in a dugout, a canoe, a coracle, or a dhow, he was probably aware of the sharks around him, and recorded his opinions for posterity. Pliny the Elder, who lived from 23 to 79 AD, wrote of the dangers posed to sponge-divers in the Mediterranean in his *Historia Naturalis:*

Divers have fierce encounters with sharks, which make for their groin and all other pale parts of their body. The only safe course is to turn on the sharks and frighten them. For sharks fear man as much as men fear them, which means that in deep water they have an even chance. When the diver reaches the surface the situation is critical for him, because he loses the means of attack as he tries to get out of the water and he is completely dependant upon his shipmates. These pull on a rope tied to his shoulders. He keeps up the struggle and tugs on the rope with his left hand, as a danger signal, while his right hand holds the knife and is busy fighting.

THE JAVANESE AND THE SHARK.

A strange furry shark menaces a Javanese boatman. *Richard Ellis collection*

Poe probably introduced sharks to poor Arthur Pym's narrative as just another maritime hazard to be suffered. Nothing he wrote about the sharks bespeaks any familiarity with the behavior of real sharks, and it seems likely that he had read something about sharks and thought he could add to the perils of Pym by throwing in a couple of these fabled ocean-going monsters. But Poe was writing *fiction*, and can be excused digressions from fact. Besides, not very much was known about the behavior of sharks in 1838, so readers probably assumed that Poe's description was accurate. (When *Jaws* was published in 1974, people didn't know much about real sharks either, so an enormous number of people believed that everything in the novel was true—or at least *possible*.)

In 1852, Samuel Maunder released *The Treasury of Natural History*, in which he continued the tradition of describing the sharks in a sinister light, much like those before him.

> *They devour with indiscriminating voracity almost every animal substance, whether living or dead. They often follow vessels for the sake of picking up any offal that may be thrown overboard, and, in hot climates especially, man himself becomes a victim to their rapacity. No fish can swim with such velocity as the shark, nor is any so constantly engaged in that exercise; he outstrips the swiftest ships, and plays round them, without exhibiting a symptom of strong exertion or uneasy apprehension; and the depredations he commits on the other inhabitants of the deep are truly formidable.*

Sharks can be found in many nineteenth-century whaling journals, since they often appeared when the bloody whale carcasses were brought alongside the ships for flensing. In *Moby-Dick*, Melville said this of the sharks around the *Pequod*: "They viciously snapped, not only at each other's disembowelments, but like flexible bows, bent round, and bit their own; till those entrails seemed swallowed over and over by the same mouth, to be oppositely voided by the same wound . . . It was unsafe to meddle with the corpses and ghosts of these creatures. A sort of generic or Pantheistic vitality seemed to lurk in their very joints and bones after what might be called their individual vitality had departed."

A little literary detective work will enable us to identify the sharks in Jules Verne's 1870 *Twenty Thousand Leagues Under the Sea*. When Captain Nemo takes his prisoners for a stroll along the bottom of the ocean, he exposes them to all sorts of dangers, not the least of which are the sharks. When Aronnax, Conseil, Ned

Land, and Captain Nemo encounter their first sharks while returning from this underwater walk, they are made aware of these "huge shapes leaving streams of phosphorescense behind them." Aronnax, a "Professor of the Paris Museum" and an authority on marine life, then describes the climax of the expedition:

> *The blood froze in my veins. I saw we were being threatened by two formidable dogfish, those terrible sharks with enormous tails and dull glassy eyes, who secrete a phosphorescent substance through holes around their snouts. They are like monstrous fireflies who can crush an entire man in their jaws of iron! I don't know if Conseil was busy classifying them, but as for me, I was observing their silver bellies and huge mouths bristling with teeth from a not altogether scientific point of view—rather as a prospective victim than as a naturalist.*

The sharks pass harmlessly overhead ("very fortunately these voracious animals have bad eyesight"), and the hunters return to the *Nautilus* safe and sound. The "dogfish," however, previously described as "monstrous fireflies," put in another appearance in the South Atlantic, and from the references provided by Professor Aronnax, we are able to take an educated guess at the species:

> *We also saw some large dogfish, a voracious species of fish if ever there was one. Even though fishermen's stories are not to be believed, it is said that in one of these fish was found a buffalo head and an entire calf, in another, two tuna and a sailor still in uniform; in another, a sailor with his saber; and in yet another, a horse with its rider. It must be said, though, that these stories seem a bit doubtful. In any case, none of these animals ever allowed itself to be captured in the* Nautilus' *nets, and I therefore had no way of finding out how voracious they were.*

Only one species of shark comes close to fulfilling these (and the earlier) criteria; only the great white, among the larger sharks, has the reputation for voraciousness and omnivorousness that Aronnax describes. It is doubtful that Verne ever saw a live one, but he may well have seen a dead one on the beach or in a taxidermist's shop. If indeed Verne's "dogfish" is a great white, it would explain the "enormous tail"—a full-grown white shark is an enormous fish—the glassy eyes (if it was a dead one), and finally, the "phosphorescent substance" they secrete "through holes around their snouts." Of course white sharks do not secrete a phosphorescent substance, but they

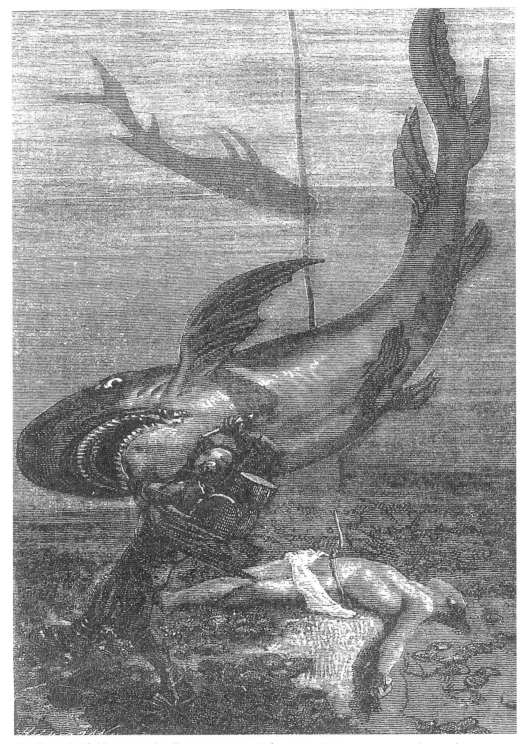

The "large dogfish" gapes and rolls its eyes menacingly as it cruises over an unconscious swimmer on the bottom. Barely visible in the gloomy left foreground is a black-clad helmet diver, the swimmer's would-be rescuer. *Twenty Thousand Leagues Under the Sea*

do have the ampullae of Lorenzini, a visible array of pores around their snouts, which probably could, in Verne's fertile imagination, exude phosphorescence.

For centuries, the egregiously exaggerated reputation of "the shark" dominated thought and literature; almost everything published was hyperbole, but it made no difference. We knew that sharks were ravenous man-eaters, and that belief could be verified almost anywhere. Here is a description of the shark by J. M. Buel from an 1888 volume with the most wonderful title, *Sea and Land: An Illustrated History of the Wonderful and Curious Things of Nature Existing Before and Since the Deluge. A Natural History of the Sea, Land Creatures, the Cannibals and Wild Races of the World*:

> *The head is broad and somewhat depressed, terminating in a dull pointed snout. The mouth is fairly huge, capable of admitting the body of a man, and still allow room for its large cartilaginous tongue. The eyes are the very personification of cruelty, craftiness and rapacity, being of a greenish cast and particularly stony glare. The stomach is not only large, but dilatable to an extraordinary degree, almost like a snake; the brain however, is very small, as are all the vital parts, and on this account, it is very hard to kill. . . . So swiftly can the shark swim through the water that no steamer can keep pace with him, and in strength, he has no equal save alone the whale. With a single snap of his powerful jaws he can cut a man in two; we may not, therefore, wonder that he is more dreaded by sailors than any monster of the monster-haunted deep.*

Does it matter that virtually every element of this description is nonsense? Of course not. What matters is Mr. Buel heard these things somewhere (or made them up), and then put them in a book that was published by the Historical Publishing Company of Philadelphia. (I have a copy of this eight-hundred-page book in front of me as I write this.) Following the description of the shark, there are twenty-five pages of tales of hungry sharks and shipwrecked sailors, swimmers, divers, and just about anyone else who ever ventured near or on the sea. Readers would be wise to stay as far away as possible from Mr. Buel's "monster-haunted deep."

Although it would be difficult to identify the most lurid reaction to sharks in the catalog of anti-shark literature, a prime candidate might be found in Capt. William Young's *Shark! Shark!* Young was a man who hated all sharks and devoted almost his entire adult life to killing them. Born in 1875 in Southern California, Young migrated to the Hawaiian Islands around 1900, where he saw his first sharks:

There they were, the savage, armored sea tigers which had become my fetish, my totem. I thrilled to the sight. As I leaned there, staring in utter fascination, my throat contracted. Tingling shivers ran up and down my spine, to my finger tips and toes. I wished for a harpoon, a rifle, anything that would give me a chance to make my first shark kill.

Young and his brothers went into the garbage-hauling business in Honolulu harbor, which gave them many opportunities to see and kill sharks. Young traveled around the world, occasionally employed by the Ocean Leather Company of New Jersey, a major producer and marketer of shark leather. In his book, "Sharky Bill" Young defines his attitude toward sharks:

When one sees or hears the word "shark" a powerful mental image is generated of a cold-blooded rover of the deep, its huge mouth filled with razor-sharp teeth, swimming ceaselessly night and day in search of any thing that might fall into the cavernous maw and stay the gnawing hunger which drives the rapacious fish relentlessly on his way; a terrible creature, in short, afraid of nothing and particularly fond of tasty human flesh. There is something peculiarly sinister in a shark's appearance. The sight of his ugly triangular fin cutting zigzags in the surface of the sea, and then submerging to become a hidden menace, suggests a malevolent spirit. His ogling, chinless face, his scimitar-like mouth with its rows of gleaming teeth, the relentless and savage fury with which he attacks, the rage of his thrashing when caught, his brutal insensibility to injury and pain, will merit the name of Afriet, symbol of all that is terrible and monstrous in Arabian superstition.

If these words had been written by anyone else and under any other circumstances, one would be inclined to regard them as hyperbolic nonsense (which they are), but Young actually believed that all sharks were "rapacious monsters" and "savage killers" and communicated his antipathy throughout the book. *Shark! Shark!* was first published in 1933 and went through many editions (one of which was bound in sharkskin), no doubt adding to the fish's reputation as a mindless man-eater that should be eradicated from the oceans by any and all means.

There were other books about shark fishing, such as *Tigers of the Sea*, written by Col. Hugh Wise in 1937; and Zane Grey's numerous accounts of his exploits in California and New Zealand, where he conquered white sharks, makos, threshers, and tiger sharks. In 1963, with Captain Bill Young, Harold McCormick and Tom

Allen wrote *Shadows in the Sea*, a four-hundred-page book mostly about the eternal conflict between sharks and men (Bill Young's contribution was a chapter on shark fishing), along with descriptions of the various shark species, and as an added bonus, several pages of recipes, including New England Fried Shark, Shark Marseillaise, and Shark Fin Soup. An Australian surgeon named Victor Coppelson wrote *Shark Attack* in 1958; David Davies, a South African scientist, wrote *About Sharks and Shark Attack* in 1964, and other discussions of the "shark menace" followed. Too early for the *Jaws* bandwagon, *The Natural History of Sharks* was published in 1969 by Thomas Lineaweaver and Richard Backus, a rational, unfrighten-ing look at sharks, with Ron Taylor's dramatic portrait of a great white repeated twelve times on the cover of the paperback. Everyone else writing about sharks had to emphasize how nasty and dangerous they were.

The most famous woman ichthyologist of our time, Genie Clark has been studying sharks since 1950.

Except for Eugenie Clark. A trained ichthyolo-gist, "Genie" Clark was the founder and first director of the Cape Haze Marine Laboratory (later the Mote Marine Lab) in Sarasota, Florida. Fascinated by sharks, she installed a couple into the lab's shark pen, begin-ning a study that would last for more than fifty years and would earn her the title of "shark lady." In 1951 she published the first of her autobiographical works, *Lady with a Spear*, which has gone through many editions and was translated into several different languages, including Braille. She was the first scientist to train sharks to press targets, challenging the age-old stereotype that sharks lack intelligence. Her work also took her to the caves of Isla Mujeres off the coast of Mexico where she studied the mystery of the so-called "sleeping sharks" that remained immobile in caves. It was previously believed that sharks had to keep moving to breathe, but diving into the caves, she observed that the enhanced oxygen content probably made breathing easier for the motionless sharks, and may even produce a narcotic effect. Clark also suggested that the sharks may use these caves as "cleaning stations," allowing smaller fishes to remove copepods, leeches, and other ectopara-sites from them. In 1969, Clark published *The Lady and the Sharks*, the second volume of her autobiography. She has written dozens of articles for the *National Geographic* (often accompanied by photographs by David Doubilet), including

one in 1975 about the sleeping sharks of Isla Mujeres. In 1981 she wrote a major article entitled "Sharks: Magnificent and Misunderstood," in which she said,

> *No creature on earth has a worse, and perhaps less deserved, reputation than the shark. During 26 years of research on sharks, I have found them to be normally unaggressive and even timid towards man with the sole exception of the great white shark. The vast majority are "chinless cowards," as zoologist William Beebe called them, meaning that unless provoked or threatened they prefer to retreat rather than to challenge anything as large as man.* *

Dr. Eugenie Clark with two kitefin sharks; Sugura Bay, Japan. *Photo by David Doubilet*

* In a 1968 "definitive" *National Geographic* article "Sharks: Wolves of the Sea," Nathaniel Kenney preserved many of the old stereotypes and clichés. This was the article from which Jerry Greenberg's photos were appropriated for *Jaws,* and the text and pictures are largely devoted to shark attacks. Describing a shark that swam harmlessly past him, Kenney wrote, "Any moment the time may come when one of these enigmatic creatures will attack a man. Results can be gruesome. Razor-edged teeth may remove an arm or leg cleanly take out a 10-pound piece of flesh. Hide rough as a rasp can flay, edges of fins and tails cut like swords. A shark is all lethal weapon."

For her diving prowess, intellectual courage, and scientific experiments with sharks, Eugenie Clark, PhD, moved on to a professorship at the University of Maryland, and a post as director emerita of the Mote Marine Lab.

In 1959, Dr. Bruce Halstead wrote *Dangerous Marine Animals*, in which he listed those shark species "dangerous to man," and his list includes just about every shark that grows longer than five feet (except the whale and basking sharks): "Mackerel Sharks or Maneaters; Requiem Sharks, Sand Sharks, and Hammerheads." In case you didn't get the message, Halstead includes a couple of grisly photographs of a man attacked in Monterey Bay, California, who had huge bites taken out of his legs. Thomas Helm, who described himself as a "former newscaster, newspaper reporter and forest ranger," wrote *Shark! Unpredictable Killer of the Sea* in 1961, in which (amidst a lot of supporting evidence to justify his title), he includes the story of the 1916 New Jersey attacks; the mass feeding frenzy on the thousand sailors of the USS *Indianapolis* after it was torpedoed by a Japanese submarine in 1945; and numerous, less populous shark attacks from Cuba, Florida, California, and assorted other locales. It is in this book that we find the oft-repeated list of objects purportedly found—by Helm himself—"in the stomach of a large blue shark that had kept company with our merchant ship for several days":

Along with an assorted mass of partly digested garbage and small fish, a total of twenty-seven different and completely indigestible articles spilled out on deck. In the collection we found soft-drink bottles, an aluminum soup kettle with a broken handle, a carpenter's square, a plastic cigar box, a screw-top jar partly filled with nails, a two-celled flashlight, several yards of one-quarter inch nylon line, a rubber raincoat, and a worn out tennis shoe. The largest and most improbable object was a three-foot wide roll of tarpaper with about twenty-seven feet of the heavy black paper still wound on the spool.

Helm explains this unusual diet by saying that sharks have poor eyesight, and will gobble up anything that falls overboard: "When the collection of indigestible junk grows large enough to become a burden, he simply belches up the whole works and swims off in search of more food." It appears that the more people wrote about sharks, the worse their reputation became.

In 1963, Perry Gilbert, a Cornell University zoology professor with a particular interest in sharks (and Genie Clark's successor as director of the Mote Marine Lab in Sarasota) edited an important volume called *Sharks and Survival*, which

he characterized as "not a comprehensive treatise on sharks; rather . . . a compendium for some of the pertinent information dealing with the taxonomy, distribution, behavior, and sense organs of sharks, many of which are presently considered dangerous to man." Material for this volume was collected by the American Institute for Biological Sciences' Shark Research Panel, and was largely dedicated, as its title implied, to surviving, repelling, or avoiding shark attacks. As Gilbert wrote, "Before World War II, sharks were of little concern to the people of the United States, or any other part of the world, with the possible exception of South Africa and Australia. . . . With the advent of World War II, and the deployment of service personnel to islands in tropical and semitropical waters, the shark suddenly became an object of considerable interest and concern, and the concern for this creature was not solely one of survival in its presence. Paradoxically, the shark was both sought for and avoided, its contribution to the war effort assumed both positive and negative roles. . . . On the positive side, the shark provided a rich source of vitamin A, highly prized two decades ago for its anti-night-blindness properties. . . . However, sharks also made a negative contribution to the war effort. As a result of air and sea disasters in tropical and semitropical waters, service personnel inevitably came into contact with sharks." One such air disaster epitomizes the negative contribution of sharks to the war effort, particularly as they affected US airman Louie Zamperini.

In May 1943, in a B-24 named the *Green Hornet*, Zamperini took off from Hawaii on a search mission. Some eight hundred miles southwest of the islands, his plane lost power and crashed into the Pacific. Only three crewmembers survived the crash (one of whom died after a month), and they drifted for forty-seven days, suffering scorching heat, dehydration, and starvation. At one point, they thought a plane was going to rescue them, but it turned out to be Japanese, and it strafed them repeatedly, puncturing their rubber life raft, but miraculously missing the airmen. According to Zamperini's account, which he called *Devil at My Heels* (he was a distance runner who had competed in the 1938 Berlin Olympics), aside from the hail of Japanese bullets, the greatest threat to their survival at sea seemed to have been the sharks that circled them endlessly, even going so far as to lunge for the emaciated airmen in the raft:

> *The calm did not prevent sharks from tailgating us as usual. The smooth surface simply allowed us a better look at their graceful movements as they swam around the raft. As one glided by I reached in behind its head and allowed*

my hand to move down its back and up over the dorsal fin. The shark didn't flinch. . . . Suddenly, the shark shot up, shattering the surface, with its mouth agape. It looked like a demon out of hell and tried to snatch me out of the raft. I reacted instinctively and thrust both my palms against its nose, which stuck out about a foot past the mouth, and was able to shove the ravenous creature back into the seas. Then, as its companion tried the same stunt, I grabbed an aluminum oar and jabbed it in the nose.

A few hours later our tranquility was shattered by a thump on the bottom of the raft so powerful that our bodies winced with pain and we were lifted a few inches off the ocean surface. Stunned and frightened, I looked over the side and followed a huge fin as it circled the raft. When it came alongside again, the monster's tail flipped sideways, sending a wave of cold water over us. Then I got a good look at our visitor: a huge, bluish gray shark maybe twenty feet long. A great white. *

Some sharks actually do jump out of the water. As part of its feeding strategy, the spinner shark (*Carcharhinus brevipinna*) charges vertically through a school of fish, spinning on its axis with its mouth open and snapping all around it. At the end of these spiraling runs, its momentum often carries it into the air, giving it its common name. In pursuit of sea lions, the momentum of some South African white sharks carries them out of the water, but like the spins of spinners, "Air Jaws" is the aftereffect of a powerful rush toward the surface. Giant sharks also launch themselves in those loony books and movies about two-hundred-foot-long prehistoric sharks that leap onto cruise ships or grab helicopters in mid-air, but real sharks prefer to do their hunting in the water. Those sharks that can—and do—leap out of the water, are makos, and they're usually hooked and trying to

* In *Unbroken: A World War II Story of Survival, Resilience, and Redemption* (Random House 2010) Laura Hillenbrand retells Zamperini's story, closely following his own *Devil at My Heels*, which had been published first in 1956 (with a foreword by Billy Graham), and then again in 2003, the second time "written with David Rensin." Zamperini and Russell Philipps were captured by the Japanese after six weeks at sea, and spent the next two years in Japanese prison camps on Pacific Islands and in Japan. Zamperini, born in 1917, was very much alive in 2010 when Hillenbrand's book was published, and according to her acknowledgments, "he could not have been more gracious… sat through some seventy-five interviews, answering thousands of questions with neither impatience nor complaint." Even though many of the incidents appear almost verbatim in both books, I could find no mention of Zamperini's book anywhere in Hillenbrand's.

escape.* Zamperini's accounts of sharks leaping out of the water to grab—and of course, *eat*—the besieged airmen are preposterous. I've read a large proportion of the literature (fictional and otherwise) on sharks, and I've never encountered sharks leaping out of the water for food. I think Zamperini embellished an already incredible tale of survival at sea by stirring a mob of leaping, ravenous sharks into the mix. He incorporates a twenty-foot white shark into his story, but otherwise never describes them. The location of his open-ocean Pacific adventure suggests they were probably oceanic whitetips, those brutes that Cousteau called "ugly but quite powerful," but whatever else they are, they are not known leapers. Detailed to carry elements of the atomic bombs destined for Hiroshima and Nagasaki from San Francisco to Tinian (Marshall Islands), the US cruiser *Indianapolis* was torpedoed after unloading her cargo by a Japanese submarine on July 30, 1945, and sank in twelve minutes, unable to send a distress signal. When the ship did not show up in Leyte on schedule, patrol aircraft and search vessels were sent out, but they did not locate the wreckage until August 2, and were not able to complete the "rescue" until August 8. Of her complement of 1,200 men, some 850 escaped the sinking, but they were left floating in shark-infested waters, and many that did not drown or die of their wounds were killed by sharks. Survivors of what was probably the greatest shark massacre in history recalled dorsal fins slicing through oil-soaked waters and the screams of sailors as they were attacked.† The destroyers *Doyle* and *Helm* arrived on the scene to rescue the floating sailors, but they arrived too late for most of them. Of the 850 who did not go down with the ship, only 318

* In 1934, western author (and passionate big-game fisherman) Zane Grey wrote an article for *Natural History* magazine entitled, "The Great Mako: Fighting and Photographing One of the Most Fearless Jumping Game Fishes of New Zealand Waters." The article included the first photographs of makos above the surface, and Grey wrote, "The highest jump I ever photographed up to 1932 is reproduced herewith. This mako, weighing some 400 pounds, leaped close to 20 feet higher than Captain Mitchell's boat. I saw another, at a distance of two miles, flash white as snow as it shot above the same boat to a height of many feet. . . . At Cape Brett, I saw one hooked by C. Alma Baker—a 503 pound shark that leaped six times behind the boat, all leaps from close to the same place, the second higher than the first, the third highest at nearly thirty feet, and the remaining three graduating down."

† In *Jaws* (the movie, but not the novel), three men sit in the cabin of the *Orca*, trading stories and awaiting the return of the great shark. Quint (the shark-hunter) tells Chief Brody and Matt Hooper that he was aboard the *Indianapolis* when she was torpedoed, and describes the carnage that followed: "very first light, Chief, sharks come cruisin' . . . lifeless eyes, black eyes like a doll's eyes . . . when he comes at you, he don't seem to be living . . . until he bites you . . . those black eyes roll over white . . . then you hear that terrible, high-pitched screaming . . . the ocean turns red. I don't know how many sharks, maybe a thousand . . . 1,100 men were in the water, 360 come out. Sharks took the rest."

were rescued. In *Shark Attacks*, author Thomas B. Allen (the same man who wrote *Shadows in the Sea* with Young and Mazet), wrote,

> The "shark-infested Pacific," as war correspondents inevitably referred to that theater of war, was indeed well-sharked, with at least 150 species, not including bottom dwellers. The deep water where most of the survivors found themselves is the habitat of one of those species, the oceanic whitetip (Carcharhinus longimanus). Whitetips, large and aggressive, are the chief suspects when survivors disappear at sea. Whitetips live in deep water, prefer seas with temperatures around 70 degrees, and are rarely found near land (except for mid-ocean islands like Hawaii). There are probably more whitetips in the sea than any other species of large sharks. Blue sharks may outnumber them in places. No one knows the true population size of either species.

After making a film about blue sharks off Montauk, Long Island, in 1965, Peter Gimbel decided to mount an expedition to film white sharks. He had seen *Hunt for the Great White Shark*, the 1964 film made by the Taylors and Rodney Fox, so there is no question that he knew from the start where white sharks could be found. (He did believe, however, that simply heading right for Australia and filming the sharks would not have made much of a feature film.) And because Gimbel had also heard that white sharks came to feed on whale carcasses off Durban, he first took his cages, his cameras, and his crew to South Africa. Gimbel, Ron and Valerie Taylor, and Stan Waterman filmed sharks feeding on a dead sperm whale, and although they got some of the most exciting undersea footage ever made—at one point, they were all out of the cages, filming oceanic whitetips, blues, duskies, and a tiger—the shark that Gimbel referred to as "Whitey" never appeared.

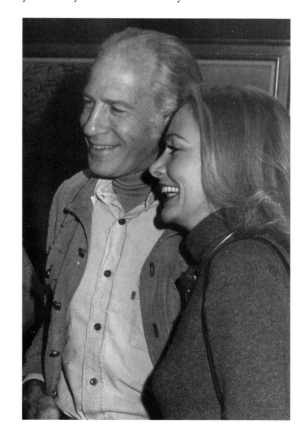

Peter Gimbel with his wife, Elga, produced and directed *Blue Water, White Death*, the thrilling story of an around-the-world search for the great white shark. *Courtesy of Sportsman's Edge Gallery*

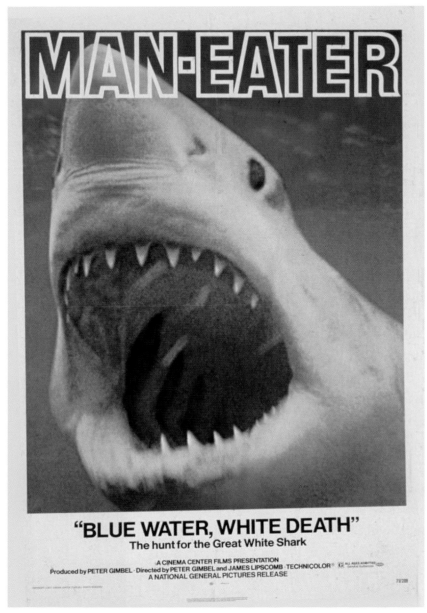

The photograph used for the *Blue Water, White Death* poster was taken by Ron Taylor in South Australia.

Several abortive attempts were made to find white sharks in the Indian Ocean, both off the Comoro Islands (where coelacanths live) and off Sri Lanka (south of India, and another location where there are no known occurrences of white sharks), but finally, with only the Durban feeding frenzy in the can, they decided to head for South Australia. With Rodney Fox and Ron and Valerie Taylor as advisors, the

Blue Water, White Death film team found their subject off Dangerous Reef, in January 1970. According to Peter Matthiessen (who chronicled the expedition with connsummate skill in *Blue Meridian*), the footage shot at that time was "surely the most exciting film ever taken underwater [that] had been obtained without serious injury to anybody." It was the first time the great white had been the subject of a major film, but it would not be the last.*

Blue Water, White Death was an enormous success. Both the expedition and the film won worldwide critical acclaim, and Gimbel, who had conceived the idea, sold it, and produced and directed the film, deserves all the credit for introducing the great white shark to the world. Of course the white pointer was not an unknown quantity beforehand, but it was probably known mostly to a handful of ichthyologists, fishermen, and South Australians. Even along the California coast, it had not yet had much press. As of 1971, with the release of Gimbel's film, the seeds were planted for the growth of the phenomenon that became *Jaws*. On May 12, 1971, *Blue Water, White Death* opened in New York, and Vincent Canby, the *New York Times'* film critic, wrote:

> *Sharks, however, are something else, often observed but until comparatively recently, little-known, the subjects of all sorts of old wives' tales, a symbol for everything from shylocking to every man's fate worse than death, an implacable, terrifying, disinterested power, an Old Testament tribulation, as well as a force of extraordinary grace, beauty, and serenity. Those of you who share my perhaps neurotic weekend skindiver's fascination with sharks will not, I think, be able to resist the quite jolly, sometimes awesome, new documentary movie that opened yesterday at the Festival Theater. . . .*
>
> *It also contains some of the most beautiful and (there is no other way to describe it accurately) breathtaking underwater footage I've ever seen—truly*

* In 1936, Zane Grey made (and starred in) a movie he called *White Death*, which was ostensibly about the white shark, but since the shark does not appear until the end, the film does not really qualify as a shark movie. In this movie, shot in New Zealand and Australia, a gent from an unspecified location on the Great Barrier Reef offers Grey the opportunity to catch a twenty-foot white shark that has been terrorizing the local aborigines, and has eaten several of them along with the wife and son of the local missionary. Grey agrees to catch the shark, partly to win a bet with a rival fisherman, and partly to avenge the death of the missionary, who has also fallen victim to the shark. He hooks the shark, and, as in *Jaws*, to which this film bears no other resemblance, his boat is towed all over the place until the shark tires and can be gaffed. The film ends as the shark—a wooden model painted white—is towed onto the beach, and the romantic leads, neither of whom is Zane Grey, gaze into the sunset.

remarkable, free-swimming encounters by Mr. Gimbel and his associates with sharks gorging themselves on newly caught whales, with barracudas, with fat pushy groupers, and finally, and triumphantly, with the great white sharks off the south coast of Australia. . . . However, the heart of the film is its action, recorded with immense technical skill, and it is so pure that it's as poetic as anything I've seen on the screen in a long, long time.

In *Blue Meridian*, a nonfiction chronicle of the expedition, Peter Matthiessen has given us perhaps the most moving, accurate, literate, and beautiful description of the white shark that has ever been written. Matthiessen had been invited to join the *Blue Water, White Death* film team on its two-year, round-the-world quest for the great white shark. He accompanied Peter Gimbel to the Bahamas (where he learned to dive) and to South Africa (where he descended in a shark cage), and with the rest of the crew, wound up aboard the *Saori* off Dangerous Reef, South Australia. This is his description of his first view of a white shark underwater:

The bolder of the sharks, perhaps twelve feet long, was a heavy male, identifiable by paired claspers at the vent; a second male, slightly smaller, stayed in the background. The first shark had vivid scars around the head and an oval scar under the dorsal, and in the molten water of late afternoon it was a creature very different from the one seen from the surface. The hard rust of its hide had dissolved in pale transparent tones that shimmered in the ocean light on its satin skin. From the dorsal fin an evanescent bronze shaded down to luminous dark metallic gray along the lateral line, a color as delicate as the bronze tint on a mushroom which points up the whiteness of the flesh beneath. From snout to keel, the underside was a deathly white, all but the black tips of the broad pectorals.

This is brilliant, powerful writing; literature with a capital "L." And in the next paragraph, Matthiessen all but transcends nature *and* literature:

The shark passed slowly, first the slack jaw with the triangular splayed teeth, then the dark eye, impenetrable and empty as the eye of God, next the gill slits like knife slashes in paper, then the pale slab of his flank, aflow with silver ripplings of light, and finally the thick short twitch of its hard tail. Its aspect was less savage than implacable, a silent thing of merciless serenity.

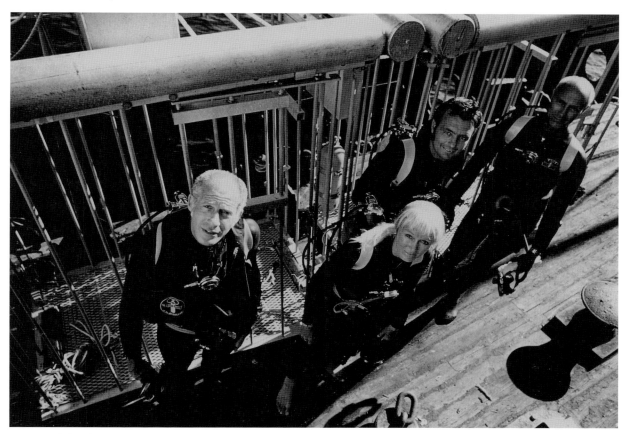

Peter Gimbel, Valerie Taylor, Ron Taylor, and Stan Waterman all left the cages to film sharks feeding on the carcass of a sperm whale on the Durban whaling grounds. *Courtesy of Peter Gimbel*

The white shark has come to represent all sharks, because in a sense, it *is* all sharks. It is big, powerful, extremely dangerous, and frightening to behold. It has all the equipment that characterizes the voracious shark: rows of razor-sharp, serrated teeth; a soulless black eye (Matthiessen wrote that it was "impenetrable and empty as the eye of God"); and of course, the all-important triangular dorsal fin, always "knifing" through the water. Of all large, predatory animals, the white shark is usually considered the most dangerous. (Cobras in India kill many more people than sharks around the world, but they don't eat their victims, so they do not have the same reputation, at least not in Western countries.) Lions, tigers, and grizzly bears also attack people on occasion, but their attacks are rare, probably because the carnivores themselves have become rare. We don't often hear that big cats or bears are a threat to our existence, or even our safety. In fact, for the most part, we regard these animals as relatively harmless inhabitants of zoos and circuses. One

would not expect to find a shark in a circus, but in the circus-like atmosphere of the oceanarium–theme park, with its performing dolphins and orcas, often the center-ring attraction is the shark tank.

Regardless of who was writing or when, sharks have almost always garnered bad reviews. Occasionally somebody would comment on how beautiful the mako or the blue shark was, but otherwise, the bloodthirsty reputation of the shark overwhelmed all other aspects of its natural history. This is probably a result of general ignorance about the great number of harmless species, but I believe it is more closely tied to the sharks' habits—real or imagined. They are aggressively carnivorous, not always restricting their menu to their fellow sea creatures. Man-eating sharks attract more attention than the little ones that glow in the dark or the huge plankton-feeders. The eponymous protagonist in *Jaws* embodies every characteristic that has contributed to the reputation of the shark today: It is massive, crafty, evil, malicious, vindictive, toothy, and anthropophagous in the extreme. Centuries of shark abhorrence were condensed into a book that consumed everything around it and brought us to a place where we became familiar with the shark—but always from a safe distance. Even though Benchley's villainous shark succeeded in frightening everybody, it was *fictional*, and you can't get much further away from man-eating sharks than a chair in your living room.

Prior to 1974, writers of fiction generally eschewed the sharks, but in one memorable exception, Ernest Hemingway wrote brilliantly about the mako. In *The Old Man and the Sea* (1952), he wrote: "He was built as a sword fish, except for his huge jaws which were tight shut now as he swam fast, just under the surface with his high dorsal fin knifing through the water without wavering. Inside the closed double lip of his jaws all of his eight rows of teeth were slanted inwards. They were not like the ordinary pyramid-shaped teeth of most sharks. They were shaped like a man's fingers when they are crisped like claws." This shark is killed by the Old Man, but others soon come to strip the flesh from the marlin he has caught, and once again, the shark appears as the archetypical malefactor.

Before Benchley's book (and the movie that followed) the "shark literature" consisted mostly of works about shark fishing or an occasional book about attacks. After *Jaws*, however, bookshops and magazine stores were inundated with every kind of publication that purported to address the issue of man-eating or killer sharks, always in near-hysterical terms. One-issue "magazines" appeared with names like *Maneater, Shark, Jaws of Death,* and *Killer Sharks,* alongside quickly produced soft-cover books with similarly frightening titles. David Baldridge's

1974 Mote Marine Lab report, "Shark Attack: A Program of Data Reduction and Analysis," resurfaced as a paperback book entitled *Shark Attack: True Tales of Shark Attacks on Man—More Terrifying than the Fiction of JAWS*. Rodney Fox, who had been attacked and nearly killed in 1963, published an illustrated booklet in 1975 called *Shark: Attacks and Adventures with Rodney Fox*, which included the story of his own attack (complete with photographs of the gory bite wounds that required 462 stitches to sew up), and any number of photographs of the gaping mouth of the perpetrator. Before 1975, a collector of shark books would use up only a shelf; afterward, his collection would fill a small library.

We can be thankful that human beings are not high on the menus of white sharks, because they are classified as opportunistic feeders, meaning that they take what's available. The greatest concentrations of white sharks are where there are sea lion populations—South Australia, South Africa, and central California—although the sharks somehow find their way to almost every temperate ocean, from the Mediterranean to the mid-Atlantic, Japan, Brazil, Hawaii, and New England. There are California sea lions in their eponymous waters, but the sharks of the west coast of the United States and Mexico prefer to dine on elephant seals, perhaps because they can get more bang for their buck: there's a lot of meat and blubber in a three-ton bull elephant seal.

In *Devil's Teeth: A True Story of Obsession and Survival Among America's Great White Sharks*, Susan Casey talks about the *tiburónes* and *elefantes* of the Farallon Islands, twenty-seven miles due west of San Francisco. Researchers live on these

In 1963, Rodney Fox was attacked and nearly bitten in half by a great white shark. He lived to initiate shark-cage diving in South Australia and contribute to this book about his adventures. *Courtesy of Rodney Fox*

almost uninhabitable rocky outcrops (known colloquially as "The Devil's Teeth," thus the name of the book), and specialize in white sharks, while the sharks specialize in elephant seals. Here is the opening paragraph of Casey's relentlessly intense study of a season on the Farallones with Peter Pyle, Scot Anderson, and the "Rat Pack" consisting of Stumpy, Bitehead, Cuttail, Sister, Spotty, Whiteslash, Bluntnose, Tipfin, and the other local residents:

The killing took place at dawn and as usual it was a decapitation, accomplished by a single vicious swipe. Blood geysered into the air, creating a vivid slick that stood out in the water like the work of a violent abstract painter. Five hundred yards away, outside of a lighthouse on the island's highest peak, a man watched through a telescope. First he noticed the frenzy of gulls, bird gestalt that signaled trouble. And then he saw the blood. Grabbing his radio, he turned and began to run. His transmission jolted awake four other people on the island: "We've got an attack off Sugarloaf, big one it looks like. Lotta blood."

To Peter Pyle, Scot Anderson, and Susan Casey, the white sharks of the Farallones are not bloodthirsty man-eaters (well, maybe seal-eaters), but fascinating animals to be studied over time, depth, and distance. It was the Farallones tagging program that revealed the heretofore unsuspected peregrinations of some of the California white sharks, who up and swam to Hawaii:

The Farallon sharks, it seemed, spent most of their time roving the open ocean rather than sticking close to the coast, as had been supposed. And when they moved away from the islands and over the lip of the continental shelf, they began diving to depths greater than seven hundred meters. That too was unheard of behavior from an animal that hunted its prey on the surface. And the sharks were booking, logging as many as sixty miles a day with purposeful efficiency. It was as though they were late for an appointment and were hustling to keep it. A Rat Packer named Tipfin, tagged by Peter in October 2000 (and again in October 2001), was discovered to have cruised 2,300 miles to Hawaii in thirty-seven days. He remained near Maui for at least four months, and then turned around and returned to the Farallones in October.

Tasmanian author David Owen has now written *Shark: In Peril in the Sea*, a book in which he discusses the timeless, complex relationship of men and sharks, and identifies a sea shift where some of us have become as concerned for the welfare of sharks as our own when these two supreme predators come into contact.* From Sid Perkins's review in *Science News*, December 2010:

* Except in the case of shark fishing, where meat of one sort or another is offered as bait, "big game fishing" usually depends on fooling the fish into accepting an artificial lure that is supposed to look like its normal prey—a small fish, say, or a squid. It is a grossly uneven contest, where the man rests comfortably on a boat, trying to fool a fish. The only way to level the playing field would be if fisherman and fish were in the same element, playing by the same rules; no spearguns or bang sticks, just the equipment God gave them. In those instances where shark and man are equally armed, the shark, designed for underwater predation, usually wins. We call those victories "shark attacks."

In large part due to the violent nature of their attacks—which often come literally out of the blue—sharks have long inspired fear and fascination. The 1975 blockbuster Jaws *tapped into that primal fear but also demonized great white sharks, and via guilt by association, many other species. Yet, Owen notes, much good came from the film. It inspired scientific interest in sharks and their relatives and spawned conservation efforts worldwide.* Shark *is a captivating portrait of creatures that have been too long been unfairly maligned as malevolent eating machines.*

Now comes Juliet Eilperin's *Demon Fish: Travels Through the Hidden World of Sharks*, published in June 2011, just as I was finishing the manuscript for the book you now hold in your hands. I am happy to report that Eilperin picks up the story where McCosker and I left off in 1991. The two icons of shark encounters, Peter Benchley and Peter Gimbel, are gone, as are many of the scientists, fishermen, divers, and attack survivors that I talked to while preparing my *Book of Sharks* in 1975. Eilperin includes many of the past personnel who brought sharks into human awareness, but she also seeks out their modern day counterparts, and tells us of fascinating new developments in the world of shark research today. "Crittercam Accelerometers," she writes, "are the same motor-sensitive computer chips used in smart phones, iPods, and the Nintendo Wii, and they are providing unprecedented detail about how sharks move beneath the water." Outfitting sharks with satellite tags has given us a much better idea of where they can be found at a given time, and Mahmood Shivji, of Nova Southeastern University, analyzes the DNA of sharks caught by fishermen to determine where they were caught, and thus which populations need protection. Her attitude toward sharks consists of an informed and eloquent reversal of the shark-as-monster archetype:

In every instance, however, I began to see how we are coming nearer to the monsters of the sea that have terrified us for centuries. . . . Ancient myths about sharks are fascinating, mainly because they reveal how we—rather than the animals—have changed over time. . . . We have doggedly viewed sharks through our own prisms, immune to the revelations that have emerged in recent years, and our popular view of them has become more, not less, simplistic over time. . . . If we pay attention, sharks can tell us about their watery world and its implications for the land we inhabit. How we negotiate sharing the planet with sharks could help determine what our own future looks like, not just theirs.

The destructive reputation of the shark is ubiquitous. An annual television series (Shark Week) is singularly dedicated to presenting stories that enhance its dangerous nature. (Naturally, the series always takes place in the summer, when most people would be swimming.) Attempts have been made to ameliorate the emphasis on anthropophagy, but with little success. The viewing public insists upon sensational stories of sharks feeding, sharks leaping from the water, sharks schooling, and people diving with sharks. *Shark Diver* magazine serves as an unofficial guidebook to Shark Week; it is the only magazine dedicated exclusively to diving with a particular sort of animal. Founded by Eli Martinez, a former rodeo bull rider from Alamo, Texas, and host/cameraman/safety diver for the Discovery Channel, Animal Planet, National Geographic Channel, and NBC's *Today Show,* the magazine is a veritable album of shark pictures and the people who dive with them. In the first issue (February 2003), Martinez elucidated the magazine's goals: "To do our part to help sharks survive for generations to come." Since that issue, *Shark Diver* magazine has featured articles and photographs that celebrate the power and majesty of free-swimming sharks, with only a cursory nod to the dangers of getting too close to great whites, tigers, whitetips, and hammerheads.* Indeed, the magazine belittles the dangers; in order to take these photographs, you have to believe that the sharks are not going to turn and attack you. (There are also many stories about the giants of the shark kingdom, the whale sharks and basking sharks, but these behemoths are acknowledged primarily for their size, not their fearsomeness.) By the magazine's first anniversary issue, the motto had become, "Not just another dive magazine . . . A way of life."

* *Shark Diver* occasionally features articles not only about threatened divers, but about threatened sharks as well. In 2004, David Wilkinson wrote "A Devastating Delicacy," about shark's fin soup and how Dr. Mahmood Shivji of Nova Southeastern University has developed a method of DNA testing shark fins to identify the species and thereby learn "which species of sharks are most affected by commercial fishing, which in turn will enable [us] to make recommendations for establishing quotas so that depleted populations can recover."

The *Jaws* Phenomenon

One afternoon, the film of choice was Steven Spielberg's Jaws. *There I sat, cross-legged on the linoleum, trying as best I could to be a well-behaved child, a good child, and there on the screen coeds lounged around a campfire on a beach, smoking something. And there on the screen one of the female coeds ran naked into the moonlit waves. And on the screen, as she swam, there came a sudden jerk, and a look on her face of awful and somehow comical surprise. And there on the screen, the naked coed disappeared beneath the waves. Across the water spread a slick of blood. And on the beach, the following morning, there appeared a dismembered forearm. And though I once dreamed of becoming a marine biologist, I have been afraid of the sea ever since—so afraid that even now on trips to the seashore I'll wade in waist deep but no farther.*

—Donovan Hohn
Moby Duck, 2011

Peter Bradford Benchley (1940–2006) was the son of author Nathaniel Benchley and the grandson of American humorist and Algonquin Round Table founder Robert Benchley. An alumnus of Phillips Exeter Academy and Harvard University, he worked for the *Washington Post*, as an editor at *Newsweek*, and as a speechwriter in the Lyndon Johnson White House. Doubleday editor Tom Congdon saw some of Benchley's articles and invited him to lunch to discuss some book ideas. Although Congdon was not impressed by Benchley's proposals for nonfiction, he was interested in the idea of a novel about a great white shark terrorizing a beach resort. (By this time, Benchley had gone shark fishing with Montauk "monster fisherman" Frank Mundus, and had also read of the 1916 attacks off New Jersey, so he was well versed about the reputation of great white sharks.) Congdon offered Benchley an advance of $5,000, and the would-be novelist submitted the first hundred pages. He wrote the rest of the book during the winter of 1973 in a room above a furnace company in Pennington, New Jersey, and in the summer in a converted turkey coop in Stonington, Connecticut. *Jaws* became the publishing sensation of 1974–75. In *Jaws* (which he originally wanted to call *A Stillness in the Water* or *The Silence of Death*), Benchley introduces the most infamous marine creature since Moby-Dick in the opening paragraph:

The great fish moved silently through the night water, propelled by short sweeps of its crescent tail. The mouth was open just enough to permit a rush of water over the gills. There was little other motion; an occasional correction of the apparently aimless course by the slight raising or lowering of the pectoral fins as a bird changes direction by dipping one wing and lifting the other. The eyes were sightless in the black, and the other senses transmitted nothing extraordinary to the small, primitive brain. The fish might have been asleep, save for the movement dictated by countless millions of years of instinctive continuity: lacking the flotation bladder common to other fish and the fluttering flaps to push oxygen-bearing water through its gills, it survived only by moving. Once stopped, it would sink to the bottom and die of anoxia.

In 1973, Universal Studios bought the rights to Benchley's novel. Filmed on Martha's Vineyard off the coast of Massachusetts, the story featured Richard Dreyfuss, Roy Scheider, Robert Shaw, and Peter Benchley (in a bit part). Its star (actually, three separate units were required) was a model of a great white shark the film crews nicknamed "Bruce."

If there is anyone on the planet who has not read or seen *Jaws*, I offer a brief synopsis. Off the beaches of a town called Amity, a large shark begins picking off swimmers and holing boats to get at their occupants. Mike Brody, the Amity police chief, becomes concerned, and because he can elicit no support whatever from the members of the town council, who are worried only about tourist income, he enlists the services of an ichthyologist named Matt Hooper. But because Brody and Hooper are helpless as the shark continues its rampage, Captain Quint, a local fisherman, offers to capture the shark for $10,000. Brody, Hooper, and Quint set out aboard Quint's boat to hunt the shark, and with harpoons, rifles, beer kegs, anesthetics, and macho determination, they succeed. In the book, Hooper is killed as the shark crushes the cage, but in the movie, he hides on the bottom until Brody dispatches the shark, which has eaten Quint. Then Hooper pops to the surface, and the two survivors swim off into the sunset and box-office history.

Produced by David Brown and Richard Zanuck and directed by Steven Spielberg, *Jaws* was a fascinating exercise in movie-making. It required a location where the shark could be filmed in calm water (and one that suggested the fictional New England island of Amity rather than Rarotonga); a re-write of the story to conform to various cinematic notions (because Benchley wrote his own first screenplay, this decision produced no real conflict); and most demanding of all,

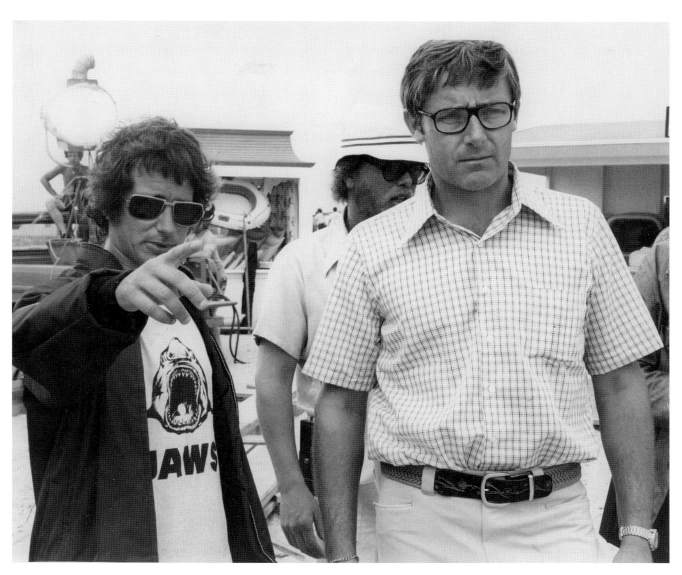

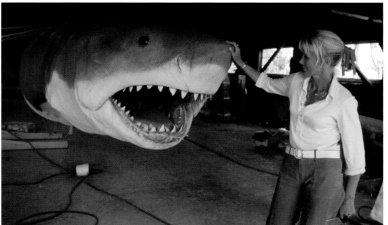

(above) Steven Spielberg's first blockbuster movie was *Jaws*; novel and screenplay by Peter Benchley (on the right), who also had a part in the film. *Courtesy of Wendy Benchley*

(*left*) **Valerie Taylor fending off the head of "Bruce."** *Photo by Ron Taylor*

the fabrication of a shark that would perform on cue. According to Carl Gottlieb, the other screenwriter, the producers "had innocently assumed that they could get a shark trainer somewhere, who, with enough money, could get a great white shark to perform a few simple stunts on cue in long shots with a dummy in the water, after which they would cut to miniatures or something for the close-up stuff."

White sharks are notoriously uncatchable, not to mention untrainable, and the special effects department was set to work designing a shark that could pass the scrutiny of the most demanding viewer. The three models—one to be shot from the left, one to be shot from the right, and one to be shot "in the round"—were built in California and trucked across the country to Martha's Vineyard, where they were kept carefully under wraps until they were to be used. After the second unit had filmed live great whites off Dangerous Reef, the three models were brought into play. Designed by Bob Mattey and Joe Alves, the model sharks were designed to run on a sunken trolley that had to be towed out to the shooting site every day, and the problems that attended the manipulation of these recalcitrant elasmo-mechanisms fill a good portion of Gottlieb's *Jaws Log*, published in 1975. The shark models were supposed to be twenty-five feet long, longer than any known white shark.

The shark was also to be much longer than the live ones that Ron Taylor and Rodney Fox had filmed in South Australia. Because all concerned knew that very few sharks sighted in South Australian waters were longer than twelve to fourteen feet, a midget stuntman was to be placed in a scaled-down cage to compensate visually for the size difference. The stuntman, Carl Rizzo, had evidently never dived before, but with some trepidation he gamely entered the cage and descended for the filming. Later that day, Rizzo was halfway through the trapdoor of his tiny cage when a shark became entangled in the support cables. The agitated animal ripped the winch from its moorings and tossed Rizzo back into the boat. When the winch broke, its red hydraulic fluid drained out all over the deck, and both Fox and Rizzo thought they were seeing their own blood. When it came time to lower the cage for the next day's filming, Rizzo was nowhere to be found. Reports differ on where he had holed up, but Gottlieb (attributing the story to an anonymous source) says that he "was located cowering in the forward chain lockers with the anchor." He never dived again.

The film was released in the summer of 1975, and it was a huge success. In an uncredited piece, *Time* magazine for June 23 called it "technically intricate and wonderfully crafted, a movie whose every shock is a devastating surprise." On

its cover, the issue carried an open-jawed shark with the caption "Super Shark." The film cost the (then enormous) sum of $8 million to make, and in its first ten weeks it grossed $21 million. It was the biggest money-maker in cinema history, and it spawned every conceivable spinoff, from plastic sharks' teeth necklaces and T-shirts to lame imitations of Benchley's novel and lurid picture books about "Jaws of Death!" and "Killer Sharks!" There were now shark movies, shark novels, shark reports, and shark television specials. (The film soon had its imitators too. The movie *Orca*, made in 1977, had its protagonists—Richard Harris as a crusty fisherman, Charlotte Rampling as a marine biologist, and Bo Derek as a person who gets eaten—hunting white sharks, but instead they encounter killer whales, who, just as vengefully as the star of *Jaws*, chased and sank boats all over the ocean.) We have indeed elevated the shark to mythic proportions; it has now become one of our own legends. Like the Hawaiians, we too have a shark god. Its name is *Jaws*.

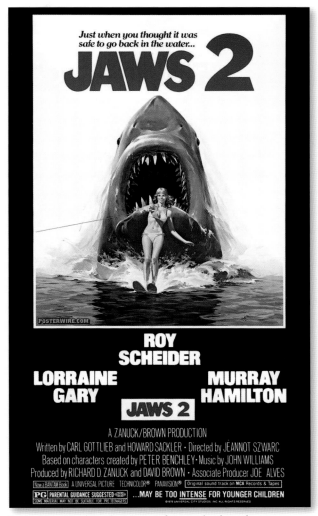

Just when you thought it was safe to go back in the water . . . they made another movie!

In a 1979 article in *Skin Diver* magazine, underwater cameraman Stan Waterman wrote, "Something there is about the shark that continues to tickle the macabre fancy of man. And it is, of course, both simple and profitable to exploit." Given Hollywood's predilection for following good films with bad, it is hardly surprising that *Jaws II* was in the works almost as soon as the success of the original was assured. No more waiting to see if the book "had legs" (as the marketers describe a property that has its own momentum), for in this instance, *Jaws II* the book was scheduled to appear simultaneously with the movie (in what the marketers called a "tie-in" sale). True, the studio had to license the name "Jaws" from the author—at a reputed price of a half million dollars, or $125,000 *per letter*—and state that their book was "based on

characters created by Peter Benchley." For the rest, however, it was open season on man-eating sharks and facts.

Jaws II takes place some four years later, and although the characters are the same, nobody seems to remember anything about a killer shark, even after the death of two divers, two water skiers, and a killer whale. Even when Chief Brody produces a *photograph* of the shark (taken by one of the divers just before the shark ate him), the town council—still determined to keep the beaches open and protect their tourist income—refuses to acknowledge the existence of the shark, and fires the chief. Brody gets drunk, mumbles "Four years shot to hell," and (never mind that he has just been fired) reinstates himself as police chief so he can rescue a bunch of dim-witted kids—including his own—who have gone for a little one-day sail. In the original *Jaws*, Chief Brody fires a shot into a scuba tank that had got jammed in the shark's mouth, producing the summary explosion of the shark. This time around, the intrepid and inventive Brody whacks on a loose high-voltage cable to gain the shark's attention (earlier in the film, he had learned that sharks are attracted by noise). As he dangles on the cable, he exhorts the shark to attack ("Come on, you son of a bitch"), and as the shark chomps down on the power line it electrocutes itself in an explosion of fire, sparks, and sizzling seaweed.

By 1983 the original cast was gone, and Brown and Zanuck had evidently had enough of sharks. Spielberg, having become Hollywood's *wunderkind* directing *Close Encounters of the Third Kind*, *Raiders of the Lost Ark*, and *E. T.*, appears to have put aquatic monsters behind him. But there is no way to persuade Hollywood that if two things are good, three are not necessarily better. And if three are better, then 3-D promises to be even better than that. We therefore move the shark rig and a new cast of actors, directors, and technicians to Florida, where an oceanarium is to be the site of *Jaws 3-D*. Joe Alves, the production designer of the first *Jaws* and the assistant director of *II*, has now become a full-fledged director. The Brody brothers have grown up, and one of them, Mike, is now a supervisor at Sea World in Florida, while the other, "who hates the ocean," has gone off to college in Colorado. In an oceanarium setting, then, with a very stiff and tired-looking mechanical shark, the story continues. A ten-foot shark has managed to sneak into an enclosure, and proceeds to gobble up a maintenance man. After a heated discussion about whether it would be better to capture the ten-footer (and thus be "the first aquarium ever to exhibit a great white") or to kill it on camera for the publicity, the sentimentalists prevail, and the shark is captured. After it nonetheless dies, the biologists realize (a) that "because it doesn't have all its teeth" it is just a baby,

and (b) that its mother, a thirty-five-footer, is right outside. Panic ensues as the enraged mother speeds around the oceanarium's lagoon hunting down water skiers, swimmers, and bumper-boaters, finally smashing its canvas snout through an underwater tunnel. More roaring, smashing, and gnashing, and finally, the shark blunders into the aquarium's underwater control room with the body of a would-be hero in its mouth. But the dead hero, it seems, had provided himself with a couple of grenades, and Mike Brody (who had cleverly slipped into his scuba gear as the shark burst into the control room) sees one in the dead man's hand. With a skewer that happens to be close to hand, he hooks the ring of the grenade and pulls the pin. This preposterous resolution explodes the shark, and makes the score Brodies 3, sharks 0.

By 1987, young Mike Brody has been installed as Amity police chief, but we will not linger in the cold waters of New England for long. In this masterpiece, *Jaws IV: The Revenge*, the shark—or its mechanical descendant—seeks revenge on the whole Brody family. After all, one or another of them has been blowing up the shark's family since 1974. When it kills Chief Brody, Jr., as he checks on a disturbance in the harbor, his mother decides that she can no longer live in a place where malevolent sharks are after her family, and everybody—including the shark—heads for the Bahamas. (The Brody family flies down in a 747, but the shark seems to arrive at the same time they do.) Mama Brody now has her granddaughter to worry about, and naturally, the kid spends a lot of time in the water. She also has Michael Caine to worry about, since Papa Brody—the original chief, that is—seems to have died of a heart attack. But never mind. After gobbling up the requisite number of swimmers, boats, and divers, the shark is hunted down and this time (did they run out of explosives?) it dies impaled on the bowsprit of a boat.

The success of the later *Jaws* movies—considerable, even as it diminished from film to film—certainly cannot be attributed to the filmmakers' craft. Though the original *Jaws* was a well-made film, with reasonably developed characters and a more or less logical storyline—not to mention a terrifying protagonist—the sequels lack even a modicum of structure, and the cardboard characters speak in comic-book lines and act with no rational motivation. They are, to put it simply, lousy movies.

Why, then, would anyone want to make these films again and again? Certainly the first motivation is greed. "We made such a bundle on the first one, why not make another?" And another and another. But there is more to it than that. Unlike the giant gorilla in *King Kong*, or the assorted "Godzilla" monsters, the villain of the *Jaws* movies *really exists*. There *are* very large great white sharks swimming in

our offshore waters, and though they do not reach thirty-five feet, work their evil ways on selected families, or cleave the water with the speed of a torpedo boat, they do occasionally attack people, with appalling and often fatal results. It is the *reality* of this creature that produces the nightmares, and leads the producers, ever mindful of signals in the marketplace, to make more nightmare films. The novel and the films, or perhaps just the mass mindset established by the films, sustained in large measure by the reality of the great white shark, have made each of us pause—if only for a moment—before going into the sea for a swim. And anything that can provoke that same brief, dark thought in all of us is a powerful force indeed.

Although he is not the only one, Jim Beller, of Providence, Rhode Island, is by far the world's largest collector of *Jaws* memorabilia. His collection consists of the usual items like books, posters, T-shirts, models, movie stills, and videos, but he also has production drawings for the mechanical shark, autographed copies of the screenplay, bumper stickers, comic books, every book that's shown in the movie, games, puzzles, models, toys, behind-the-scenes photographs, press releases, newspaper and magazine articles (including movie reviews), and the rubber teeth used in the scene where Quint is attacked and swallowed. Beller—who calls himself "Jimmy Jawz"—was nine years old when the movie came out, and he has been obsessed with it ever since. His collection, which numbers thousands of items, is an obvious testimony to the effect that the film has had on him, but all that stuff was not created only for Jim Beller. It was made for a receptive worldwide audience that cannot get enough of big, nasty sharks.

Ever since the 1974 publication of *Jaws* and the hugely successful movie directed by Steven Spielberg, authors have tried to improve on Peter Benchley's formula for success. If a twenty-five-foot shark could generate all that money, think of what a hundred-footer could do. Or a two-hundred-footer! There is no shark that is one hundred feet long, but it so happens that the great white shark has a relative—or rather, *had* a relative—that may have reached a length of fifty feet. This is the creature known as *Carcharodon megalodon*, where *megalodon* means "giant tooth." In the original *Jaws*, Benchley couldn't resist speculating on the existence of megalodon today. After spotting the great white at sea, "marine biologist" Matt Hooper tells the terrified Chief Brody, "We have fossil teeth from megalodon. They're six inches long. That would put the fish at between eighty and a hundred feet. And the teeth are exactly like the teeth you see in great whites today. What I'm getting at is, suppose the two fish are really one species. What's to say megalodon is really extinct? . . . Just because we've never seen a hundred-foot great white doesn't mean they couldn't exist."

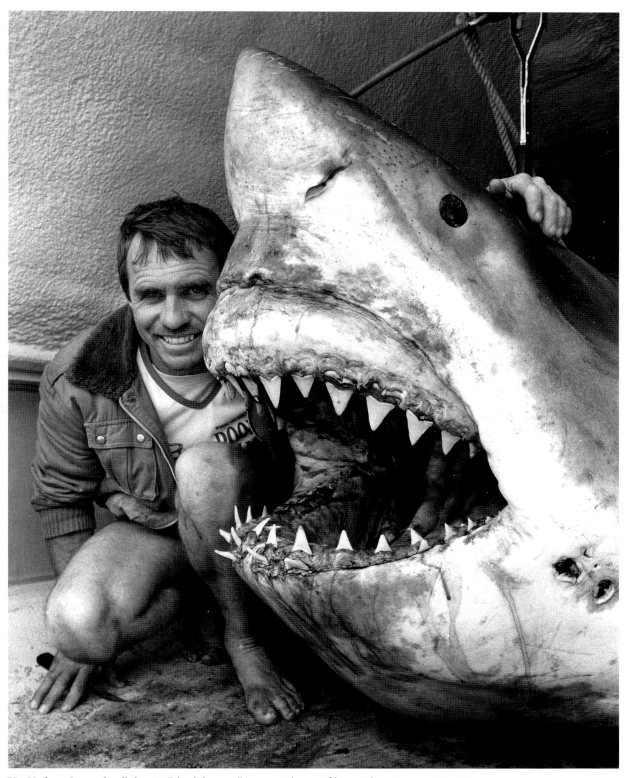

Vic Hislop, Queensland's heroic "shark hunter," poses with one of his catches. *Courtesy of Vic Hislop*

Megalodon teeth, often larger than a grown man's hand, closely resemble those of its smaller relative in general form, but the differences are sufficient to justify our separating the extinct and recent sharks as distinct species. Besides their obviously greater size, megalodon teeth have more and relatively smaller serrations and, above the root, a "chevron" that is lacking on the teeth of an adult *C. carcharias*. That they are conspicuously different in color is a consequence of fossilization: The teeth of all living sharks are white, whereas the teeth of extinct or fossil species range from light brown to black. The fact that no fresh megalodon teeth have ever been found strongly suggests that this giant relative of the white shark is extinct, but of course,

The great megalodon is extinct. All that is known of its existence is its gigantic fossilized teeth.
Richard Ellis collection

there is no way of conclusively proving that this monster does not exist, and this is the stuff that giant shark novels are made of.

In 1983, Robin Brown wrote a novel he called *Megalodon*, which was about a two-hundred-foot-long ancestor of the great white shark that was blind, covered with a coat of crustaceans, and living at great depths. In 1987, George Edward Noe self-published a little number he called *Carcharodon*, in which the giant shark has been imprisoned in an iceberg for a couple of million years, but because it is *really* hungry when it thaws out, all hell breaks loose. It goes on a rampage like its predecessor, and before we are finished, we have the marine-biologist hero renting a Norwegian whaling ship and shooting the shark with a grenade harpoon. Charles Wilson's *Extinct* (1997), whose jacket bears the ominous inscription, "Coming to NBC-TV," is set on the Gulf coast of Mississippi. Even though we have a whole new setting, we still have the same old stuff about a gigantic shark rising from the depths with its maw gaping to pluck unwary children and fishermen from the water.

Perhaps of all "sea monsters," the giant shark is the most enduring. It incorporates virtually every element that we require of our mythological sea beasts: great size, mysterious habits, verified anthropophagous inclinations, and a history that goes back to the beginnings of recorded time. More than leviathan, more than the sea serpent, more than the kraken,

megalodon may be the ultimate monster, which makes it a natural for a new genre: giant-shark-emerges-from-the-depths-to-kill-and-eat-everything-and-everybody.

Carcharodon megalodon probably reached a length of fifty feet or more, large enough to swallow a horse. The only evidence of the existence of these terrifying creatures is their huge fossil teeth, but quite often in the popular literature, these teeth mysteriously lose their fossil character, and are used to prove that *megalodon* still exists. In Peter Matthiessen's otherwise excellent book *Blue Meridian*, the chronicle of the *Blue Water, White Death* expedition, the author incorrectly assumes that *C. carcharias* and *C. megalodon* are the same species, and therefore, that there might be fifty-foot white sharks cruising the seas today. There are not, but writers of fantastic fiction don't care about those details.

Meg, which arrived on the scene in 1997, is surely the worst title of all—it sounds more like a nanny than a man-eating shark. It was published by Doubleday with all the fanfare of another *Jaws* or *Jurassic Park*. Indeed, the advance reading copy that I saw was emblazoned with every sort of encomium and sales pitch: "If Peter Benchley, Michael Crichton, and Clive Cussler were to combine their talents to create the ultimate summer read, MEG would be the result—a jaw dropping and terrifying page-turner of the deep." Didn't they wish. Not only is it not the slightest bit terrifying, it is unintentionally, hilariously funny, largely because almost every page contains a genuine howler. Whenever author Steve Alten discusses biology, paleontology, oceanography, or any other recognized scientific subject, he gets it wrong. It is obvious that Alten equipped

Steve Alten's novel about a two-hundred-foot-long prehistoric shark that can leap out of the water and grab a helicopter.

himself with a book about sharks, a study of submersibles, some weirdly off-base material about whales, and everything that Peter Benchley, Michael Crichton, and Clive Cussler ever wrote, and then mixed them together to produce an almost totally incoherent story, in which the human characters make no sense, the sharks and whales behave like unknown animals from the planet Zarkon, and the technology sounds like Rube Goldberg out of Buck Rogers.

One of the more imaginative inventions in the megalodon canon is Alten's explanation for why the giant sharks have remained unnoticed for so long. It seems that they live in the very deepest part of the ocean, the bottom of the Mariana Trench, which has somehow become a hydrothermal vent area, bubbling with superheated water. "The water temperature above the warm layer," he writes, "is near freezing. The Meg could never survive the transition through the cold in order to surface." Whoa! What happened to physics as we know it? Only in Alten's topsy-turvy world can there be a situation where warmer water remains below colder water. There is no way Alten could have written this nonsense unless he had convinced himself that it wouldn't matter if he played fast and loose with reality. "Listen, man," you can hear the author say, "this is *fiction*—I get to make stuff up."

Like this phantasmagorical description of the monster shark: "It's totally white, actually luminescent. This is a common genetic adaptation to its environment where no light exists."

As a helicopter hovers above this luminescent monster, "the *Megalodon* launched straight out of the sea like an intercontinental ballistic missile, flying at the hovering helicopter faster than Mac could increase his altitude. . . . Only the seatbelt kept his body from falling into the night where the garage-sized head closed quickly, its fangs five feet away."

The shark approaches a submarine, which, "at 3,000 tons easily outweighed her. But the *Meg* could swim and change course faster than her adversary; moreover, no adult *Megalodon* would allow a challenge to its rule to go unanswered. Approaching from above, the female accelerated at the sub's hull like a berserk, sixty-foot locomotive. BOOM!!" [BOOM?]

A man falls out of a helicopter into the water where Meg is on a rampage: "He struggled in time to catch the ladder in a death grip, feeling the warm aluminum, refusing to let go. His legs, decapitated at the knees, slipped out of the monster's mouth." *Decapitated at the knees?* Decapitated at the *KNEES?*

As might be expected, the shark is dispatched by an intrepid marine biologist, but nothing in this ridiculous book compares with Alten's unbelievable conclusion. The hero, named Jonas Taylor (*Jonas = Jonah?*) is in his one-man submersible when he is swallowed by the shark. He climbs out of the submarine, reaches into his backpack where he always carries a fossil *megalodon* tooth, and *he carves up the shark and kills it from the inside.* Then he climbs back into the submarine (which he relocates by shining his flashlight around in the belly of the shark) and ejects himself from the shark's mouth. As Dave Barry says, I'm not making this up.

Under ordinary circumstances, a book as terrible as this would hardly be noticed, or at least, it would be recognized for what it is: a stepping-stone to a Hollywood extravaganza with expensive special effects, throbbing music, and plenty of blood. But *Meg* was hyped so hysterically that it doesn't matter if it made any sense or even if it was readable. It's enough that it's about a giant shark that glows in the dark, launches itself like an ICBM, and eats fourteen whales at a time.

When Doubleday published *Jaws* in 1974, they paid Peter Benchley an advance of $5,000. The same publisher paid a million dollars for this outrageously awful book, crammed with egregious errors of fact, and stuffed to the gills with writing so awful that it would insult the intelligence of a sea cucumber. And the most embarrassing thing about all of this is that they—and the author—are proud of what they have done. On the flap of the copy I have, somebody wrote, "Steve Alten's story is an inspiring tale of perseverance against the odds, and the power of a good yarn. In a single month, he went from being an unemployed father of three with $48 in the bank to a multi-millionaire author and screen writer." Doubleday was obviously looking for another *Jaws* to make them rich. For publishing this rubbish, they ought to be ashamed of themselves.

I am more than a little embarrassed to see that in the author's note, Alten acknowledges me and John McCosker for our book, *Great White Shark*, as "an excellent source of information on both Megalodons and great whites." If *Meg* is what we spawned, then we ought to be ashamed of ourselves, too.*

There is something about giant sharks that brings out the worst in writers—or maybe it just brings out the worst writers. Here's a little number called *Quest for Megalodon*, which calls itself "A Thrilling Tale of Action, Adventure and Prehistoric Brutality." The book was published in 1993 by Swan Publishers, located in New York, Texas, and California, but a Google search for "Swan Publishers" produced no results, so it seems likely that the author, Tom Dade, published the book himself. Dade's bio gives his home address as Lafayette, Louisiana, and coincidentally, the place to order copies of *Quest for Megalodon* is Lafayette, Louisiana. There's nothing

* My discussion of *Meg* ran as a book review in the *Los Angeles Times* on July 20, 1997. In *The Trench*, the 1999 sequel to *Meg*, Alten introduced a marine biologist named "Ellis Richards," whom he describes thus: "an obstinate man who preferred the use of bully-tactics rather than concede he might be wrong. Though mankind knew more about distant galaxies than about the Mariana trench, Richards proclaimed himself an expert on the abyss, somehow knowing everything from its hidden geology to its mysterious life forms." Richards is the pilot of the submersible *Proteus*, which is attacked by three Megs (this time with "luminous crimson eyes") and Ellis Richards is killed. That'll teach me to write a critical book review.

wrong with publishing your own book, but unless you admit that you published it yourself, it might give the impression that a real editor read the manuscript at some point, and that a publishing executive thought the book would sell enough copies to justify its publication. It is painfully obvious that no editor ever read Mr. Dade's manuscript, and equally obvious that Mr. Dade (whose son Tommy drew the cover illustration) thought that all you had to do to write a thriller—rather like Steve Alten's—was to combine a giant man-eater, an assortment of idiot fishermen, a lot of teeth, and oceans of blood. Here's an example of Dade's adjective-happy prose:

> Not far below, a massive shape rose effortlessly through the dark water. The absence of an air bladder condemned the monstrous creature to perpetual motion. As the sea parted, ultrasensitive nerves and timeless muscles rippled beneath a leprous skin and instinctively remolded its hideous appearance. Its prehistoric brutality was being sucked unerringly to the source of an infuriating sound that was now close . . . very close. As the frequency increased, the pulsations became intolerable. Streamlining itself, the malignant shape shot upward. An ageless sensory system formed accurate images of its prey long before sight came into play. As the depths fell away beneath its accelerating bulk, exceptionally keen vision took over. In dawn's early light, Megalodon saw the slender object floating above. Destroy!!! Instinct demanded it.

It's difficult to understand what "timeless muscles" or "prehistoric brutality" are supposed to mean, but the instinct to "destroy!!!" is clear enough. This monstrous creature with the hideous, leprous skin will go berserk for a couple of hundred pages until heroic fishermen vanquish it. Ho hum. It's *Meg* all over again. To show that he deserves to be classified with Peter Benchley (and probably Steve Alten), Mr. Dade describes himself as "an exceptional writer, demonstrating the ability to place his readers in the marine environment, and have them see, feel, and experience much of what he has been through."

A somewhat better book was Mark Renz's 2002 *Megalodon: Hunting the Hunter*, but for some reason, Renz has decided to believe Alten's nonsense about the Mariana Trench, and writes that megalodon "has even been found as deep as the Mariana Trench." Renz's book (also self-published) is mostly about megalodon teeth, but it does contain a lot of foolishness about megalodon attacking dugongs in the Florida Miocene, seven million years ago:

Lost in group courtship, the love-struck dugongs were unaware that another large animal was also moving erratically across the bay without creating any underwater turbulence. As if anticipating the dugongs' projected path, the huger mass veered to one side of the unsuspecting herd. Within minutes, the enormous shape—a 60-foot pregnant megalodon shark—began to give birth.

There were never dugongs in Florida; but never mind—they look like manatees and are related to them, and manatees are still found in Florida waters. The best thing about Renz's book is the color photographs of megalodon teeth—it must have cost him a pretty penny to publish this book—and it turns out that "Hunting the Hunter" means searching for teeth, not hunting two-hundred-foot monsters that are killing fishermen, marine biologists, or women in bikinis. Renz does, however, include this self-serving encomium from Steve Alten: "When it came time to research my first two Megalodon thrillers, *Meg: A Novel of Deep Terror* and *The Trench*, I quickly realized that there was a lack of information about this prehistoric beast. . . . Forget T-rex and his dino-pals. If you want to read about the number one monster of all time, read this book." Renz also interviewed Alten, who took the opportunity to confront anyone (like me) who was dumb enough to believe that megalodon was extinct. "What I vehemently disagree with," said Alten, "is when so-called 'experts' state that an ocean dwelling species like meg is extinct simply because we haven't seen one. To me, this isn't science, it's guessing without research."

The complete absence of evidence for a living megalodon is more than conclusive to show that it is as extinct as T. rex. All megalodon teeth are fossils. We have abundant paleontological evidence for the existence of ichthyosaurs, plesiosaurs, mosasaurs, and numerous other prehistoric ocean-dwelling species, but, with the exception of the Loch Ness Monster—sometimes said to be a plesiosaur—nobody seriously argues that they still exist. Those who maintain that you can't disprove a negative—and of course, you can't; there is always the *possibility* that little green men will arrive from Alpha Centauri tomorrow—are using this misinterpretation to show that because anything is possible, why not two-hundred-foot-long bioluminescent man-eating sharks?

The 1976 discovery of the first megamouth shark (*Megachasma pelagios*) off the Hawaiian island of Oahu was one of the most remarkable zoological finds of the century, and fueled the fires of those who wanted to believe that "anything

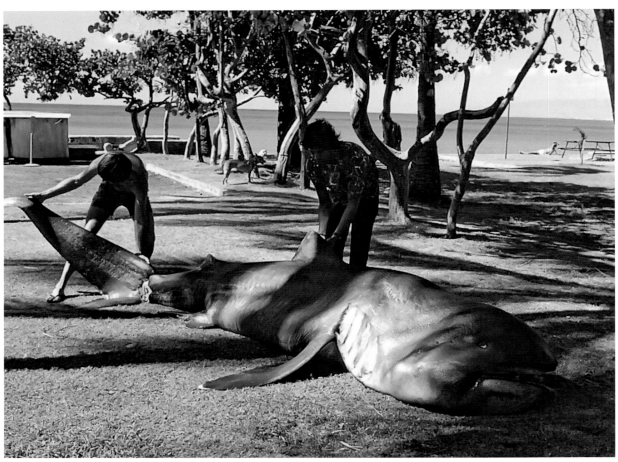

A species of shark that had never been seen before 1976, "megamouth" (*Megachasma pelagios*) was a plankton-eater, 14.5 feet long, that weighed 1,600 pounds. It was caught at a depth of five hundred feet off Oahu. *Courtesy of Leighton R. Taylor III*

is possible."* Completely unexpected because nothing like it had ever been seen before, this shark, tangled in the parachute sea-anchor of a US Navy research vessel, was 14.5 feet long, and weighed 1,653 pounds. A male, it had big rubbery lips lined with tiny teeth, and the examination of its stomach contents showed it to be a plankton feeder. It was originally classified in its own family, genus, and species, but it has now been shown to be related to the Lamnidae or mackerel sharks. Since the original specimen, more than forty more have been collected, usually dead, but in

* The megamouth shark and the coelacanth (*Latimeria chalumnae*) are usually considered the "poster children" of newly discovered or rediscovered species. The first coelacanth was recovered from a fishing trawler in South African waters in 1938; the second one was not found until 1952. After many more were found, usually in the vicinity of the Comoro Islands off Madagascar, a dead coelacanth was spotted in the Manado fishmarket on Sulawesi in Indonesia, and another specimen was hauled up there in July, 1998. Sulawesi is six thousand miles from East Africa, indicating that there is another, distinct population of coelacanths.

1990, a healthy specimen was caught in a gill net by a California fisherman, filmed, tagged, and released. Other specimens have come from Japan, Australia, Brazil, Taiwan, and the Philippines, indicating a worldwide—albeit limited—distribution. Although the discovery of megamouth shook the marine biological community to its very core—how could there be a fourteen-foot-long shark that nobody ever heard of?—its deepwater habitat and harmless toothlessness have kept it out of the sensational literature, and its primary claims to fame are its uniqueness and its strandings, which are harmful only to the sharks.

I first heard of megamouth when Peter Benchley called me on November 15, 1976, and said "They've found megalodon!" He said he'd heard it on Walter Cronkite, who was the CBS newscaster at that time, and I couldn't believe my ears. When I called CBS to verify Benchley's report, I learned that Cronkite had actually said "megamouth," the nickname that Leighton Taylor, the director of the Waikiki Aquarium, had bestowed upon the carcass that had been delivered to his front lawn. I had just published *The Book of Sharks*, and although I had written "for every known species, there is a new one waiting to be discovered," I just didn't expect it to happen so quickly.

An unintentionally hilarious film shot in Bulgaria about a giant shark that terrorizes a Mexican resort. This is the film in which the shark swallows an entire life raft, passengers and all.

If the novels that followed in the wake of *Jaws* were pitiful imitations, the movies were often wildly overblown extravaganzas, with sixty-, seventy-, hundred-, and two-hundred-foot-long sharks terrorizing beaches, killing everybody in sight, sinking ships, and, in one memorable computer-generated image, swallowing an entire life raft with a dozen people aboard. One of the essential ingredients of these movies—lacking in *Jaws*—is an abundance of bikini-clad actresses, some of whom are even cast as "marine biologists." Thus we have *Shark Attack*, *Shark Attack II*, and *Shark Attack III* (the one with the life-raft sequence), each one bloodier, noisier, and more ridiculous than its predecessor. None of these movies could afford to make a model such as the ones used in *Jaws*, so they simply intercut live footage of sharks (sometimes having tiger sharks turn into whites and then back again),

assuming that all that fake blood in the water would mask such transgressions, and besides, a shark is a shark, isn't it? Cut from a fifteen-foot shark swimming in Australian waters to a computer-generated two-hundred-footer grabbing a helicopter in Mexico and hope that nobody notices the difference.

There are now dozens of shark movies, and with the exception of documentaries, almost every one of them involves sharks attacking people. Attempts to convince the producers of Shark Week on the Discovery Channel (which first aired in 1987) to show other aspects of shark behavior or biology have failed, and most of the programs still center around our fear of sharks, and of course, continuations of the *Jaws* phenomenon, featuring great whites swimming, great whites attacking seals, and endlessly repeated tales of great whites attacking people. A quick search of the Shark Week website shows the following "most popular" links: "Top 10 Shark Attack Videos," "Top 35 Great White Shark Photos," "Shark Attack Survival Guide," and "Top 10 Shark-Jumping Videos." People want to see shark attacks, no matter how many species of sharks there are that have never attacked anybody, or how endangered sharks are today. Will we ever overcome the persistent image of the shark as a man-eater? Probably not.

In the 1999 movie *Deep Blue Sea*, scientists have been hard at work in a floating laboratory off Baja California, growing giant makos (a departure from the *Jaws*-dependent great whites, but makos, are, if possible, more frightening-looking), so they can mine their brains for a substance that will combat Alzheimer's disease in people. As with any giant-sharks-floating-laboratory movie, things quickly begin to go wrong, and the (animatronic) sharks begin escaping from their pens, killing people, and generally wreaking underwater havoc. In the obligatory storm that wrecks the lab even further, those who survived the first round of attacks have to contend with collapsing structures filled with sharks whose enhanced brain power enables them to outthink the soggy, beleaguered scientists, one of whom—Hello!—has to strip down to her underwear. As in all shark movies, people triumph in the end—even though a lot of them have to be chomped—proving once again that human brawn and brains can outperform the shark's. (Because sharks are so essential to these movies, perhaps we owe it to them to make at least one picture where the sharks win and eat everybody.)

There will always be a market for horror movies, but shark horror movies are different because they have ingeniously tapped into a vein of reality. Most of us don't believe in zombies, vampires, werewolves, giant gorillas, or re-created carnivorous dinosaurs, but there is no denying the existence of sharks, some of which

have even been known to attack people and eat them. It is this harsh reality that boosted *Jaws* to the top of the charts, and provided the sequels, no matter how bad or ridiculous, with an almost inexhaustible capacity to attract and frighten people. Most species of sharks are small and harmless, such as the foot-long cigar shark, which lives only in the depths of the ocean, and couldn't frighten anything larger than a lanternfish. Still, the word "shark," especially if shouted by a lifeguard, provokes our most primal fear—that of being eaten alive. The sharks, ancient or modern, real or imaginary, have always been with us, and will probably remain with us forever. They appear not only in movies and literature, but in countless permutations of size, shape, and materials, permeating our daily lives with their silent menace. In a sense, humans live in a world replete with sharks, not vice-versa.

What Good Are Sharks?

Around 1496, Wynkyn de Worde, one of the first printers in England, printed the *Treatyse of Fysshynge with an Angle*, which was based on even earlier treatises on "fysshynge." Izaak Walton published *The Compleat Angler* in 1653, inspiring a vast number of his fellow Englishmen to take up fishing. But no matter how much they enjoyed the sport, they still ate the fish they caught. Since Walton's day, however, the art and science of fishing often took precedence over the number and size of the catch that the fisherman brought home to feed his family. Thus did salmon- and trout-fishing—particularly in England—develop into pastimes suitable for gentlemen, along the lines of fox-hunting or bird-shooting. The conquest of a fox or a pheasant might require a certain degree of skill, but for the most part, all that was needed were a few dogs, a proper kit, and privacy enough to practice these aristocratic pursuits.

Another field usually restricted to the aristocracy or to those officers posted to exotic locales was big-game hunting. Much of this sort of thing was dedicated to the acquisition of a large set of horns or antlers to display over the mantelpiece, but hunters with powerful weapons also took aim at tigers and leopards in India; lions, leopards, rhinos, and buffalos in Africa; and almost everything larger than a woodchuck in North America: bison, bighorn sheep, moose, elk, every kind of deer, and of course, the predators, such as bears, wolves, and mountain lions. If there was ever any sort of justification offered for the slaughter of these animals, it was a sort of hunters' "manifest destiny," where the privileged classes were entitled to shoot

everything with legs or wings, and if the targets happened to be predators, the hunters were making the world safer for farmers and their livestock. If and when the predators preyed upon people—think of "man-eating" lions and tigers—well, it was clearly the duty of the hunters to rid the world of these malicious carnivores. Big-game fishing was the aquatic analog to big-game hunting.

Obviously, "big-game fishes" had to be big—many of them could exceed a thousand pounds—but they also had to be "game," that is, prepared to put up a valiant fight to avoid being captured. This conspicuous reluctance to be reeled in often took the form of spectacular, repeated leaps out of the water, an exaggerated, large-scale version of the fight a hooked salmon might put up. The pursuit of large fishes on an adversarial basis began in the early decades of the twentieth century, where the goal was the conquest of an opponent worthy of an intrepid and well-outfitted fisherman. (The idea of fishing for food was eschewed; some of these "big-game fishes" were far too large to be eaten by anything but a small village.) The big-game fishes include the larger tunas—bluefin and yellowfin—and all the billfishes: the marlins, sailfish, spearfish, swordfish, and some of the larger sharks, including the mako (probably the most acrobatic of all game fishes), the tiger shark (record 1,780 pounds), and the great white, which can weigh as much as a buffalo.

If you're going to go fishing, there have to be fish, and if you're going to go shark fishing, there must be sharks. Big-game fishing may or may not be a noble pursuit, especially when it involves pitting (presumably) high-IQ humans, armed with sophisticated fish-finding and fish-catching equipment, against a fish whose intelligence has never been considered particularly impressive. But if catching a thousand-pound marlin is a significant accomplishment, then reeling in a shark that weighs more than a ton must be even more noteworthy. While makos are the fighting acrobats of shark fishing, great whites rarely jump when hooked, but stubbornly linger below the surface, their great weight serving to counter the angler's test of strength. Even in pre-*Jaws* days, fishermen in Australia and South Africa specialized in great white shark fishing, a derby that was won in 1959 by Alf Dean, who caught a great white shark off Ceduna, South Australia, that weighed 2,664 pounds, the largest fish ever taken on rod and reel. (The record still stands.)

In the early 1960s, Frank Mundus, a charter fisherman working out of Montauk, Long Island, recognized that some of his clients got more of a kick out of shark fishing than just trolling for bluefish. In addition to the relatively common blue sharks, there were great whites in the waters of eastern Long Island, and by 1965, Mundus had caught a monster that was said to weigh more than four thousand pounds. Its

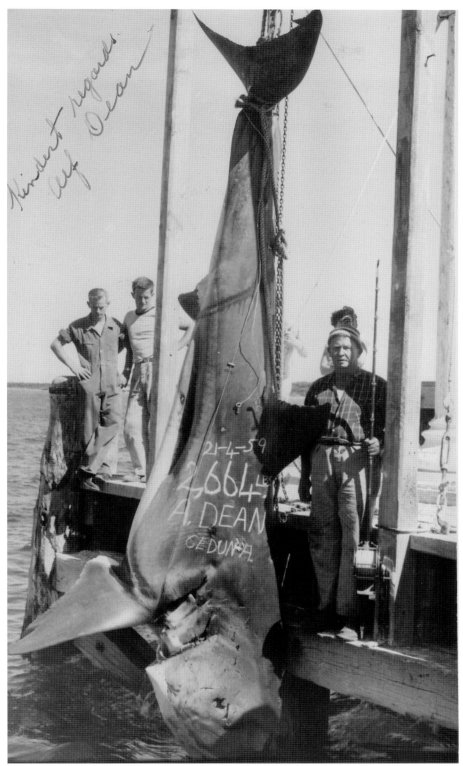

The largest fish ever taken on rod-and-reel: a 2,664-pound white shark caught in 1959 by Alf Dean off Ceduna, South Australia. *Courtesy of International Game Fish Association*

taxidemied head resided in Salivar's, a popular watering-hole in Montauk, where an aspiring novelist named Peter Benchley saw it, and wondered what would happen if a shark like that ever came close to shore. Benchley had been shark fishing with Captain Mundus, and there are those who believed that he based the fanatical Captain Quint on Mundus. (I know Frank Mundus believed it because he told me so.) He was upset that he received no acknowledgment for the use of his character in *Jaws*, but Benchley maintained that Quint was pure fiction. (In an early draft of *Jaws*, however, the Captain was named "Moon.") As Benchley describes him in the novel, Quint doesn't look anything like Mundus—or like Robert Shaw, for that matter: "He was about six feet four and very lean—perhaps 180 or 190 pounds. His head was totally bald—not shaven, for there were no telltale black specks on his scalp, but as bald as if he had never had any hair. . . . His face, like the rest of him, was hard and sharp. When he looked down from the flying bridge, he seemed to aim his eyes—the darkest eyes Brody had ever seen—along his nose as if it were a rifle barrel."

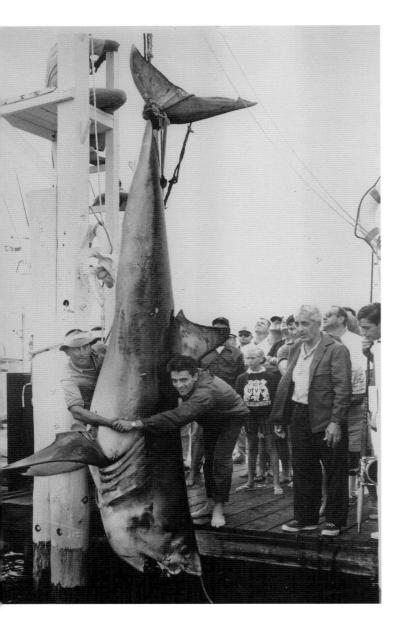

Frank Mundus was actually a round-faced man with thinning hair, a hoop earring in one ear, a sharktooth necklace around his neck, and one red and one green sock to remind him of which was port and which was starboard. He was more of a chubby, oddball clown than a lean and rifle-nosed shark hunter. For twenty years, Mundus led his clients

Captain Frank Mundus (in hat) and one of his "idiots" can barely get their arms around a great white caught off Montauk, Long Island.
Courtesy of Frank Mundus

—whom he referred to as "my idiots"—in pursuit of sharks. He oversaw the capture of every shark species that swims in Long Island and adjacent waters, including makos, porbeagles, blues, sandbars, duskies, hammerheads, and threshers. Before the passage of the Marine Mammal Protection Act in 1972, he harpooned pilot whales to use as sharkbait. His customers hunted sharks with heavy tackle, light tackle, bows and arrows, and harpoons. In 1991 the US Coast Guard said that his captain's license had expired and he had to reapply, but instead he sold his boat *Cricket II,* and moved to Hawaii, where he continued charter shark fishing. He officially retired as a charter captain in 1997. In the years before his death he would return to Montauk for its shark tournaments and would ride along on high-priced *Cricket II* excursions. He died in Hawaii on September 10, 2008, shortly after returning from Montauk.*

Fishing for sharks used to consist of dropping a baited hook over the side and hoping a shark took the bait. Because sharks were dangerous and often quite large, they became a target for certain big-game fishermen, who sought out whites, tigers, and makos for the record books and for personal gratification. In those areas where white sharks were relatively common—South Australia, South Africa, and central California—a rod-and-reel fishery for the man-eaters developed. Earlier, most sport fishermen thought of sharks as "trash fish" that would take the baits otherwise intended for *real* game fish, such as marlins, tuna, and swordfish, but the International Game Fish Association (IGFA) now recognizes several species of sharks as game fishes, and posts records of the following species: blacktip, blue, bonnethead, hammerhead, mako, porbeagle, thresher, tiger, tope, whaler, and white.

Although "sportsmen" still fish for sharks, the thrill of meeting the man-eaters one-on-one from the deck of a boat has largely been replaced by diving with them.

* For a 1975 episode of ABC-TV's *American Sportsman,* I was invited to join Benchley on a shark-fishing trip out of Montauk with Mundus. With a full TV crew (producer Pat Smith, two cameramen, and a sound man) we boarded the *Cricket II* and set out. Benchley, a full-fledged literary lion by this time, was to have the first rod, so he strapped himself into the fighting chair and let the line play out. It was only a matter of minutes before he felt a strike, and he began the back-breaking process of reeling in a very heavy and very reluctant fish. Mundus was supposed to be guiding Benchley through the process, but nobody knew what was on the end of the line. Mundus talked as if it was a shark, and probably the kind that Benchley had recently made so famous: "Okay, now take it slow. . . . Reel it in as you lean forward, then put your back into it. . . . Sharks have skin like sandpaper, so if he gets tangled in the line, he'll snip it like a thread. . . . sharks are dangerous even when they're hooked. . . . Easy . . . easy. . . ." While the cameramen filmed the fisherman on the afterdeck, Pat Smith had climbed up onto the flying bridge so he could see the whole scene that was playing out below. That vantage point put him in a position to see the fish before anyone else did, and when it was close to the surface, he saw that it was iridescent purple in a way that no shark was supposed to be—and had something very long sticking out of the front end. Mundus was still lecturing Benchley on the dangerous shark he was bringing up, but as the fish broke the surface Pat shouted, "That son of a bitch is a swordfish!"

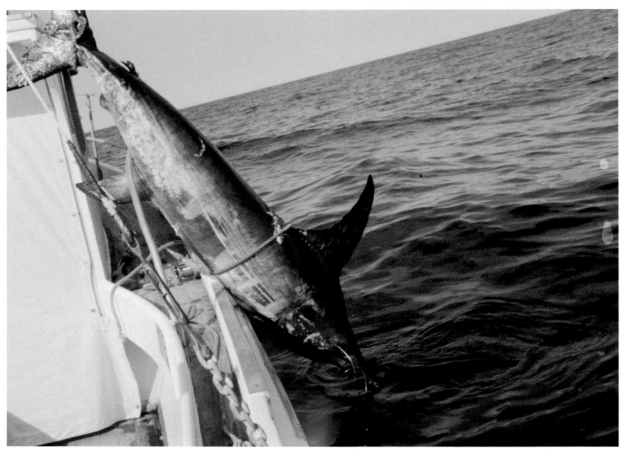

Shark-fishing aboard Frank Mundus's *Cricket II,* Peter Benchley caught this 250-pound swordfish. *Photo by Richard Ellis*

Shark fishing, however, has taken a decidedly more dangerous turn—dangerous for the sharks, that is. From a simple test of man vs. shark, fishing has now become a multimillion-dollar industry, where the sharks always lose, to the point where many shark species are endangered. The consequences of removing apex predator sharks from a marine ecosystem can be disastrous for the ecosystem. In studies reported by Stevens, Bonfil, et al. in 2000, heavy fishing on sharks in three different ecosystems (one of which was French Frigate Shoals), resulted in an increase in the sharks' prey species, such as sea birds and monk seals, and because the birds and seals increased, *their* prey species—larval tuna and jacks—decreased. Removing sharks results in a corresponding decrease in tuna and jacks, and upsets the previously balanced system. Heavy shark fishing, therefore, not only results in the depletion of total shark numbers, but it also creates a long-term, perhaps irrevocable, imbalance in the ecosystem.

It was always assumed—at least by fishermen—that as a particular fish species grew scarce, they would simply find another place to fish. Or if a particular species declined, they would find another species. There are, after all, a lot of fish in the sea. But this rosy attitude has proven to be disastrously flawed. If you take most of the fish of a given species out of the ocean, there may not be enough left to regenerate the species. Long gone are the days when cod fishermen on the Grand Banks—once the world's richest neighborhood for *Gadus morhua*—could lower a basket on a rope and bring it up filled with wriggling cod. The cod fisheries of New England and maritime Canada can no longer sustain any level of commercial fishing, and the fisheries have been shut down. In May 2003 Ransom Myers and Boris Worm published a study in *Nature* in which they came to the startling conclusion that "the large predatory fish biomass today is only about 10% of pre-industrial levels"; that is, 90 percent of the world's predatory fish species (cod, tuna, billfishes, swordfish, flatfishes, sharks, skates, and rays), have been fished out, and commercial fishers are now working on the remaining 10 percent.

Because the top predators are usually sought first, "it stands to reason that prey populations and their effects on marine communities will increase after release from predator control. Accordingly, fishing alters the organization and structure of entire marine communities via 'cascading' trophic chain reactions" (Steneck 1998). Because the top predators are the least numerous, as one moves down a food web, biomass increases, but nowadays fish catches have stagnated as fishers have moved from top predators to species at lower trophic levels. Once a top predator has been depleted or exterminated by fishing, alternative predators of no commercial value thrive in the absence of competition and thus deplete the biomass of prey species at lower trophic levels. In 2005 Pauly and Maria-Lourdes Palomares suggested that fishing down the food web was "far more pervasive than previously thought, and in fact occurs in areas where initial analyses failed to detect it. This confirms the common verdict of absent sustainability for most fisheries of the world."

Analyzing the data from Japanese longliners over the past fifty years and combining that with US and Australian scientific observer data for the same period, Boris Worm and Ransom Myers of Dalhousie University, along with Marcel Sandow, Andreas Oschlies, and Heike Lotze of Germany's Leibniz Institute for Marine Science, found that the variety of species has dropped by as much as 50 percent in the past half century. To no one's surprise, overfishing was found to be the major cause of the decline, but temperature anomalies such as El Niño also contributed, as did habitat destruction and climate change. Their data, published

in *Science* in July 2005, showed that pelagic longliners were catching half the number of fish—and half the number of species—that they were able to catch in the 1950s. The reduction in species diversity—primarily the removal of the large predators such as sharks, tuna, swordfish, and cod—leaves an ocean ecosystem vulnerable to environmental changes like global warming.

Among the most eloquent and persistent spokespersons for the sharks is Sylvia Earle. A renowned undersea explorer, Sylvia Alice Earle was born in 1936 in New Jersey, did her undergraduate work at Florida State, and received her PhD from Duke. Trained as an algologist, she studies marine plants, and is currently a research associate in botany at the Smithsonian. She was curator of phycology (seaweeds) at the California Academy of Sciences from 1979 to 1986, a research associate at the University of California, Berkeley, from 1969 to 1981, a Radcliffe Institute Scholar from 1967 to 1969, and a research fellow at Harvard University from 1967 to 1981. (That she held many of these posts concurrently is a testimony to her level of dedication and her indomitable work ethic.) In 1998 Earle was named *Time* magazine's first "hero for the planet." She has amassed more than six thousand hours underwater, and holds the record for an untethered dive at 1,300 feet. Sylvia Earle is a scientist who writes beautifully and passionately. In her 1995 book *Sea Change*, she discusses the exponential increase in shark fishing in response to a National Marine Fisheries Service directory that because other fish species were being overfished, sharks were "underutilized":

Famed underwater explorer Sylvia Earle is our most dedicated and eloquent marine conservationist.
Courtesy of Sylvia Earle

> *The dangerous decline of "overutilized" kinds was not perceived as fair warning that the same pattern could—and would—follow with the new targets, but that is exactly what happened. . . . There are other, more recent, explanations for the increase in shark killing. One is the growing popularity of shark-fin soup, especially in Asia, a demand fueled by economics strong enough to pay top prices for fins imported from all over the world. The high value of fins relative to the rest of the shark led to the grotesque practice of "finning"—slicing off fins and tail and then dumping the still-living body overboard. There is also a belief*

that consuming the cartilage that forms the basis of a shark's skeletal structure will deter certain kinds of cancer. Since 1992, hundreds of thousands of sharks have been taken from ecosystems in Central and South America, even from the presumably protected waters of the Galápagos, especially to supply the demand for dried, powdered cartilage.

Despite the total absence of evidence, someone, somewhere, was going to cash in on the possibility that shark cartilage could prevent cancer in humans, since sharks were believed to be immune from the disease. First came a New Jersey company called Cartilage Consultants, Inc. which obtained a patent for pills made of powdered shark cartilage. The *Journal of the National Cancer Institute* announced that "there is no proof that it is effective when taken this way," and Carl Luer, in an article written for the Mote Marine Laboratory, said, "The statements made by cartilage pill promoters that it is cartilage that gives sharks their immunity to cancer, then, are inaccurate and irresponsible." In February 1993, the CBS program *60 Minutes* aired a story on shark cartilage as a treatment for cancer in humans, bringing forth an outraged response from the people who were actually doing the research. Carl Luer wrote (in the March 1993 issue of the *American Elasmobranch Society Newsletter*), "We cannot support the marketing of shark cartilage for this application, especially since the promoters of the product intend to rely on the natural resource as an endless supply of material." If it were true that shark cartilage could somehow prevent cancer in humans, perhaps the take of sharks might be justified, but since no such evidence exists, they should not be caught and ground up for their components.

In 2000, a new chapter opened in the shark cartilage story. A study published then concluded that not only do sharks actually get cancer, they even get *cartilage* cancer. Gary Ostrander and John Harshberger found at least forty cases of cancer in sharks and other cartilaginous fishes after surveying scientific papers and tumor samples from the National Cancer Institute's Registry of Tumors in Lower Animals. In an article in *Science* (April 14, 2000), Ostrander is quoted as saying that he hopes the study will help explode the "huge myth" that sharks are immune to cancer—a misapprehension shared even by "people in my own field." It's hard to believe that susceptibility to cancer can save your life, but that's what happened to the sharks. Chalk up one for the elasmobranchs.

Because the skin of sharks is composed of tiny, toothlike processes known as "dermal denticles," the skin has a rough, abrasive texture. Also known as placoid

scales, dermal denticles are embedded in the skin of elasmobranchs, and are characteristic of all sharks and rays. They are actually modified teeth, since each one has an outer layer of enamel, and a central pulp canal containing nerve cells and blood vessels. In most species, the denticles are aligned in one direction, pointing tailward, but in the basking shark, they are randomly arranged, making the skin rough to the touch in every direction. The very large, randomly distributed denticles in the bramble shark (*Echinorhinus brucus*) are responsible for its common name.

In the seventeenth and early eighteenth centuries, the term *shagreen* was applied to leather made from sharkskin or the skin of the stingray *Hypolophus sephen*. Also known as sharkskin or *galuchat*, the skins are studded with round, closely set, calcified papillae, the size of which is dependent on the age and size of the animal. When used as a covering for boxes, mirror frames and even chairs, the scales are ground down to produce a surface of rounded pale protrusions, often dyed green. Shagreen was first popularized in Europe by Jean-Claude Galluchat (d. 1774), a master leatherworker in the court of Louis XIV of France. It quickly became fashionable among the French aristocracy, and could be found throughout Europe by the mid-eighteenth century. The word is believed to have come from the Persian *saghari*, which referred to horsehide into which seeds were imbedded, and when the skin dried and the seeds fell out, the hide had a granular texture, which was popular as a handmade wall-covering. The French word *chagrin* also refers to "rough skin," and became a metaphor for vexation, disappointment, or humiliation.

Shagreen was sometimes used in place of sandpaper in the finishing of wood. The nature of the leather also made it useful for those items where a good grip was required, such as oars, where water might make them slippery, or sword handles, where blood might do the same. Sharkskin hilt wrappings (*samekawa*) were particularly popular with Japanese samurai swordsmen, but were also used by European soldiers in the eighteenth and nineteenth centuries. Until a process was developed for the removal of the denticles, sharkskin was commercially useless, but once they are removed, it can be marketed as a durable and attractive leather. Sharkskin is almost impervious to scuffs. The denticles can be removed by grinding them down, or by chemical means, where the entire denticle is extracted from the skin. Thus treated, sharkskin makes excellent leather, and marketed by a New Jersey company called Ocean Leather, it became popular for shoes, boots, small accessories (wallets and belts), and bookbinding.

But there are other ways in which sharks—or parts of sharks—can actually be useful to mankind. Divers and scientists have recently observed that there is

something about the skin of sharks that repels the growth of barnacles or bacteria. (Whales, particularly right whales and humpbacks, are notorious for the colonies of host-specific barnacles and whale lice that populate their skin.) Anthony Brennan, PhD, a research scientist and endowed professor in materials science and biomedical engineering at the University of Florida, has been studying shark skin to try to ascertain why nothing will grow on it. He has developed "Sharklet," a plastic sheeting material incorporating the microscopic diamond pattern of sharks' denticles, to which nothing adheres—even when it is affixed to the hulls of ships, where marine growths are a major hindrance. "Sharklet" is now being tried out in hospitals, where secondary infections from bacterial growth—think of bedside tables, door panels, and patients' wristbands—are an enormous problem.

There are those who would argue that we need monsters, and big sharks fill that bill nicely. Even before Peter Benchley chose to glorify it, the great white shark was already firmly ensconced in the pantheon of sea monsters. It is the largest predatory fish in the world; the longest accurately measured specimen is twenty-one feet long. This monster was captured in Cuba in 1948 and weighed 7,300 pounds. A twenty-two-footer was captured off Kangaroo Island, South Australia, in 1987, and in the Mediterranean off Malta in 1988, a fisherman named Alberto Cutajar hauled in a twenty-three-footer. A shark this size weighs as much as a full-grown rhinoceros. *Carcharodon carcharias* is the quintessential shark, equipped with all of the components that characterize the most feared fish in the sea: razor-sharp teeth, exquisitely honed senses, a blood lust that is unequaled by any vertebrate in the sea (and perhaps on land as well), a healthy appetite for warm-blooded prey, a black eye that stands for the unplumbed depths of evil, and the cliché of all shark clichés, a triangular dorsal fin knifing through the water. E. O. Wilson, better-known for his sociobiological and entomological work than for his involvement with sharks, loves the great white. He wrote:

> *The ultimate product of all this evolution, in my admittedly humble opinion, is the great white shark,* Carcharodon carcharias. *It has rightfully been called a total carnivore, a killing machine, the last free predator of man—the most frightening animal on earth. We're not just afraid of predators, we're transfixed by them, prone to weave stories and fables and chatter endlessly about them, because fascination creates preparedness, and preparedness, survival. In a deeply tribal sense, we love our monsters.*

If you really need to answer the age-old ecological and epistemological question, "Why do we need sharks?," the answer might be found by identifying those people who, in one way or another, earn a living from an association with the cartilaginous fishes. In my *Book of Sharks*, first published in 1975, I devoted an entire section to "The Shark People," which I defined as "individuals who have spent a significant portion of their lives involved with sharks." Many of the people discussed in that book already had most of their careers behind them when I wrote about them, and indeed, some of them, like Zane Grey, were long gone even before I began to write the book. Although I'm sure it has nothing to do with the subject matter of that book (or this one), most of the original cast of The Shark People are gone—not one of them a victim of a shark attack: Shelly Applegate, David Baldridge, Peter Benchley, David Davies, Beulah Davis, J.A.F. Garrick, Perry Gilbert, Peter Gimbel, Scott Johnson, Gavin Maxwell, Louis Moresi, Frank Mundus, Art Myrberg, Don Nelson, Stewart Springer, and Bill Young. Still hanging in are Jack Casey, Genie Clark, David Doubilet, Jack Randall, Rodney Fox (who *was* notoriously attacked by a shark), Ron and Valerie Taylor, and Stan Waterman. I missed a lot of people in my first catalog, like Sonny Gruber and John McCosker, whom I added in later editions, but the ranks have now been filled by a cadre of new Shark People, some of whom were not even born when I compiled the original list.

There are many ichthyologists who specialize in the study of sharks (or have done so in the past); and paleontologists whose particular area of interest is fossil sharks, rays, and chimeras. Starting with the irrepressible Peter Gimbel, cinematographers have filmed sharks from submerged cages, but now a new breed of underwater photographer dispenses with cages and protective devices altogether, and shoots the sharks without bars to get in the shot or protect the divers. Peter Benchley based a monstrously successful career on sharks, and it might even be said that he based a career (and what became an industry) on a single shark. In the wake of *Jaws*, any number of talentless hacks tried to capitalize on Benchley's formula, and the "literature" that followed spawned a swarm of lousy movies, none of which came close to replicating the genius of Steven Spielberg. There are now dive-tour operators who specialize in shark diving (Rodney Fox was the originator), and photographers whose primary subject matter is sharks. They are aided and abetted by the existence of the uniquely specialized magazine *Shark Diver*. There are now artists who pay homage to sharks by sculpting them in every medium, from stainless steel (particularly appropriate, I think), to wood, bronze, hard rubber, and fiberglass. From the early, lonely position of world's only shark painter, I've been

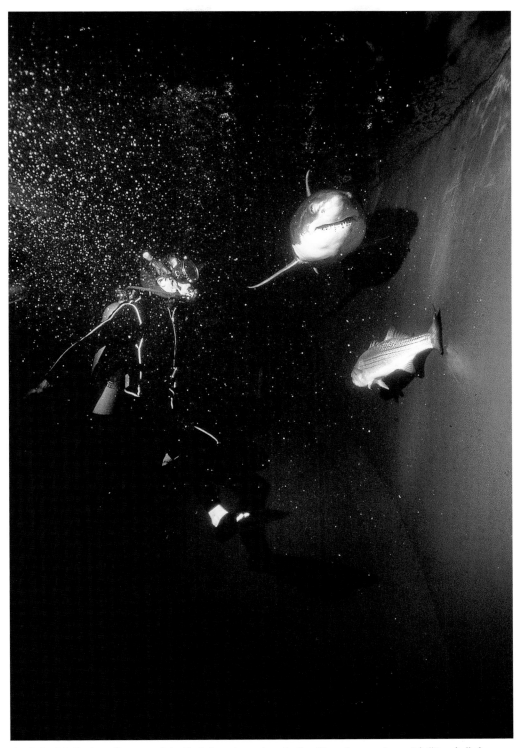

Dr. John McCosker, director of the Steinhart Aquarium in San Francisco, swims with "Sandy," the juvenile white shark that was exhibited for three days in 1980 and then successfully returned to the Pacific. *Photo by Al Giddings*

joined by a host of newcomers whose work I can only envy. As one of the artists and writers, I needed the sharks as subject matter; without them, I would have gone in a completely different direction, and you wouldn't be reading this book.

Many people—especially devotees of *Jaws*—believe that sharks are a menace, and that the world would be a better (and safer) place if sharks could be eliminated, rather like our attitude towards cockroaches, rats, and mosquitoes. Aside from the arrogance that these people demonstrate towards other creatures—as if we had the *right* to eliminate species just because they annoy us—sharks pay an important role in the oceans' ecosystems. Many shark species cruise at the top of the food chain (as do we, thank you), and apex predators are as important to the system as the lowliest plankton, krill, or copepod. In Chesapeake Bay, the decreased shark populations have resulted in increases in typical prey species, such as rays, with a subsequent decrease in the populations of commercially important shellfish and invertebrates that the rays feed on. In coral reef systems, losses of large sharks have resulted in increased numbers of smaller sharks (large shark prey) which then placed increased pressure on herbivorous reef fishes. Around the world, shark populations are being drastically depleted by longline fishing, mostly to feed the insatiable Asian maw for shark's fin soup.

On the individuality of living things, you must listen to Henry Beston. In *The Outermost House* (1928) he tells us that,

> *We need another and a wiser and perhaps a more mystical concept of animals. Removed from universal nature, and living by complicated artifice, man in civilization surveys the creature through the glass of his knowledge and sees thereby a feather magnified and the whole image in distortion. We patronize them for their incompleteness, for their tragic fate of having taken form so far below ourselves. And therein we err, we greatly err. For the animal shall not be measured by man. In a world older and more complete than ours, they move more finished and complete, gifted with extensions of senses we have lost or never attained, living by voices we shall never hear. They are not brethren, they are not underlings; they are other nations, caught with ourselves in the net of life and time, fellow prisoners of the splendour and travail of the Earth.*

In other words, we're all in this together: parrots, houseflies, killer whales, spiders, hippos, cassowaries, corals, crabs, dugongs, dingos, flamingos, anacondas, ants, bees, beagles, beetles, beavers, leopards, iguanas, ducks, platypuses, albatrosses,

crows, alpacas, centipedes, tanagers, tunas, toucans, tigers, horses, mackerel, mongooses, magpies, moray eels, butterflies, butterfly fishes, polar bears, antelopes, pit vipers, pelicans, gorillas, macaws, octopuses, penguins, porcupines, shearwaters, kangaroos, koalas, oysters, worms, wolves, woodchucks, buffalos, mice, ferrets, scallops, bobcats, turtles, turkeys, hamsters, hummingbirds, rattlesnakes, cowries, baboons, raccoons, dolphins, giraffes, sea cucumbers, squid, starlings, cobras, elephants, elephant seals, sparrows, foxes, pigeons, hornets, whales, sharks, and millions of other living things. No creature is more "important" than any other, despite our disastrously anthropocentric view of the world.

Embedded in our culture and consciousness is the idea that humans are the crown of creation, put here to rule over the earth and its inhabitants. Early in *Genesis*, God tells Noah that "The fear of you and the dread of you shall be upon every beast of the earth, and upon every fowl of the air, and upon all that moveth on the earth, and upon all the fishes of the sea; into your hands they are delivered." For centuries, humans have manhandled the earth and its other inhabitants as if this exhortation was a law to be followed, but time and tide eventually began to reveal the cracks in this anthropocentric foundation. There are many religious doctrines that still hold that everything on Earth was put here for our advantage, but there are also people who believe the earth is flat, or that it was formed six thousand years ago.

When Charles Darwin theorized that humans occupied no biologically privileged position, our unchallenged place at the top of the ladder was no longer quite so secure. Still, it is more than a little difficult to view the world from anything but your own viewpoint. "To be anthropocentric," wrote W. H. Murdy in 1975, "is to affirm that mankind is to be valued more highly than other things in nature—by man. By the same logic, spiders are to be valued more highly than other things in nature—by spiders." Ours is the only species that can actually alter the face of the planet, and while such a realization might conceivably engender humility, it has instead given us a renewed sense that because we can, we ought to. Think of cities, dams, highways, bridges, strip mines, pit mines, garbage dumps, irrigation canals and ditches, clear-cut forests, smog, acid rain, radioactive waste, pollutant aerosols, napalm, and nuclear bomb tests—and the idea that we are somehow "authorized" to hunt down (and sometimes eat) every kind of wild creature on land or sea, solely for the gratification associated with hunting or fishing.

Perhaps because of their reputation, sharks have always been the prime attractions in public aquariums, or, as some are now known, oceanariums. When Marine

Studios, America's first oceanarium, opened in Florida in 1937, it included what Craig Phillips, the first curator, described as a "gigantic circular shark channel . . . ring-shaped and 750 feet in outer diameter that would house sharks and other swift sea creatures." In "Marineland, Florida's Giant Fish Bowl," a chapter in the 1952 *National Geographic Book of Fishes*, John Oliver La Gorce* wrote, "Sharks still carry the primitive cartilaginous skeletons used by fishes before Nature apparently perfected hard bones. As relics of a distant age, however, they remain terribly efficient. Few fish or men care to face them. Restless tiger sharks are always on the move. Razor-sharp teeth of some species move into line as they are needed. One snap of this monster's jaws could crush a sea turtle's shell." Nowadays, every oceanarium worth its salt (water) proudly exhibits sharks of one kind or another, most frequently sand tigers, which although fairly harmless, look like the very essence of sharky malice, with their pale-eyed, snaggle-toothed visage. Of course, the most sensational exhibit in any oceanarium would be the movie-star man-eater, the great white. Even before *Jaws*, the attractive power of the white shark challenged aquarium husbandry experts and tantalized aquarium directors. The rarity of the species, as well as the difficulties of capture and transport, have denied most aquariums the opportunity to display a healthy specimen.

Leighton Taylor, a shark scientist and past director of the Waikiki Aquarium in Honolulu, suggested in a 1985 article that the first opportunity for the public to view a captive white shark might not have come from the temperate American coast at all, but from Hawaii. In March 1961 a thirteen-foot specimen was captured in Honolulu Harbor, and was displayed at Hawaii Marineland for twenty-four hours before it died. Frank Inoue, a local, remembers that an employee of the oceanarium rode the nearly dead shark around the aquarium tank for several hours. In December 1962 an eight-foot male was captured off St. Augustine and brought to Marineland of Florida. According to the press release issued at that time, the "new record for a man-eater in captivity" was 35 or 36 hours, which record "exceeded the old one by almost 35 or 36 hours." After showing some signs of recuperating from its capture, the shark sank to the bottom of the tank and died.

* In the book, the author of this chapter is listed as "Gilbert Grosvenor La Gorce," a strange nomenclatural admixture of two different people. Gilbert Grosvenor (1875–1966) was the editor of *National Geographic* from 1899 to 1954, and president of the National Geographic Society from 1920 to 1954. He was succeeded in his former positions by his old friend and longtime assistant editor, John Oliver La Gorce, who served as editor for three years, then retired and became vice-chairman of the society. There is no such person as Gilbert Grosvenor La Gorce.

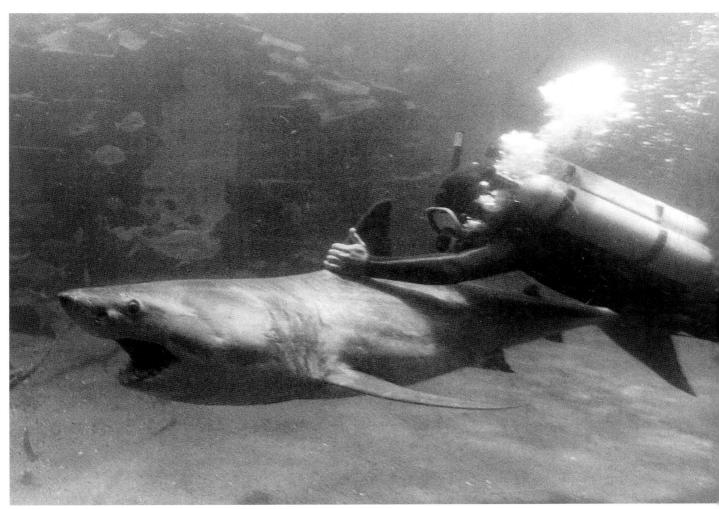

In 1978, a young white shark was trapped in the nets off Umhlanga Rocks (Natal, South Africa), and brought to the Durban Aquarium, where it survived for just one day. *Courtesy of the Natal Sharks Board*

When a six-foot white pointer was hooked off the north Sydney beach known as Warriewood and brought to the Marine Aquarium, it swam around for five days, attacking other fishes and a handler until the manager of the aquarium ordered the "berserk" animal destroyed. According to the headline in the *Australian Post* for May 23, 1968, "The White Pointer Was Mad. . . . It Had to Die Before It Emptied the Aquarium." In 1969 a young white shark was rushed to the aquarium in Durban, South Africa, but it died almost immediately. In October 1978, a seven-footer was captured in the nets off Umhlanga Rocks, a popular beach on South Africa's Natal Coast. (This is one of the Indian Ocean beaches where since the 1960s the Natal Sharks Board has set nets to keep the sharks—mostly bull

sharks and duskies—from bothering or attacking the bathers.) The Umhlanga Rocks shark was in poor condition, having been immobilized and suffocating for several hours before the nets were hauled in, and it died the following day.

While there are some species of large sharks, such as nurses, lemons, and sand tigers that have been successfully maintained in aquariums, all attempts to keep makos or porbeagles (smaller relatives of the great whites) have met with unqualified failure. Occasional specimens were caught and brought to aquariums, but they died. In the summer of 1980, a competition took place between various California aquariums to be the first to *successfully* exhibit a great white shark, which meant more than holding it for a couple of days until it expired. Sea World in San Diego and the Steinhart Aquarium in San Francisco led the chase. On August 12, the Steinhart team drove a specially designed truck to Bodega Bay to pick up a 7.5-foot female white shark that had been trapped in a net, and transported it back to San Francisco. Nicknamed "Sandy," the shark appeared healthy and swam slowly around the aquarium's "Roundabout," but then unaccountably began swimming into the wall at a particular place in the tank. Aquarium director John McCosker (who had named the shark after his first wife) believed that Sandy was attracted to an electrical leak on the side of the tank, and decided to release her after three days because they didn't want her to die—especially in full view of the aquarium's visitors. So they carefully removed her from the tank, packed her up, and drove her back to Bodega Bay, where she was released back into the wild. Almost everybody saw this as an opportunity to study a living white shark up close, adding a little to our limited understanding of the species. (McCosker and other divers had entered the Roundabout and swum with Sandy, briefly demonstrating that not all white sharks are killers.) But there were some people who believed that "the only good shark is a dead shark," and resented even the *idea* that Sandy would be released. Bob Brumfield, a columnist for the *Cincinnati Inquirer*, wrote a piece that he entitled "There Is No Reason to Spare the Sharks," in which he said,

> It is hard for me to believe that anyone of sound mind would capture *a shark when he could* kill *it, unless his purpose was to study the shark in order to develop an effective shark repellent or a way to eradicate the entire species once and for all. And anyone releasing a* captured *[the emphases are his] shark alive once it had been studied, should have his head examined.*

And that was just for openers. He concluded by saying, "This isn't a Bambi movie, McCosker! You've let loose a relentless eating machine with a life span of God only knows how long. You've released a dreadful, silent killer to stalk swimmers as well as its normal food supply of fish." According to Brumfield, McCosker had released "a savage, man-eating monster . . . that will spawn hundreds of other man-eating monsters," and then he went on to suggest that the first man to be eaten by this monster should be McCosker:

> *I hope that the big booger gets you, McCosker. I hope one night you're swimming in the Pacific, and you feel something brush against your leg. I hope you look up and see a big, dark dorsal fin cutting through the ocean, leaving a sparkle of luminescence behind it—just before it slips below the surface—and* WHAMMO! WHAMMO! WHAMMO!

Talk about somebody who believed every word of *Jaws*! Brumfield was probably not the only one, then or now, who believed that all sharks were "savage, man-eating monsters!" Okay, it was 1980, in the midst of what was still *Jaws*-mania (*Jaws II* was released in 1978), which, by the way, might explain why aquariums were so eager to exhibit a great white shark in the first place. In the decades that followed the movie and its sequels, *Jaws*-mania should have abated, and people were supposed to have realized by now that sharks are not unreconstructed homicidal maniacs, cruising the world's waters, ready to kill and eat anyone foolish enough to go for a swim. But still . . .

On August 12, 1980, Al Wilson was hauling in his flounder net in Bodega Bay, when he realized that he had a white shark entangled in it. He slipped a rope around its tail and towed it to shore. The Sea World team had set up its headquarters at a local motel (where they were planning to use a plastic backyard swimming pool as a holding tank if the shark ever materialized), and Wilson knew they were there and were prepared to pay him $1,000 on the spot for the delivery. When he reached the dock, he called them, only to discover that they were all out, doing their laundry at the local laundromat. He then called Steinhart, and the SWAT team (Steinhart White Acquisition Team) set out to retrieve the shark. Six hours later, the three-hundred-pound, 7.5-foot shark was swimming groggily in the aquarium's Roundabout.

"Sandy" proved to be light-sensitive, having come from murky coastal waters that are considerably deeper than the Roundabout. So as to duplicate as closely

as possible the circumstances from which she'd come, they reduced the light level and introduced filters. For most of the remaining daylight hours of the first day, she swam against the current (as almost all other fish in the tank do), and seemed to improve her navigational skills, despite an occasional collision with a wall or window.

For three days, Sandy swam slowly, as the crowds watched in awe. By the fourth day of her captivity, however, peculiarities in her behavior began to appear. Although she swam normally most of the time, slowly circling into the current, she would occasionally swim erratically through a particular five-degree arc of the tank, and collide with the outer wall at pretty much the same point each time. There didn't seem to be any visible discontinuity in the tank's perimeter at that point, but she always seemed to react peculiarly there. There were no noticable differences in the levels of light, sound, or current in that area, so whatever was disturbing her movement was something beyond the landlocked observational skills of the aquarists.

Because white sharks are particularly sensitive to electrical discharges in the water, an electrical engineer was called in. He arrived with a sensitive silver chloride cell, which he employed like a sophisticated dowsing rod. After one trip around the tank's perimeter, he located the problem. There was a minute anomaly between two of the windows, a differential of 0.125 millivolt, an amount so tiny that the other sharks didn't notice it at all, or if they did, it didn't seem to bother them.

San Francisco mayor Dianne Feinstein came to visit Sandy, as did some 40,000 other visitors over the three-and-a-half-day period. Sandy made the wire services, the news magazines, and a double-page spread in *Life* magazine. Walter Cronkite dubbed her "the darling of San Francisco," and in a way, she was. Yes, she was the fabled "man-eater" of *Jaws*, but she was also a baby, and swimming slowly around the tank, she didn't look as if she was going to attack even the fish that swam with her, let alone the divers that hovered anxiously just out of sight of the crowds. For many people, it was hard to reconcile this sleek, black-eyed creature with Benchley's vengeful monster. Was she an unreconstructed killer, or simply a small shark that was so confused by her surroundings that she kept crashing into the wall? If nothing was done, she would probably be dead in a week.*

* In 2008, the Steinhart Aquarium was completely redesigned as a part of architect Renzo Piano's master plan for the California Academy of Sciences. Once a separate building attached to the natural history museum, the Steinhart now occupies the basement of the new building, which features a four-story dome that emulates a rainforest, a roof garden, a planetarium, and some elements of the natural history museum. The Roundabout, Sandy's temporary home away from home, is gone.

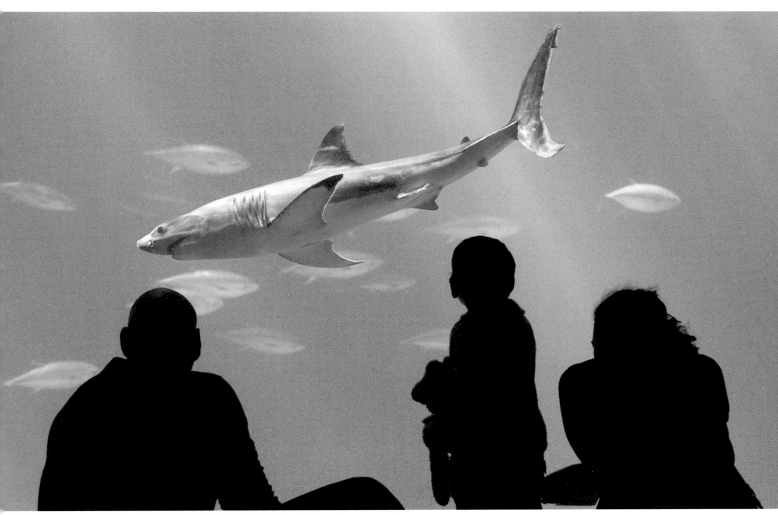

So far, the Monterey Bay Aquarium (California) has exhibited six young white sharks (at different times), and after studying them, returned them all to the Pacific. *Courtesy of the Monterey Bay Aquarium*

It was decided to release her. She was taken to the Farallon Islands, twenty-six miles out to sea, where she would encounter no nets and no swimmers—no swimmers because Sandy's adult relatives, which feed on the sea lions and elephant seals that breed there, had several years earlier effectively discouraged swimming and diving around the islands. With a proper police escort, sirens wailing, Sandy was driven over the Golden Gate Bridge to the Sausalito wharf, where she was loaded aboard the *Flying Fish*, a fifty-five-foot salmon-fishing boat. Through several hours of hammering seas and a stiff onshore wind, the *Flying Fish* fought its way out to the Farallones. The water sloshing in Sandy's box

had been more than adequately oxygenated, and when she was tipped into the Pacific, she was off like a shot.

The Monterey Bay Aquarium has succeeded where others have failed. From 2004 to 2011 the Aquarium exhibited six young white sharks in the million-gallon Outer Bay exhibit. As the Aquarium's PR department had it, "Seen by millions of visitors, these animals have helped us convey their powerful beauty, and educate visitors about the threats they face in the wild. After the first white shark in 2004 drew almost a million visitors, Executive Director Julie Packard called it 'the most powerful emissary for ocean conservation in our history.'" Three of the sharks stayed at the Aquarium for more than four months; one was on exhibit for two-plus months; and one remained in the tank for just eleven days. All were released healthy, and carried tracking tags that indicated they were doing well in the wild. The White Shark Project, started in 2002, is helping research and exhibit white sharks caught off the California coast. This project is promoting study, awareness, and conservation of these magnificent animals, including the latest white shark, which was captured off Marina del Rey (near Los Angeles) on August 18, 2011. According to aquarium officials, more than two million people have visited the white sharks in Monterey.

What Does the Shark Mean?

Obviously, it means to eat us. Why else would it have all those razor teeth, that baleful eye, and the ability to digest anything from a suit of armor to a hippopotamus?

Again: There is no such thing as *the shark*. There are hundreds of different kinds, and they come in all shapes and sizes. While some of the larger, nastier ones have been known to eat people, most of them are small and harmless, and never come near people, never mind attacking them. Somehow, however, sharks (singular or plural, harmless or dangerous) have occupied a very special place in the society of men (and women too). Our attitude towards sharks differs from our attitude towards any other animal in that it is almost totally contradictory. We fear them and admire them; we love them and hate them; we slaughter them and worry that they might become endangered.

Back in the day, sharks were considered big, scary fish, with sandpaper skin, lots of teeth, and a tendency to follow boats, waiting for somebody to fall overboard. Sharks of evil intent appeared in works of literature like *Twenty Thousand Leagues Under the Sea* (1880), *The Old Man and the Sea* (1952), and *Thunderball* (1965), always as malicious creatures that lived in an environment that people were

well-advised to stay out of. Unless, of course, you were Jacques Cousteau, and you plunged into the water, eager to film every kind of animal, no matter how dangerous. But then, even Cousteau recognized the contradictory nature of sharks: He titled his 1970 book *The Shark: Splendid Savage of the Sea.*

For two thousand years, people and sharks have waged an uneasy battle; men won the skirmishes when they were armed with heavy fishing rods and spear guns, but the sharks occasionally won when they could meet their opponents on a more level playing field—the shark's own watery realm. Of course the score was heavily weighted in favor of the men; for every "shark attack," there were probably a thousand sharks killed by men. If there was a record book, the score would probably be men 100,000, sharks 100. (As will be seen at the end of this essay, this tally does not include recent accomplishments by men, where the total for them would have to be increased by several orders of magnitude.)

Our attitude toward sharks—indeed, our attitude toward swimming in the ocean—changed dramatically on that day in 1974 when *Jaws* appeared in book-

stores—and was then amped up exponentially when the movie came out. The story of a rogue white shark that terrorizes a beach community struck fear into the hearts of almost everybody, causing many to think twice before swimming in the sea. Some decided never to enter the ocean again. It made no difference that Benchley's book was fiction and not a true account of multiple attacks; its protagonist was a real creature, occasionally biting people so that they died. Nobody looks at the Empire State Building expecting to see a giant gorilla swatting

1975. Peter Benchley and Frank Mundus about to set out on a shark-fishing expedition aboard *Cricket II* **out of Montauk. A crew from ABC-TV's** *American Sportsman* **also came along.**
Richard Ellis collection

at biplanes because we know that King Kong wasn't real, but the great white shark is very real indeed. And there are, unfortunately, many attacks on people that can be attributed to *Carcharodon carcharias*. Benchley said he got the idea for the novel after going shark fishing with Frank Mundus out of Montauk, and then going back to Salivar's, a local restaurant where the massive head of a seventeen-foot, 4,500-pounder was mounted on the wall. He also knew the story of the New Jersey attacks, so adding a substantial helping of imagination, he combined these two elements into a tale of a single monster shark with a taste for human meat.

The book was an enormous best-seller, turning Peter Benchley into the most famous author in America, and *Jaws* into a must-read—and must-stay-out-of-the-water—phenomenon. I do not believe that there has ever been a novel in English that affected so many people so dramatically, and caused so many to change their behavior—sometimes permanently. The movies that followed amplified that behavior modification because many more people saw the movie than read the novel, and also because Steven Spielberg was able to turn his version into the first summer blockbuster—a movie where people screamed, ducked under their seats, and then returned to see it again and again. *Jaws*, then, in all its permutations was a turning point for shark consciousness in America, forcibly causing people, who had never given a thought to sharks before, to accept the notion that "they were out there."

And indeed, they *are* "out there." They are in every ocean in which people swim: the Atlantic, the Mediterranean, the Caribbean, the Pacific, the Indian Ocean. It is their very presence in all the tropical and temperate oceans of the world that gives the lie to their reputation as ravenous man-eaters, malevolent woman-biters, or hungry ship-followers. If sharks had any interest in eating people (or even biting them), no beach on earth would be safe. Yes, there is an occasional attack on a swimmer or surfer, but these are rare compared to the number of swimmers on the world's beaches, and the number of sharks in the world's inshore waters. Whether it is a brush with a two-foot-long shark in a foot of water, or a sighting of a shadow in

The Advertiser

SHARK RIPS WOMAN IN TWO

Advertiser Print, Adelaide · MONDAY, MARCH 4, 1985

On March 3, 1985, a great white shark attacked Shirley Ann Durdin while she was snorkeling in eight feet of water in Peake Bay, South Australia. Witnesses—including her children—said that she was bitten in half. *Richard Ellis collection*

the surf, the media turns every encounter into a "shark attack," guaranteeing that the sharks' fearsome reputation is secure.

Shark consciousness takes many forms. Probably the simplest is fear: the (mostly incorrect) realization that sharks are dangerous to your health, and in the right (or wrong) circumstances, will take a bite out of you. For the most part, people try to avoid situations where they believe the possibility of getting hurt or killed is high. But it is these very situations that are particularly appealing to voyeurs: Movies about people getting attacked by sharks are preternaturally popular, along with movies that include car chases, armed robberies, airplane disasters, explosions, war, gunfights, swordfights, various martial arts, space invaders, and natural disasters such as earthquakes, volcanoes, and asteroid strikes. Even though many parents might disagree, violence in movies (or video games) does not actually hurt anybody. We are more than willing to have our fears condensed and moved a couple of steps from reality.

The overwhelming notoriety of sharks, not only because of *Jaws*, but for other, even better reasons, has led to the creation of every imaginable artifact, either shaped like a shark, named for a shark, or decorated with a toothy shark jaw. It was the power, grace, and of course, the fear-provoking *menace* of the shark that was the obvious explanation for its appearance on military craft such as airplanes, warships, icebreakers, and submarines. The US Navy named several of its submarines after specific sharks—*Thresher*, *Dogfish*, *Hammerhead*, *Squalus*, and *Shark* (twice). (Curiously, there was once a huge white shark in South African waters that fishermen had nicknamed "the submarine.")

In April 1937, Claire Chennault, a captain in the US Army Air Corps, retired from active duty and accepted an offer from Madame Chiang Kai-shek for a three-month mission to China to introduce much-needed fighter planes for the Chinese Air Force. He developed a squadron of P-40 fighters (Curtiss "Warhawks") that were decorated with a dramatic shark mouth painted on the nose, which somehow resulted in the squadron being known as "Flying Tigers." The group defeated the Japanese air force in more than fifty air battles without a single defeat. With the R.A.F., the Flying Tigers had kept the port of Rangoon and the Burma Road open for two and a half months while supplies trickled into China. Their reputation alone was sufficient to keep Japanese bombers away from Chunking. The Flying Tigers freed the cities of East China from years of terror bombing and finally gave both Chinese and American morale an incalculable boost at a time when it was sagging dangerously low.

The P-40 fighters known as Flying Tigers during World War II resembled sharks a lot more than tigers. *Richard Ellis collection*

Even before that, the German Air Force painted shark's teeth on some of its Messerschmitt 109 fighters, and some squadrons of the US Air Force also decorated their P-51 Mustangs with open shark mouths, the cone-shaped propeller housing serving as the nose of the shark. In 1975, the Northrop Aircraft Company designed a jet fighter known as the F-20 Tigershark. Even though it was much faster, had greater air-to-air capability, and was capable of firing most US weapons, it lost out to the F-16, and within a decade the development program was abandoned. (It is my opinion that the project failed because they made it look too much like a traditional jet fighter, and not enough like a shark.) The otherwise fire-engine-red Russian nuclear icebreaker *Yamal* has shark teeth painted on its black prow, but it's not immediately clear who or what these teeth are intended to frighten. Maybe everybody.

Some frightening and some not so much, shark images can be found everywhere.

Items that remind us of our vulnerability, but are themselves harmless, are particularly popular. Shark-tooth necklaces, T-shirts with gaping shark maws, and just about every other item of clothing that can be worn by boys can be found with a shark on it. Girls are less attracted to shark imagery on their clothing, which suggests that shark fighting (or shark diving, or shark fishing) is a characteristically

The Russian nuclear icebreaker *Yamal* has a set of shark teeth painted on the prow, presumably to frighten off icebergs.
Photo by Richard Ellis

macho exercise, the pursuit of which enhances one's masculinity: "Me big strong man, me kill shark." ("Me kill shark to protect *you*, helpless woman.") Shark pajamas or bedspreads are unlikely accoutrements for a girl's bedroom, but *Jaws* posters, models, fake teeth and jaws, and virtually anything else that can impart the "conquering hero" mystique to its owner can be found in a young boy's room. Where there are boys there will be video games, and we now have *Depth: Aquatic Stealth*, where you can be the killer shark or the diver; *Sharks: Terror of the Deep*, where you can "discover the graceful beauty of Earth's most feared creatures"; and *Jaws Unleashed*, where guess who runs wild. *Jaws* was so popular that many people believe that it was the *name* of the killer shark. Sharks rarely have names—except for scientific ones and "Bruce" in *Finding Nemo* (which is derived from the nickname given to the mechanical shark in *Jaws*)—but there is one case where a man was named for a shark: "Jaws" was the name of the acromegalic steel-toothed villain played by Richard Kiel in the James Bond movie, *The Spy Who Loved Me*.

Given the shark's reputation for aggressive ferocity, it is not surprising that sports teams, intent upon intimidating their opponents, would choose the shark as a mascot or symbol. Thus we have the San Jose Sharks of the National Hockey League (who



that a shark attack has just taken place. Suddenly, a thirty-two-foot-long monster shark roars out of the water, threatening everyone in the boat. The skipper fires at the shark, but hits some fuel pumps instead, adding fire to the fast-accumulating dangers. They take refuge in the darkness of Quint's boat shed, where some unseen force rocks the boat and threatens to topple it. As in *Jaws II*, the shark chomps on an electrical cable, and when it surfaces again, its face is charred black, but just to make sure, the skipper fires at it with a grenade launcher. It sinks in a froth of bubbles, and the visitors live to tell of their terrifying experiences to the folks back home. (You'll never guess what music plays during this ride.)*

Guests of Universal Studios for the grand opening of the Jaws Ride in 1985. Clockwise from left: Carl Roessler, David Doubilet, Stan Waterman, Susie Waterman, Peter Benchley, John McCosker, Pam McCosker, Annie Doubilet, Emily Doubilet, Richard Ellis. *Richard Ellis collection*

* For the official opening of the Jaws Ride in 1985, Universal Studios invited a host of shark people to participate in the event, including Peter Benchley, Stan Waterman, John McCosker, David Doubilet, Rodney Fox, and me. Since that time, the ride has gone through many modifications, including replacing the carrot-shaped teeth of the original models with more realistic ones; eliminating the "swimmers" being pulled under; and painting more scars, scratches and bloodstains on the face of the shark. In our experience, the boat had windows separating the splashy sharks from the passengers, but I understand that they have removed these, and now, part of the Jaws experience is getting wet.

As early as 1965, Peter Gimbel's fascination with sharks took him deep into their world. After he had dived with blue sharks in a homemade cage off Montauk, Long Island (and made a film about his adventures) he was hooked, and by 1969, he had assembled a team to accompany him on a round-the-world expedition to film the great white shark. When the *Blue Water, White Death* film team left the cages and swam with the sharks that were feeding on a sperm whale carcass on the Durban whaling grounds, the idea of swimming with sharks was planted. Among the first to offer such an opportunity was Rodney Fox, who had been almost killed by a white shark in 1963.

In a spearfishing contest off Aldinga Beach, south of Adelaide, he was diving after a large dusky morwong (a bottom fish of the kelp beds) when he felt a blow on his right side as violent as if he had been struck by a moving car. He found himself in the mouth of a white shark, and the shark was squeezing his midsection with its powerful jaws. He tried to poke the shark in the eye, but succeeded only in jamming his hand into the shark's mouth. For whatever reason, the shark released him and he swam toward the surface, but the shark did not stand off and wait; it closed again with the badly injured diver. To prevent it from biting him again, Fox managed to wrap his arms around it—and this time it took him toward the bottom. Because he was running out of air—and out of blood, though he would not know that until later—he let go of the shark and struggled back to the surface through water that was stained rust-red with blood. The shark followed him up, and just when Fox was prepared to meet his maker, the shark veered off, took the fish line that hung from Fox's waist, and dragged him down again. Evidently, the teeth of the shark severed the line, for Fox was suddenly free of the pressure that had seemed to be pulling him to his death. (He later commented that "it seemed ridiculous to drown after all I'd been through.") When he was pulled into a boat that had responded to his cries, it was seen that his ribcage, lungs, and upper abdomen had been punctured, his ribs were crushed, and he had obviously lost a lot of blood. The arm that he had poked into the shark's mouth was bare to the bone. He had been held together by his wetsuit.

A near-miraculous series of events saved his life. The boat had been on the scene and had got him quickly ashore. There was an ambulance on the beach, and it rushed him to a hospital in less than an hour. On duty in the emergency room of the Royal Adelaide Hospital was a surgeon who had returned from England that very day from a specialized course in chest surgery. Operating immediately, he took 462 stitches to sew Fox together again.

Rodney Fox showing some of the 462 stitches required to sew him back together in 1963. *Courtesy of Rodney Fox*

A mere three months after his near-fatal attack, Rodney was back in the water, and the following year he became a professional abalone diver, working in the same dangerous waters. He also began a legendary career of diving in shark cages with visiting photographers and scientists. (For many years, South Australian abalone divers had been accompanied by white sharks, but eventually they took to diving in one-man cages so they could work without the fear of being attacked.) In the course of things, Rodney Fox has become one of the

world's most foremost authorities on the natural behavior of the great white shark.

No sooner had *Jaws* become a bestseller than John Wilcox of ABC-TV's *American Sportsman* called Peter Benchley and asked him if he'd like to go to South Australia and dive with white sharks. As Benchley later wrote in *Shark Trouble*,

> *This was the world of the great white shark and the home of Rodney Fox. Fox had become a national hero in Australia, introducing the* Blue Water, White Death *crew to the great whites of South Australia, and embarking on a career as shark expert, tour guide, and conservationist. Even back then, Rodney knew ten times more than anyone else, scientist or civilian, about great whites, and he was the only individual in the known world who had any notion of how to attract or film them, under water, in relative safety.*

With television cameras grinding away, Benchley entered the cage and was lowered into the water to confront the jaws that had made him famous. Somehow, the shark became entangled in the cage ropes, and instead of serenely swimming by for a calm viewing, it tossed the cage around violently, and, as he wrote, "It was Rodney's name that I invoked in vain as I was slammed about in the cage, envisioning myself reduced from a suddenly successful writer to a surf-'n'-turf snack for a prehistoric monster." Peter's wife Wendy, who had been watching from the bridge, came down to the fantail and pulled the rope from the shark's mouth: "Wendy found herself nose-to-nose with—perhaps twenty-four inches away from—the most notorious, hideous, frightening face in nature. The snout was smeared with red. Bits of flesh clung to its jaws, and rivulets of blood drooled from the sides of its mouth. The upper jaw was down, in bite position, and gnashing as if trying to climb the rope. The eyes, as big as baseballs, were rolled backward in their sockets—great whites do not have nictitating membranes—and as the great body shook, it forced air through the gill slits, making a noise like a grunting pig." Wendy survived her face-to-face encounter with the "most hideous, frightening face in nature," and Peter survived his adventure in a tangled cage. He would dive many more times with sharks, in Australia, Tahiti, the Caribbean, and South Africa, but he never forgot his first dive, which he thought he wasn't going to survive.

For the *Jaws* movie that was made in 1975, Rodney Fox and Ron Taylor shot the underwater footage of great whites in South Australia. Ten years later, on

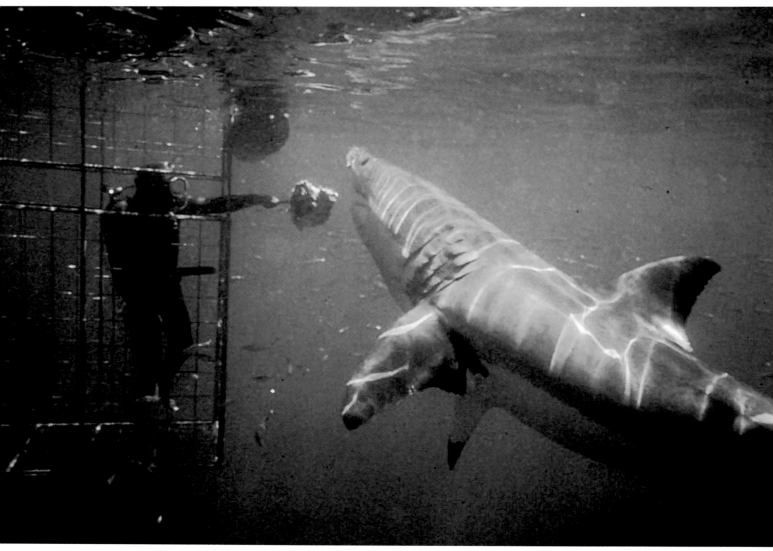

From outside the cage, the sharks look enormous. (From inside, they look even bigger.)
Courtesy of Rodney Fox

assignment for *National Geographic*, Genie Clark, David Doubilet, and I dived with Rodney off the aptly named Dangerous Reef. I wrote the story about South Australia's fishing industries, and David took the pictures. We investigated tuna fishing, crayfishing, abalone diving, and the acknowledged superstar of South Australian waters, *Carcharodon carcharias*. In "Australia's Southern Seas" (March 1987), David's photographs brought white sharks into millions of living rooms, and incidentally, were instrumental in publicizing Rodney's successful cage-diving enterprise out of Port Lincoln.

Although diving with great whites is still the *ne plus ultra* of the sport, there are now companies that will take you cage-diving in South Africa, New Jersey, California, Hawaii, the Bahamas, the Caribbean, Florida—almost anywhere there are sharks of any kind and tourists willing to descend in a cage to look at them. (There are now people who leave the cages—or never even get into them—in order to swim unencumbered with white sharks, but this is not an activity recommended for the faint of heart.) One of the more unusual shark-related events in recent years has been seventy-four-year-old Elizabeth Taylor's descent in a shark cage off Hawaii. As reported in *People* magazine [August 2006], "She has survived a brain tumor, addiction, the wrath of the Vatican, and eight marriages, including one to an abusive relative of Paris Hilton's. So don't expect Dame Elizabeth Taylor to be afraid of a few sharks. In fact, as she was submerged in a shark cage off the Hawaiian Islands one bright morning, she was downright giddy—even goggles and a snorkel couldn't hide her smile. "There were 12 sharks cruising the cage!" says Taylor. "The water was very warm. It was beautiful. I had on a T-shirt that said 'Shark Bait.'"

Sharks in Trouble

Big-game fishermen in pursuit of sharks do not pose much of a threat to shark populations, but longline fishermen do. As much as forty miles long and festooned with thousands of baited hooks, longlines are the gear of choice for many commercial fishermen around the world. Their hooks catch everything, regardless of the target species. Even if they're set where swordfish or tuna are endemic, longlines snag everything, including sea turtles, dolphins, albatrosses, fishes of every kind—and sharks. There are many areas where sharks have become the primary target. Shark specialists estimate that more than 100 million sharks are killed every year. In all the world's oceans, sharks are being caught in incomprehensible numbers for their fins.

Millions of sharks are part of the unintended catch ("bycatch"), but far more are harvested expressly for fins. They are hauled onto fishing boats where their fins are cut off and their bodies thrown back into the ocean as waste. Because sharks are tough, most of them are still alive when they're thrown back, but without fins they cannot swim, and they suffocate or are killed by other sharks. Why throw the body of the shark away instead of saving it? Shark meat must be properly refrigerated and takes up a lot of space on a boat, but fins can be cut off, bundled, and hung to dry in large nets. The fins produce the largest profit by far and can be sold for hundreds of dollars per pound.

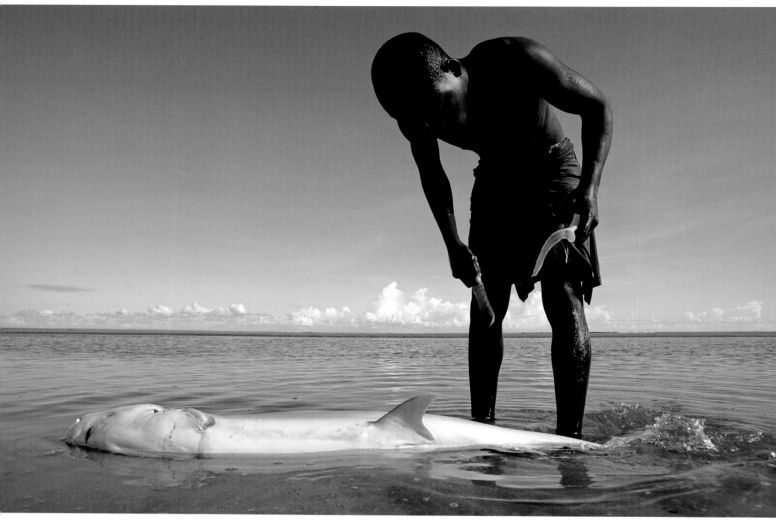

A man slices off a shark's fin on a beach in Pomarene, Mozambique. Taiwanese traders drive along the beaches to pick up the fins. *Photo by Paul Hilton*

The fins are used to make shark's fin soup, sometimes known as "celebration soup" in China, Singapore, Hong Kong, and other Asian countries. "Shark's fin" is actually the cartilage; the flexible tissue in the fin that gives it its rigidity. The dorsal fin is the most valuable, followed by the tail fin, and lastly, the pectoral fins. Shark fins are graded by length—the longer the cartilage, the better the quality. The cartilage can range from an inch to more than a foot long. The fins are sold frozen or dried; the frozen ones come in strands and require an hour of soaking. Two versions of dried fins are available: skinned (shredded) or un-skinned (whole), which require more preparation. Although the fins are tasteless and have little nutritional value,

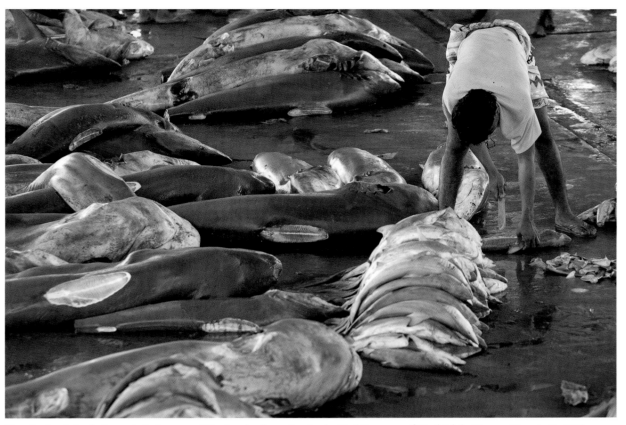

Hundreds of sharks have their fins cut off in the shark market in the Red Sea port of Hodeidah, Yemen. *Photo by Paul Hilton*

they are usually added to chicken- or other meat-based soups. Shark's fin is prized for its slippery and glutinous texture that results in a thickened soup without the use of cornstarch, similar to bird's nests, another Chinese delicacy. Regarded by the Chinese as a tonic food and an aphrodisiac, shark's fin is believed to strengthen the internal organs and retard aging. As with tiger bones, consumption of parts of the shark is believed to confer the power and savagery of the animal on the consumer. The 2011 Michelin Hong Kong/Macau restaurant guide awarded three stars (its highest ranking) to the shark's fin restaurant known as Sun Tong Lok. Despite a backlash from green groups, anti–shark's fin campaigners, and many consumers, this decision unfortunately reflects the old school Cantonese dining values that still persist in Hong Kong. On a restaurant menu in New York City's Chinatown, a bowl of Crab Meat with Shark Fin Soup for four sells for $110.

To fight the misconceptions about shark cuisine, outspoken British television celebrity chef Gordon Ramsay has launched a program called *Shark Bait*, in which

he takes a look at the controversies surrounding shark's fin soup. With an estimated 100 million sharks being killed worldwide, and a third of the world's open ocean shark species being driven to extinction by overfishing, Ramsay wants to find out if this slaughter is really necessary. The popular shows of this three-star restaurateur and chef appear on ITV in England and on the Fox Network in the US. On his show in January 2011, Ramsay asked, "What does it taste of? It's really bizarre, because it actually tastes of nothing. The broth is really good, but it could have anything in there, chicken, duck, pork belly, anything. The one item spoiling it is the shark's fin. The bland fin doesn't deliver. They eat it because it is a symbol of status. It's f**king mad."

Shark fisheries around the world—in Mexico, for example, where fishermen also cross into American waters —are in business largely to supply fins to this market. In some parts of the world, finning is so widespread that the local populations of sharks have become endangered. In 1991, Honolulu fishermen landed 2,289 sharks. By 1998, the number had leapt to 60,857 (a 2,500 percent increase), and of that total, 99 percent was for fins. The introduction of the US Shark Finning Protection Act on March 13, 2002, banned US fishing vessels anywhere in the world and foreign vessels fishing in US waters, from possessing fins unless the rest of the shark's carcass is also on board (Raloff 2002). In August, US Coast Guard officers boarded the Honolulu-based *King Diamond II* off Acapulco, and found 64,000 pounds (32 tons) of fins and no other shark parts. The *King Diamond* had not actually caught the sharks; the Korean fin-broker on board had evidently bought them from Asian vessels plying the eastern South Pacific around Fiji and the Solomons, and was planning to sell them in Guatemala. The fishing vessel was escorted to San Diego and the cargo confiscated. In the Pacific, where most finning takes place, there are no restrictions on finning or bringing in severed fins, with

In 1985, in the Indonesian village of Lomblen, I took this picture of an old man who had just cut the fins off sharks that had been caught by local fishermen.
Photo by Richard Ellis

Large dried shark fins in a restaurant window in Yokohama advertise the availability of a very special soup on the menu. *Photo by Alex Hofford*

or without the carcasses. (Fins can sell for a wholesale price of $300 per pound, while shark meat might bring 50 cents per pound, demonstrating the unfortunate economics of finning.)

Until 1987, China was only marginally involved in the finning trade. Because the government rejected the concept of individual affluence, shark's fin soup was considered an inappropriate status symbol, but the economic upswing in Peking and Shanghai created a basis for prosperity and thus opened a market for shark fins aimed at the new middle class. Chinese fishermen then began to fish sharks themselves. Catch quantities are unknown, but the number of heavy-capacity ships suitable for this type of fishing increased from one ship in 1975 to twenty-six ships in 1992. By 1996, Shanghai alone already counted sixty-four ships. Chinese fishing ships have been sighted mainly in the North Pacific, the Atlantic, and the Indian Ocean. Taiwan, which ranks fifth in the worldwide shark fin trade, maintains the largest international fishing fleet and fishes primarily in international waters, away from its own territorial waters. Only a handful of countries have introduced finning restrictions: Canada (1994), Brazil (1998), the US (2000), Spain (2002),

A bowl of shark's fin soup. *Richard Ellis collection*

In some parts of the world you can buy shark's fin soup in a can. This one was bought in San Francisco. *Photo by Richard Ellis*

and Costa Rica (2005). Certain restrictions are also valid in South Africa, England, Mauritania, Mexico, Malta, Namibia, Oman, the Philippines and Israel, but the ocean-wide slaughter continues largely unchecked.

Today, more than one hundred of the four hundred shark species are being commercially fished. Many of these species are so overexploited that their long-term survival can no longer be guaranteed. There is no monitoring and control program for the international shark trade. The year 1980 saw about 3,000 tons of shark fins traded worldwide. In 2004 it was 22,000 tons. Statistics from Taiwan, Singapore, and Hong Kong—the world center of finning trade—indicate an explosive expansion. According to customs officials in Hong Kong, 6,954 tons

of fins were cleared for re-export in 1999, destined mainly for Taiwan, Singapore, Malaysia, Korea, and China. In 2007, Hong Kong was the largest importer of shark fins, buying about $277 million worth of fins, or 10,209 tons, according to United Nations figures. One kilogram (2.2 pounds) from certain species can sell for $120 or more in Hong Kong, where shark's fin is a staple at high-end restaurants and wedding banquets, a mark of affluence in a city that accounts for as much as 80 percent of the world trade in fins. The US banned finning ten years ago, but it is still legal in the Pacific, as long as the fins' original owners were not finned onboard a vessel. The ever-increasing popularity of shark's fin soup has spawned a booming clandestine industry throughout Asia. Shark fin cuisine is readily available in many upscale Chinese restaurants in the US.

In early 2011, two California congressmen introduced a bill into the state legislature that would ban the possession, sale, and distribution of shark fins used in soup. If successful, the proposed ban would follow a similar measure enacted in Hawaii in 2010, where restaurants have until June 30, 2011, to cook or dispose of their fin inventories, or face fines of up to $15,000. Restaurant owners are opposed to the ban because shark's fin soup is a staple of their banquet business, as it conveys affluence, something like caviar. State Senator Leland Yee, who is running for mayor of San Francisco, believes the proposed state law to ban all shark fins from consumption—regardless of species or how they were fished or harvested—is the wrong approach and an unfair attack on Asian culture and cuisine. The proposal to ban shark's fin soup hit the front page of the *New York Times* on March 6, 2011, with the headline, "Soup Without Fins? Some Californians Simmer." In the article, written by Patricia Leigh Brown, we learn that San Diego and Los Angeles are two of the main entry points for shark fin imports from China and Mexico. State and federal laws prohibit shark finning in US waters but do not prohibit imports. John McCosker, shark expert of the California Academy of Sciences, affirms that 90 percent of the sharks in the world's oceans have disappeared. "They're among the ocean's most vulnerable animals," he said, "The whole food web becomes bollixed when you take out the top-level predators." Approximately 85 percent of US dried shark fin imports come in through California, according to the National Marine Fisheries Service. On September 6, 2011, over the objections of two senators who called the measure racist because the fins are used in a soup considered a delicacy in some Asian cultures, the California Senate passed AB 376 and AB 853, prohibiting the sale, trade, or possession of shark fins. Hawaii, Oregon and Washington now have similar laws on the books.

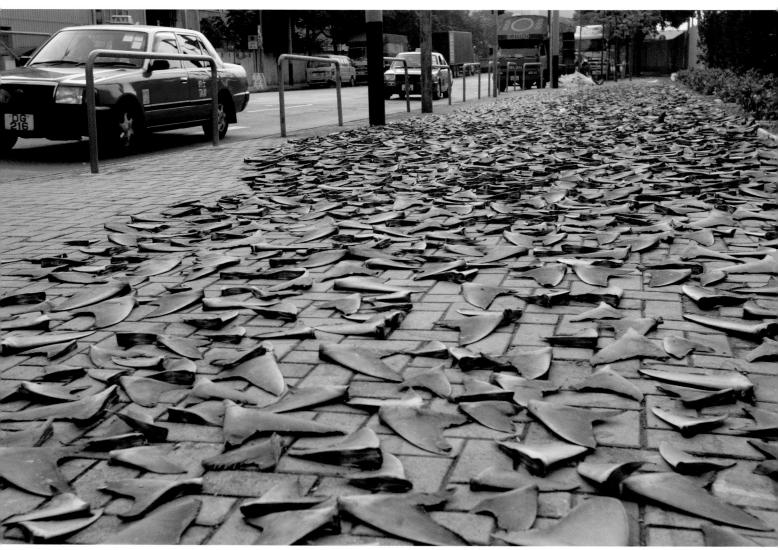

Laid out endlessly to dry on a street in Hong Kong, these shark fins illustrate the extent and the popularity of the product. *Photo by Alex Hofford*

In other parts of the world, here's how they make shark's fin soup: Only the first dorsal, pectorals, and lower lobes of the tail fin are used. The skin is removed, and all muscle tissue as well, leaving only the inner cartilaginous fin rays to soak. The fibers are boiled in water for hours, then the water is changed, and the fibers boiled again and again, a process that may take as long as five days. The glutinous mass that results is served in a thick broth of chicken stock seasoned with soy sauce, ginger root, onions, vinegar, mushrooms, and other ingredients, and after the soup is drunk, the gelatinous fibers of the shark's fin are eaten. If slaughtering sharks for

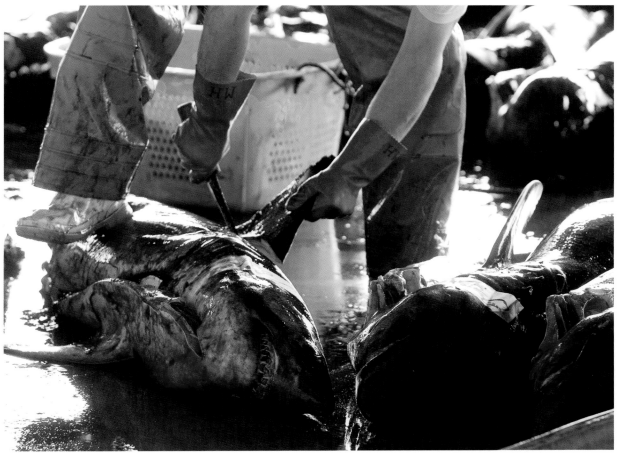

In Kesennuma, Japan, the special sushi contained the hearts of salmon sharks (before the tsunami wiped out the fishery, that is). *Photo by Alex Hofford*

their fins isn't repugnant enough, consider the way the fins are prepared for market. In the "factories" where the fins are processed, they are first boiled, then bleached in a vat of bubbling liquid, which is said to be a mixture of industrial grade hydrogen peroxide and ammonia. The result of this hazmat chemical treatment is fins that are bleached white, which makes them palatable for soup. Do the consumers of shark's fin soup worry about poisonous chemicals in their soup?

Well, then, what if overfishing was to reduce the number of sharks available for finning? No problem, we'll fake it, according to a report from China. Because shark fin has no taste—it is the gluey mass that is the ingredient in soup—it is easy to mix (or exchange) fake fins for real. The boiling and chemical bleaching process that results in the glutinous fibers used in soup is similar to that employed in the manufacture of fish glue, which was used for centuries in furniture making.

Evidently, any fishy, glutinous substance will do, as the resulting soup doesn't have to include anything that remotely resembles a fin. In the Japanese version, however, the fin is supposed to be visible, floating in a vegetable broth. The Japanese version?

Although we tend to associate shark's fin soup with Chinese cuisine, it is also quite popular in Japan, where it is called *fukahire*. The shark-fishing capital of Japan—probably the most concentrated shark fishery in the world—is in Kesennuma, a fishing port on the Pacific, about 250 miles north of Tokyo. The sharks, mostly blues and Pacific salmon sharks, are caught in longline operations in an area of the Pacific east of the Izu and Ogasawara islands. In 2009, Kesennuma landed almost 14,000 tons of sharks, worth just over $21 million. A decent-sized tailfin can fetch as much as $111. The sharks are brought to the "factory" in Kesennuma, where workers cut the fins off and toss them into plastic buckets, while the carcasses are scooped up by a forklift and loaded onto a truck. All parts of the shark are used: fins for use as ingredients for cooking, cartilage for chondroitin that is used in dietary supplements, skin for collagen, meat to be minced and used in fish cakes, and the reproductive organs to be ground into feed for farmed fish. Stalls at the port's market sell everything from

The tsunami of March 11, 2011, destroyed almost the entire fishing fleet of Kesennuma, the shark-fishing capital of Japan.

Paul Hilton and Alex Hofford collaborated on one of the most important—and shocking—books on the destruction of sharks for soup. *Warrior Books*

dumplings and jerky to sharkskin bags and accessories. Salmon-shark hearts—a local specialty—are eaten raw. Nothing is wasted except the shark. The port of Kesennuma accounts for 90 percent of Japan's shark-fin trade, and Japan's best shark's fin soup draws busloads of tourists every day in summer. The factory, with workers lopping off fins on concrete floors awash with blood, is only one of Kesennuma's tourist attractions. There is also the Kesennuma Rias Shark Museum, located on the second floor of the seafood market building, where shark attacks and the harm sharks do to fisheries are the prevalent themes. In the window of a restaurant near the museum there is a plastic replica of a dish of shark's fin ramen noodles. The real dish costs around $27.

As of this writing, everything about the city and shark fishery of Kesennuma has been relegated to the past tense. On the afternoon of March 11, 2011, a 9.0 earthquake, one of the largest in recorded history, struck northern Japan. The epicenter was just off Sendai, immediately to the south of Kesennuma. Buildings were toppled and massive tsunamis rushed ashore all along the northeastern coast of Japan. Thousands of people were reported dead or missing. The city of Kesennuma, with a population of 74,000, was hit by widespread fires and one-third of the city

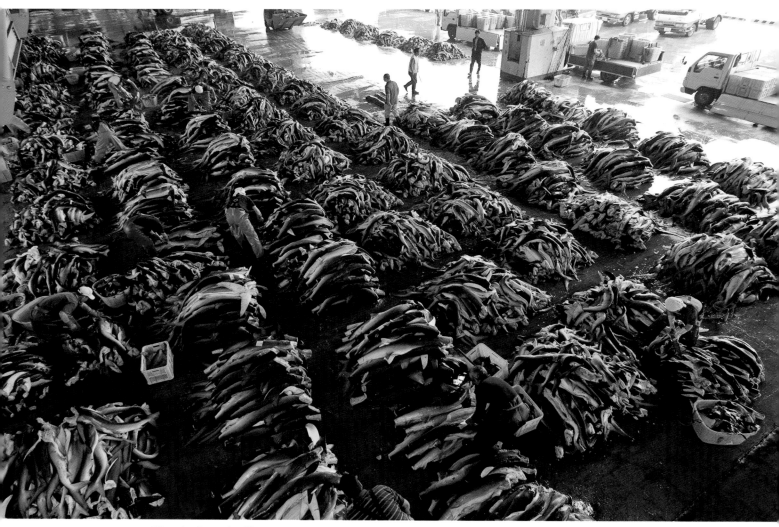

Blue sharks in the "factory" at Kesennuma, Japan. *Photo by Alex Hofford*

was submerged after the massive earthquake and tsunami. The factories, shops, and the museum were completely destroyed.

Sharks are being slaughtered in incalculable numbers in almost every country with a coastline on a tropical or temperate ocean, their fins cut off and shipped to China and Hong Kong. In their 2010 book *Man & Shark*, photographers Paul Hilton and Alex Hofford include any number of sickening images of sharks being caught, sharks being killed, fins being lopped off, ranks of dead sharks on the dock, warehouses full of finless sharks and shark fins, soup being prepared, and people eating it. The photographs were taken in French Polynesia, Micronesia, Kiribati, Fiji, the Solomon Islands, Vanuatu, the high seas of the Western Pacific,

Costa Rica, Yemen, Somalia, Mozambique, South Africa, the Maldives, Sri Lanka, Thailand, Indonesia, the Philippines, Hong Kong, and China. Not documented in this book by the photographers, but also playing a major role in the capture and slaughter of sharks, are the fishing fleets of Japan, South Korea, and Taiwan. In almost all of these countries, the fishers arrange to have the fins delivered to those places where they can be turned into soup. As Hilton and Hofford wrote, "Up to 80 percent of the world's shark fin—76 million sharks a year—is served up in mainland China and Hong Kong. The remainder is consumed in other Asian restaurants around the world. This unchecked demand has led to the environmental disaster that is now taking place in our oceans. Fishermen in poor, less developed nations fish for lucrative shark fin that commands a high price in Asian markets. Lax fishing regulations fail to enforce what little internationally agreed protection there is for the remaining sharks."

As of late 2009, the world's population of sharks had already diminished by 50 to 75 percent. A North Atlantic population survey reports as much as an 89 percent decrease. The *IUCN Red List of Threatened Species* shows that for the 181 species of sharks for which they have adequate data, more than 64 percent of those populations are listed as "threatened" or "vulnerable." Of those, more than 21 percent are categorized as "endangered." Most countries now have laws against endangering the population of wild animals, but only a few have laws against shark finning. The identification of species by the fin is extremely difficult as most are pre-skinned and dried prior to inspection sampling. The only way to be sure that the fin is not from an endangered species is DNA testing. Only a real change in the importing and regulating of any shark product worldwide will allow their populations to recover. In an editorial entitled "Endangered Predator" (January 2, 2011), the *New York Times* wrote,

> *Each year, commercial and recreational fishing kills more than 100 million sharks globally (the number of humans killed by sharks in 2008: four). Of these, an estimated 73 million are slaughtered solely for their fins to provide the shark fin soup that is so popular in Asia. The fins are sliced off and the sharks dumped back in the water; unable to swim, they sink to the bottom and die.*
>
> *Sharks have been around for 400 million years, and as top predators in the food chain have played an important role in the complex web of ocean life. Fully one-third of about 1,000 shark and ray species are thought to be in serious trouble or nearing extinction.*

The entrance to the Shark Story Restaurant in Xiamen, China, might very well be the most dramatic restaurant entrance in the world. It is certainly the scariest.

Steak—broiled in panko and herb encrustment, over potato and ricotta gnocchi, creamy sun-dried tomato and roasted red pepper pesto ($22). The Fat Radish, a new restaurant in New York City, offers "mako shark vindaloo," a traditional East Indian dish usually made with chicken or lamb. Then there's a chef in Bali who has opened a restaurant called Pak Item, where he serves shark meat in a variety of ways, including stewed, barbecued, fried, or mixed with a local favorite, fried rice.

China is the world leader in fish capture, aquaculture, and fish consumption. This country of more than a billion people has a very long history of utilization and consumption of shark products. In an ancient Chinese book named *Food Medical Treatment*, shark meat is described as sweet, salty, smooth, non-poisonous, and able to help the proper function of the five internal organs. Another antique treatise states that shark meat can help people to alleviate swelling and stasis in their bodies. In *Food List of Daily Life* it says that shark skin can relieve poisons arising from fish, kill parasites, and help recovery from weakness. From the Chinese *Materia Medica*, we learn that shark skin burnt to ashes can treat poisoning from eating fish; shark fin is sweet and can help build up one's health; shark fat is sweet, salty, and smooth and is very helpful in nourishing lungs and heart; and shark bile can be used to cure throat problems.

In China shark meat can be cooked in different ways such as fried, in soup, and as fish balls. In the area of Fujian and Zhejiang Provinces, shark's fin soup is a famous and expensive dish. It is estimated that over half of the sharks landed in China are processed into fillets and fish balls for local consumption. There are factories in Fujian Province engaged in extracting fish liver oil and manufacturing it into drugs and health food products. Shark liver contains vitamin A, vitamin D, DHA, EPA, and dogfish alkene, all of which are valuable in medicine and promoting health. Given the importance of sharks in Chinese medicine and culture, is it so surprising that they would open a shark restaurant? In the city of Xiamen (formerly *Amoy*, Fujian Province), we now have the Shark Story Concept Restaurant, heralded as "the first shark-themed restaurant in China." From their website:

> *With a four metres high shark's head placed at the entrance, the restaurant can easily grab passerby's attention. Walking into the shark's gaping mouth, you are fully drawn into the world of sharks. Looking up at the ceiling you can see a group of sharks swimming in the sea. Customers sit on the "shark cartilages" and enjoy the delicious shark dishes on the "shark vertebrae." The signature dish of the Shark Story Concept Restaurant is shark ball. As the "sister store" of Yuan*

Xiang Kou, a 200-year-old shark ball store, their shark ball is famous for fresh flavor, tender taste and juicy fillings. Worth it for the name alone, the restaurant provides a series of shark dishes such as curried shark, shark and pickled pepper, braised shark in soy sauce and fried shark skin. Besides shark dishes, they also supply traditional Chinese cuisine like baked chicken with spices, bell peppers frog and hot pot.

Man-eating sharks? Big problem. Shark-eating men? Not so much. Except, of course, for the sharks.

* * *

Throughout history, the shark has unceasingly been regarded as a man-eating menace. Even a perfunctory review of the literature, from Aristotle to Melville to Benchley, will show that the reputation of "the shark" (never mind the hundreds of small, harmless species) as a malicious, vengeful, bloodthirsty, omnivorous killer has dominated the past two thousand years. This view has never abated, and was inflated exponentially with the 1974 publication of *Jaws*. And since that seminal moment, the films, books, photographs, magazines, TV specials, video games (and, it must be admitted, the occasional shark attack) have maintained the shark's reputation intact, with nary a blip on the upward (or downward, if you will) curve. Photographs of the gaping maw, always with its "razor-sharp teeth," have obliterated any and all attempts to portray the shark as simply an element in the chain of life. It's always the *food*-chain (with us as a link) that has taken precedence. Efforts to exhibit sharks (particularly whites) in aquariums were made with the best intentions, but more often than not, these juveniles, swimming harmlessly in circles, were perceived as man-eaters just waiting to be released to wreak their particular kind of anthropophagous havoc. Books were written to explain that sharks were not the embodiment of malice (Peter Benchley's *Shark Trouble*, for example), but the image persists, despite attempts to soften, or at least modify it. In truth, we cannot assign the sharks' continuing bad press only to authors and moviemakers: By continuing their occasional attacks on people, the sharks themselves must be held at least partially responsible for the public relations mess they're in.

While everybody might be concerned about attacks from big, dangerous sharks such as whites and tigers, there has been a dramatically documented report of an attack on a swimmer by a shark that was fewer than 20 inches long. On March

16, 2009, a marathon swimmer named Michael Spalding was attempting to swim from a point on the northwestern tip of the big island of Hawaii to a point 29 miles away on Maui. During the night, Spalding was bumped by small squid, attracted to the lights of the accompanying boat, and then felt a nasty bite on his chest. The pain was excruciating and he knew he had to get out of the water, but as he tried to climb onto the kayak, he was bitten on the leg. He reached down and felt a big round hole. He was brought to shore and taken to the emergency room at the Wailuku Hospital, where the bleeding from the deep, circular wound was stopped and the healing process begun. The wound took nine months and several skin grafts to heal because a 2½-inch round chunk had been removed from the back of his left calf just above the Achilles tendon. (The wound on his chest, while painful, did not tear the flesh.)

What could take a cookie-sized bite out of a man's leg? *Isistius brasiliensis,* that's what, the cookie-cutter shark, whose common name comes from its feeding strategy of taking scooplike bites out of large prey such as dolphins, billfishes, tuna, and even whales. The cookiecutter is a small, skinny shark, with two very small dorsal fins placed far back on the body. Its teeth differ in the upper and lower jaws; the uppers are small and thornlike for getting a grip; while the lowers form a continuous, sharp-edged band that removes the plug as the shark rotates on its long axis. (The lower teeth are shed and replaced as a unit, ensuring that the shark has a full cutting edge at all times.) For years the pluglike bites taken from the rubber covering of submarines' radar domes were a mystery until it was determined that cookiecutters were responsible. And now, according to the 2011 paper by Honebrink, Buch, Galpin, and Burgess, we have the "first documented attack on a live human by a cookiecutter shark."

October 2010. Nineteen-year-old Lucas Ransom was body-boarding off a California beach near Vandenberg Air Force Base in Santa Barbara County, when a shark rose out of the water, grabbed him by the leg and pulled him under. He screamed for help, but his buddy, Matthew Garcia, was unable to do anything as the water turned red with Ransom's blood. When Garcia towed Ransom's body ashore, he was dead, and his left leg was missing. Sheriff's deputies patrolled the coastline to search for Ransom's missing leg but were only able to recover the boogie board, which had a 1-foot chunk bitten out of it. Garcia described the shark as being "maybe 18 feet long," which means it could have been only a great white. Even these grisly attacks, however, do not come close to redressing the imbalance in the war of sharks vs. people. The sharks are losing. Big time.

In 1969, Lineaweaver and Backus wrote that the oceanic whitetip (the species Cousteau thought so ugly) "is extraordinarily abundant, perhaps the most abundant large animal, large being over 100 pounds [45 kg], on the face of the earth." There were few population studies until 2003, when the numbers were estimated to have dropped by as much as 70 percent in the Northwest and Western Central Atlantic, and another study focusing on the Gulf of Mexico, estimated a decline in numbers in this location of 99.3 percent over this period. Today, *Carcharhinus longimanus* is endangered throughout its worldwide pelagic range, and in the Gulf of Mexico (even before the Deepwater Horizon blowout of 2010), it is believed to be extinct.

In January 2010, a French tourist was attacked and killed by a shark while diving in a more remote site off Egypt's Red Sea coast. She was bitten on the leg by an unidentified shark and bled to death before she was lifted to the surface. About a year later, in December 2010, at the Egyptian Sinai resort of Sharm el Sheikh, a shark tentatively identified as an oceanic whitetip attacked two swimmers, biting off the hand of one woman and damaging the legs of her male companion. The same shark is believed to have attacked a Russian couple a day earlier in the same area. Because *longimanus* is a pelagic shark, rarely found near shore, the identification of the perpetrator of the attacks has been questioned, and some authorities believe it might have been the silvertip shark, *Carcharhinus albimarginatus*, or even a mako. A shortfin mako was caught in the vicinity, but there was no evidence that it had been responsible for any of the attacks. Maybe the whitetips are retaliating. A photograph taken of the shark as it came close to the Russian swimmers is inconclusive.

Just as in *Jaws*, after an attack, the local fishermen began a frenzied hunt for the killer shark, and as soon as they caught a shark—any shark—the authorities announced that the problem has been solved and they re-opened the beaches to tourists. But as life (or, in this case, death) follows art, four days after the attacks on the Russians, the beaches were re-opened, and a large shark (perhaps the same one; perhaps a different one) attacked and killed a German snorkeler who was bitten on the thigh and arm and died of loss of blood. Local authorities were at a loss to explain these savage attacks, because they claimed that large sharks had never been seen before in the shallow waters of the resort's popular beaches. However, a local diving instructor pointed out that an Australian cargo ship had been bringing in sheep for sacrifice during the Muslim festival of Eid al-Adha, also known as the Festival of Sacrifice, and had been dumping the carcasses overboard of those sheep that had died during the voyage. (The holiday commemorates the willingness of Abraham [Ibrahim]

to sacrifice his son Isaac as an act of blind obedience, but then God intervened and provided him with a ram to sacrifice instead.) Did dumping sheep carcasses in the vicinity of a tourist beach have anything to do with the shark attacks?

On February 17, 2011, South Australian white sharks (note plural) made sure that their reputations as man-eaters remained intact—and were even enhanced. Abalone diver Peter Clarkson was surfacing after a dive when boat skipper Howard Rodd saw two sharks—almost certainly white pointers—grab him and pull him under. We have no idea what happened next, but the more sensational accounts reported that the sharks ate him.

Réunion is an isolated French island in the Indian Ocean, six hundred miles east of Madagascar. On June 16, 2011, surfer Eddy Auber was killed in a multiple shark attack off the shores of Saint-Gilles, the island's primary tourist area. The attack, the second in a year, occurred when Auber was about two hundred meters from shore at a place call Ti Boucan. He was already dead when he was brought out of the water. "His right arm was severed and one of his legs had been shredded," said the commander of the gendarmerie of Saint Paul. "He had several bite marks on the thigh and hip, and his board had a big bite taken out of it." It appeared that several sharks attacked the surfer at the same time, but the identity of the sharks could not be determined. This was the second serious shark attack off Réunion since the beginning of 2011; in February, a surfer lost his leg in a shark attack, also off the coast of Saint-Gilles.

It gets worse. During the summer of 2011, it appeared that the sharks were doing their best—or rather their *worst*—to ensure that nobody would feel the slightest pang of sorrow for their predicament. In August, off the isolated Seychelles island of Praslin, about 750 miles from east Africa, Ian Redmond, a thirty-year-old honeymooner from Lancashire, England, was attacked by a shark, his arm torn off and his hip lacerated. He died shortly after he was brought to shore. "Experts" brought in from South Africa identified the perpetrator as a great white, and suggested that the beaches be closed until they caught it. A week later, halfway around the world, in what has to be among the least likely parts of the world for swimming, let alone shark attacks, two Russian men were attacked by a shark (or sharks); one lost his hands, and the other's legs were severely wounded. The attacks occurred off the Primorye coast in the Russian Far East, in Telyakovsky Bay, south of Vladivostok and just north of the border with North Korea. The Russian authorities responded by closing the beaches (such as they were) and sending local fishermen out to catch all the sharks they could until the threat to swimmers was removed.

August 23, 2011. Tim van Heerden, a forty-nine-year-old surfer from Plettenberg Bay, South Africa, died from injuries after he was attacked by what may have been a great white shark, according to local news reports. He was surfing off Lookout Beach near the Keurbooms River mouth and was with a large group of surfers, said Craig Lambinon, a spokesman for the National Sea Rescue Unit. Heerden saw the shark coming in and was able to shout a warning to other surfers in the area, "But he couldn't save himself as the beast attacked, first biting him at the top of the leg, then pulling him underwater before biting him again." Van Heerden appears to have been bitten in the groin area and the femoral artery may have been severed, Lambinon said. A month later, halfway around the world, twenty-one-year-old Kyle James Burden was bodyboarding off Bunkers Beach, Cape Naturaliste, southwest Australia, when he was grabbed from below by a shark, believed to be a great white, and bitten in two. The vast quantity of blood in the water suggested he died instantly. Is this a trend? A feeding frenzy? Are the sharks trying to tell us something?

Maybe they're trying to tell us to stay out of notoriously "shark-infested" waters. Off Cape Town, at places like Gansbaai, Dyer Island, and Fish Hoek Bay, the great white shark population is probably the densest in the world (that's where the South African fur seals congregate), and the sharks are often spotted patrolling the waters of popular swimming beaches. On September 28, 2011, the "white shark" flags were flying, but forty-two-year-old Michael Cohen chose to ignore these warnings and paid no attention to reports of large sharks seen offshore. Big mistake. About one hundred feet from the beach—and therefore clearly visible to people on the shore—he was repeatedly bitten by a shark, his right leg and left foot torn off. Three men waded into the water to pull Cohen onto the beach, while the perpetrator of the attack continued to circle the bleeding victim. They got him to shore and he was rushed to a nearby hospital, where, as of September 29, he was listed in critical condition.

Regardless of efforts made to ameliorate the reputation of sharks, they seem more than a little unwilling to submit to a complete makeover. Indeed, in many parts of the world, they seem hell-bent on ensuring that they continue to be seen as the *Jaws* paradigm; great white sharks in particular are doing a much better job of destroying their reputation than Peter Benchley ever did. Chris Fallows's sensational photographs of South African white sharks launching themselves skyward with sea lion pups in their mouths (the activity that Shark Week called "Air Jaws") did nothing to soften the already ferocious reputation of *Carcharodon carcharias*.

Bad behavior, however, is by no means a legitimate justification for eliminating an animal. In the *National Geographic* thirty years ago, Genie Clark wrote:

> *As we become more familiar with sharks, the move to protect them may spread Seen in their own environment, sharks are incredibly beautiful. . . . With further research we may one day be able to predict sharks' behavior with great accuracy. When that day comes, I feel certain that we will recognize that sharks present no threat to mankind. I only hope the reverse will be true.*

For millennia, people feared sharks. Now we also have to fear *for* them. Concern for the survival of shark species, endangered as a direct result of greedy, insensitive human exploitation, might be the tipping point that shifts us away from our anthropocentric world view, and in the direction of a legitimate concern for some of our fellow passengers on Spaceship Earth. "A thing is right," said Aldo Leopold, "when it tends to preserve the integrity, stability, and beauty of the biotic community. It is wrong when it tends otherwise." Could anything be more wrong than the elimination of entire species for soup? At one time sharks were being killed for their cartilage, under the misguided belief that because sharks didn't get cancer, taking powdered shark cartilage would prevent cancer in people. (The idea made as much sense as taking powdered redwood to make you taller.) Maybe we ought to stop killing animals to feed a baseless market for cures, or worse, for the enhancement of male sexual performance. Maybe the time has come to put an end to "celebrating" with soup made from the fins of mutliated sharks. Maybe we might stop worrying about our own comfort long enough to recognize the environmental havoc we are creating around the world. Maybe we could recognize that the health of the ocean is a symptom of the health of the human race. Maybe the wanton decimation of sharks around the world will inspire a new attitude toward sharks.

Maybe.

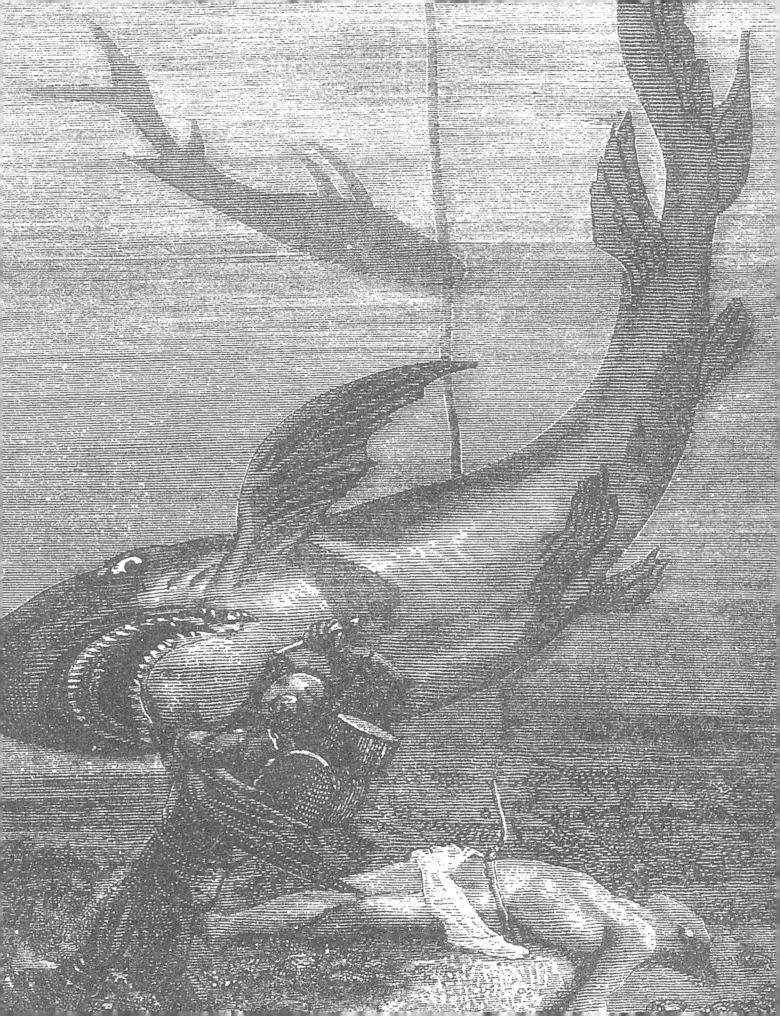

SHARK: THE EXHIBITION

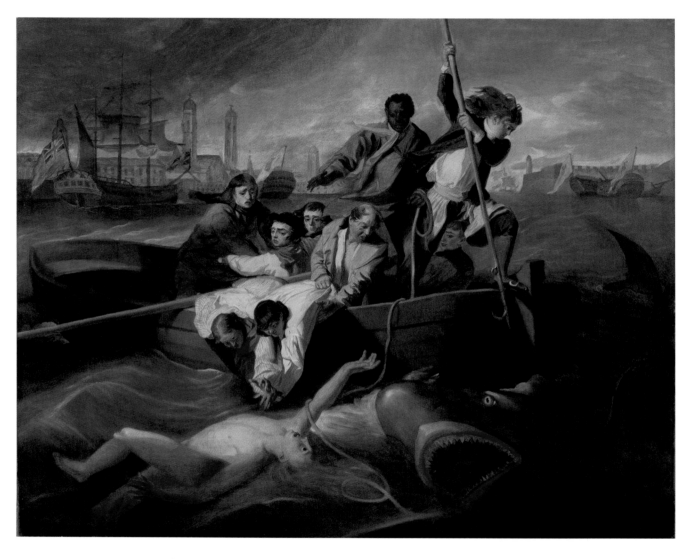

After John Singleton Copley, Boston, MA, 1738–1815 London

Watson and the Shark

American, ca. 1778

Oil on canvas, 24⁷/₈ x 30¹/₈ inches

The Metropolitan Museum of Art

Gift of Mrs. Gordon Dexter (42.71.1)

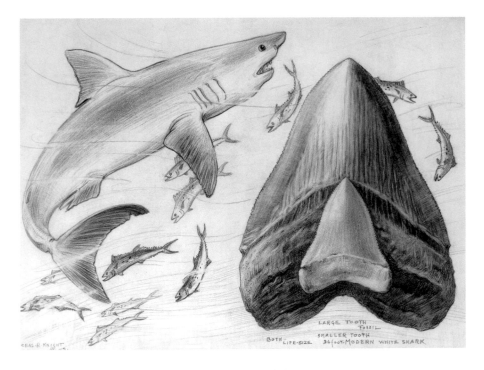

Charles R. Knight
Megalodon and Teeth
Pencil on paper, 14 × 18 inches
Courtesy of Rhoda Knight Kalt and Richard Milner

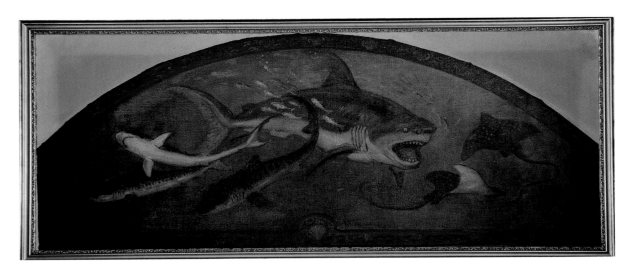

Charles R. Knight
Carcharodon and Rays
Oil on panel, 27 × 78 inches
Florida Museum of Natural History

Judy Cotton
Shark's Fin Soup, 2011
Oil on canvas, 60 × 36 inches
Courtesy of the artist

Sebastian Horsley
Study of the Great White Shark, No. 4, Dangerous Reef, South Australia, 1994
Oil and acrylic on canvas, 84 × 60 inches
Collection of Rachel Campbell-Johnstone

Don Ed Hardy
Tattoo Seas Shark, 1995
Color lithograph from the edition of 30
30 × 20 inches
Courtesy of Shark's Ink, Lyons, CO

Pascal Lecocq
Corrida III
Oil on canvas, 48 × 40 inches
Courtesy of the artist

Adam Straus
Swimming with Sharks, 2010
Oil on canvas on wood panel, 70 × 96 inches
Courtesy of the Nohra Haime Gallery
(Following spread)

José Bedia
Destino Final (Final Destiny), 1997
Acrylic and Conté crayon on wood, 8 × 33½ inches
Collection of Pearl and Stanley Goodman

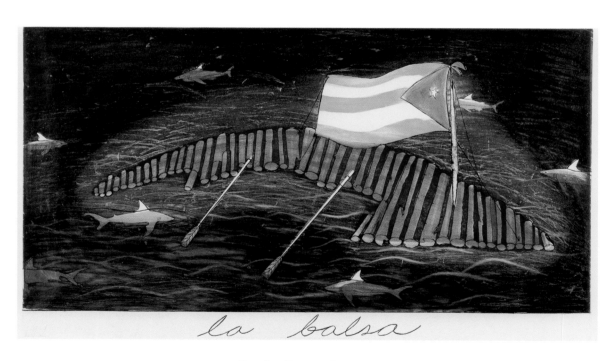

Sandra Ramos Lorenzo
La Balsa (The Raft), 1998
Engraving, 19 × 34¼ inches
Collection of the Museum of Art | Fort Lauderdale
Nova Southeastern University; Gift of Jorge H. Santis

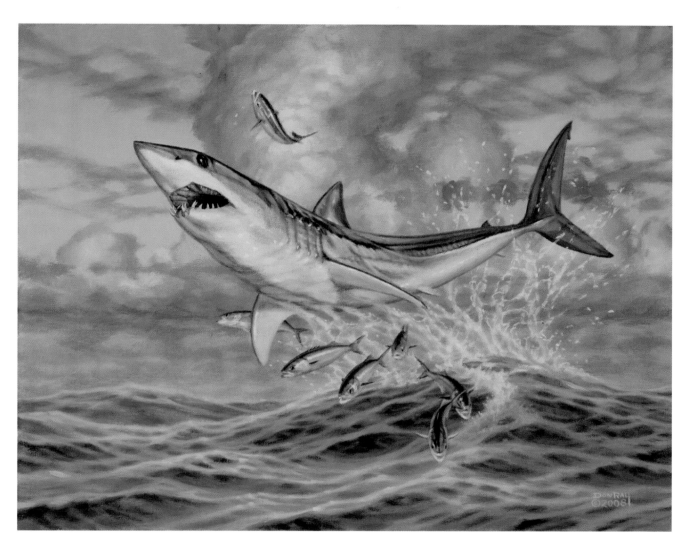

Don Ray
Leap of Faith
Oil on canvas, 16 × 20 inches
Courtesy of the artist

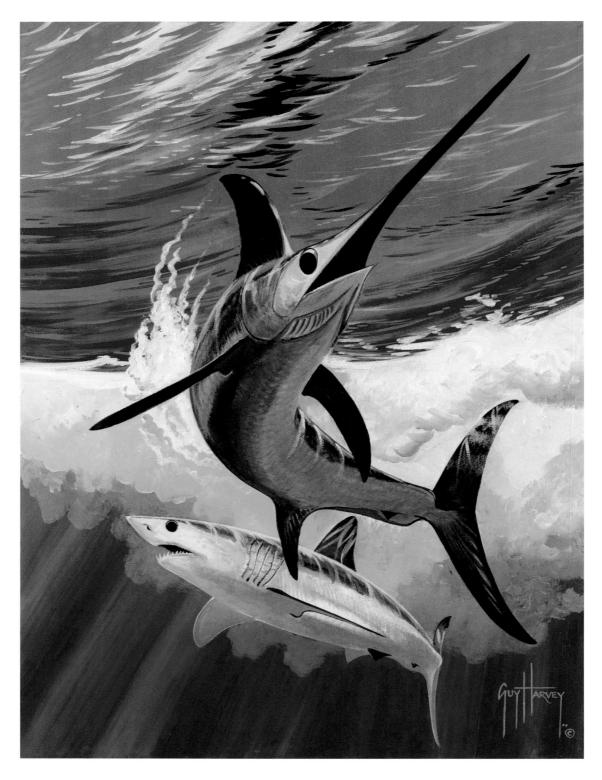

Guy Harvey
Live by the Sword, 2000
Acrylic on canvas, 80 × 49 inches
Collection of the artist

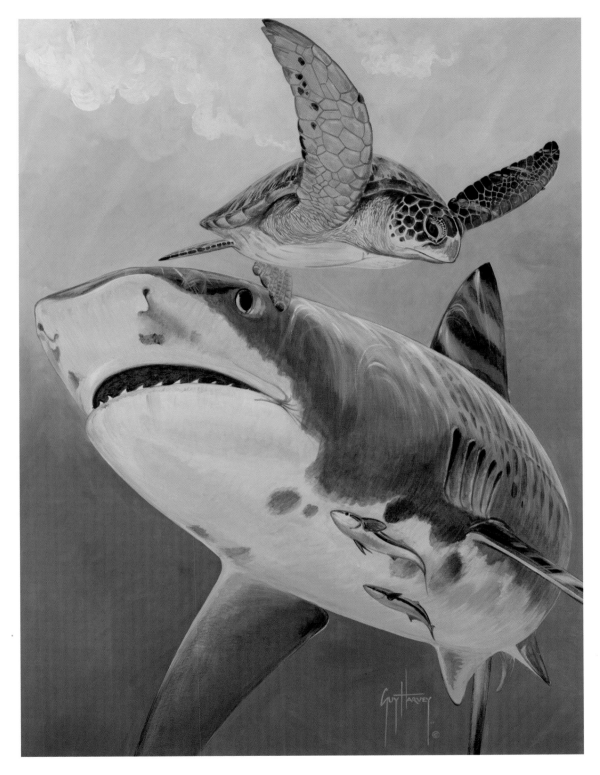

Guy Harvey
Eye of the Tiger, 2011
Acrylic on canvas, 51 × 41 inches
Collection of the artist

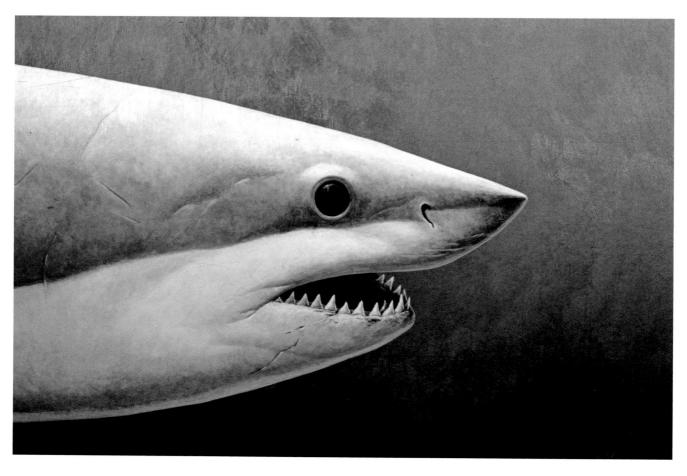

Richard Ellis
Great White Shark Portrait, 1974
Acrylic on board, 30 × 40 inches
Peter and Wendy Benchley Collection, Princeton, NJ

Richard Ellis
Chain Dogfish, 1973
Acrylic on canvas, 32 × 24 inches
Collection of Jonathan Snow

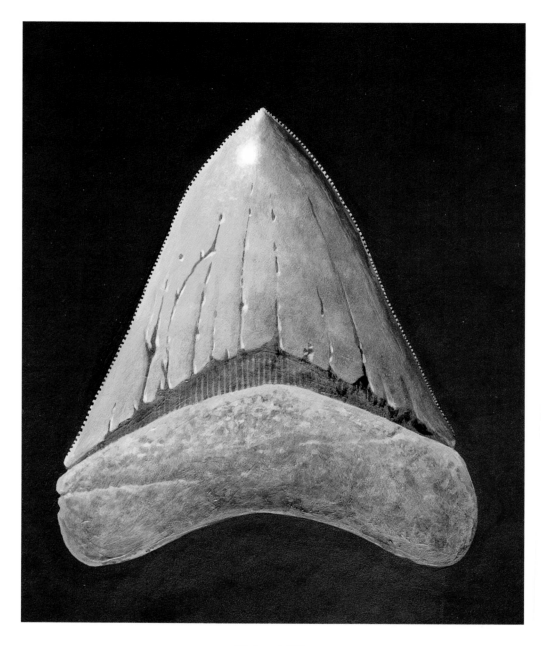

Richard Ellis
Megalodon Tooth, 2009
Acrylic on board, 28 × 24 inches
Courtesy of the artist

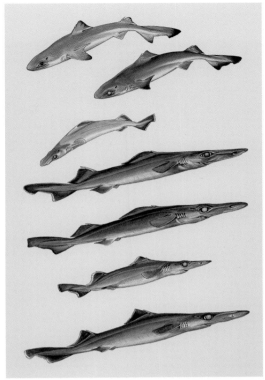

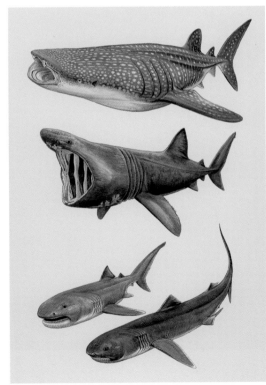

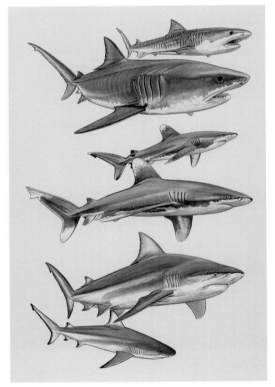

Marc Dando

A Field Guide to the Sharks of the World

126 full-color illustrations from 2001–2004

Watercolors, each 11 × 15 inches

Courtesy of the artist

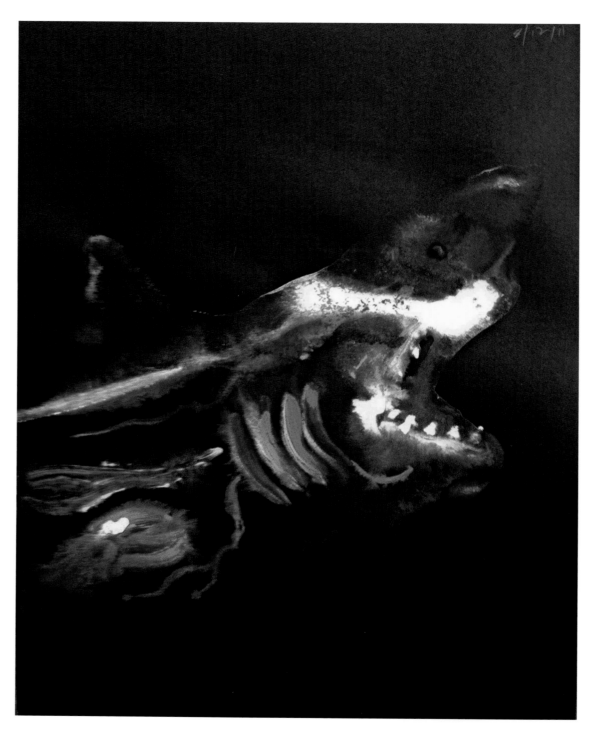

Alexis Rockman
Lateral View, 2011
Gouache on paper, 12 × 9 inches
Collection of the artist

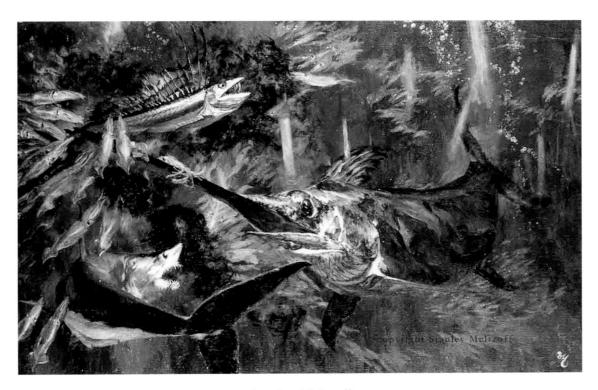

Stanley Meltzoff
Swordfish 3: Broadbill, Mako, Lancetfish, and Sea Arrows
in the Glow of the Cyalumes, 1988
Oil on panel, 31 × 48 inches
Courtesy of Mike Rivkin

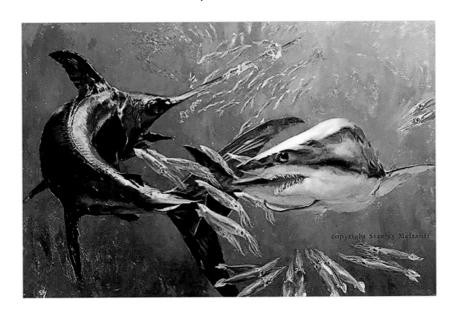

Stanley Meltzoff
Mako and Broadbill with Sea Arrows (Squid)
Oil on canvas, 30 × 43 inches
Courtesy of Mike Rivkin

Mark Weinhold
Hammerhead, 1988
Acrylic on canvas, 54 × 72 inches
Courtesy of the artist

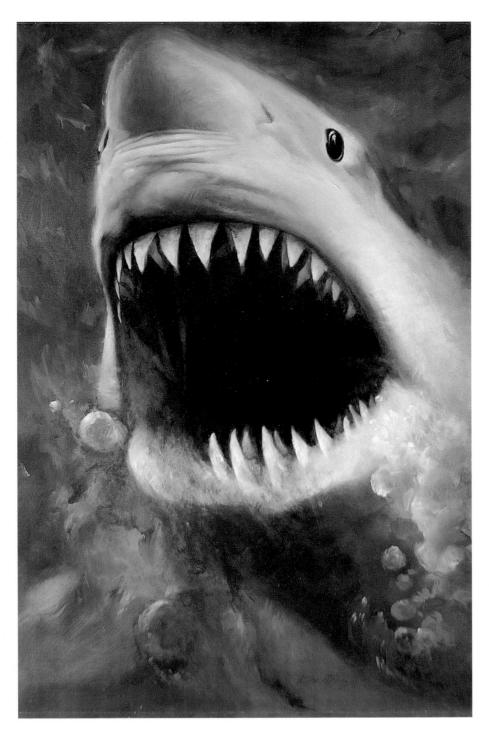

Roger Kastel
Original painting for second Jaws *paperback,* 1991
Oil on board, 32 × 28 inches
Courtesy of the artist

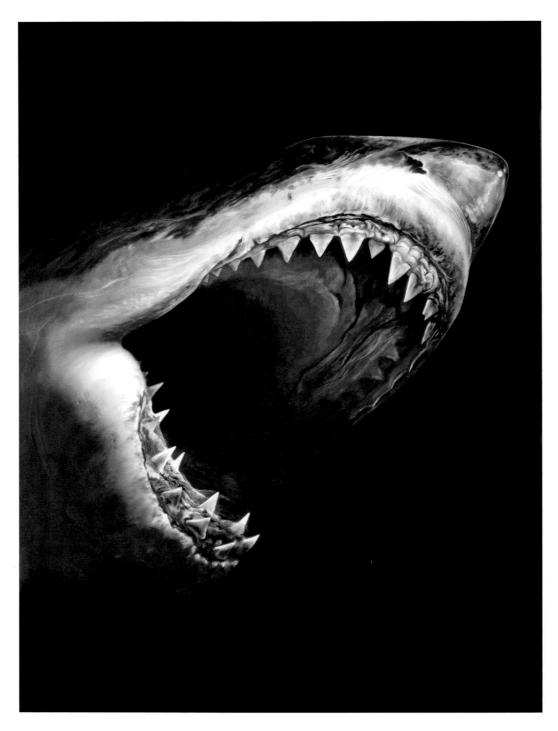

Robert Longo

Shark

Charcoal on mounted paper, 88 × 70 inches
Courtesy of the artist

Joe Alves
Production drawings for Jaws
Charcoal on paper, 16 × 18 inches
Courtesy of the artist

Ila France Porcher
Circles of the Sea, 2006
Airbrush acrylic, 32 × 26 inches
Collection of Mary O'Malley and Robert Dion

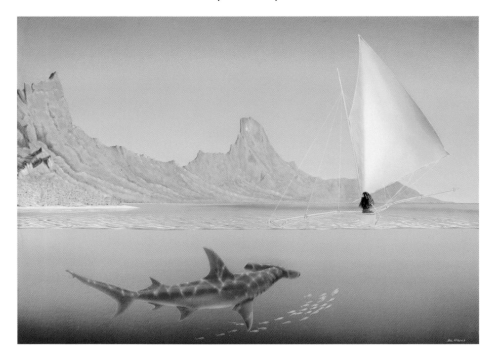

Ila France Porcher
The Guardian, 2001
Airbrush acrylic, 16 × 12 inches
Courtesy of the artist

Charles Lawrance
Pura Vita Water Walking, 2007
Acrylic on canvas, 60 × 72 inches
Courtesy of Robison and Richard Fine Art, Charleston, SC

Ray Troll
Ornithoprion, 2000
Colored pencil on paper, 33½ × 38¼ inches
Collection of Linda Millard and Sam Bergeron

Ray Troll
Nurse Sharks, 2001
Colored pencil on paper, 33½ × 38¼ inches
Collection of William Anthres

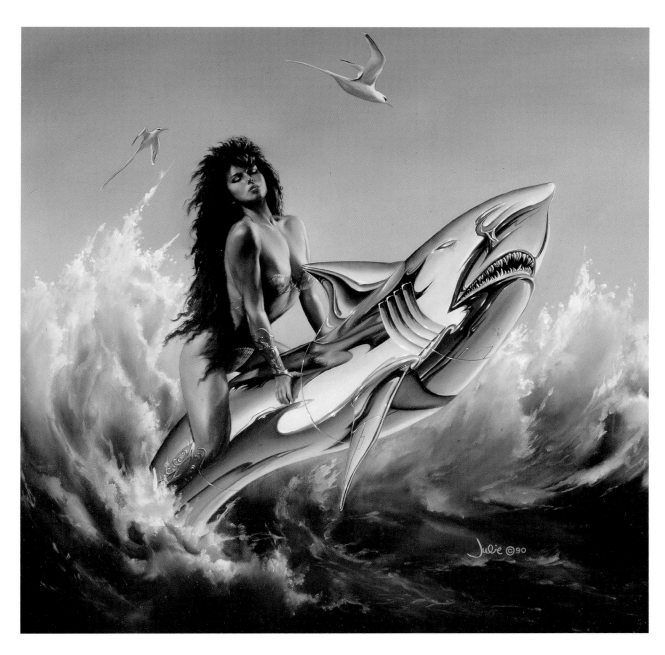

Julie Bell

Beauty and the Steel Beast

Oil on board, 18 × 18 inches

Courtesy of the artist

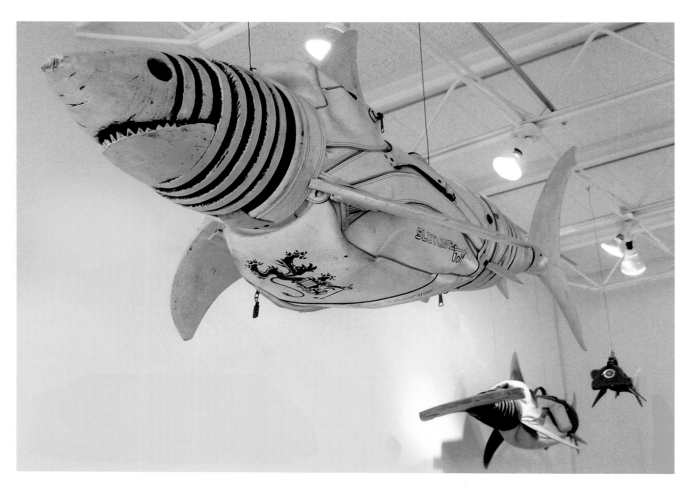

Robbie Barber
Great White Shark, 1992
Golf bag, wood, and oil paint, 27 × 94 × 22 inches
Courtesy of the Anderson Museum of Contemporary Art, Roswell, NM

Bill Wieger
Tiger Shark
Cast resin, 12½ × 6 × 4 inches
Courtesy of the artist

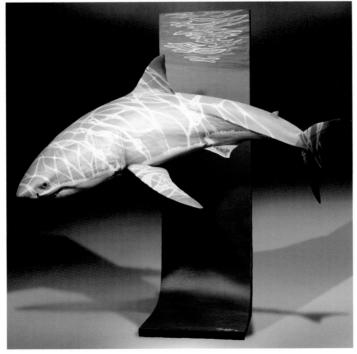

Bill Wieger
Great White Shark
Cast resin, 4 × 4 × 2½ inches
Courtesy of the artist

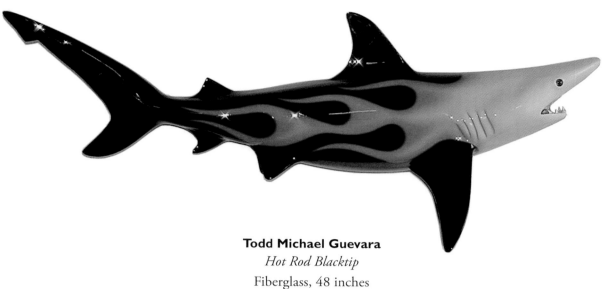

Todd Michael Guevara
Hot Rod Blacktip
Fiberglass, 48 inches
Courtesy of the artist

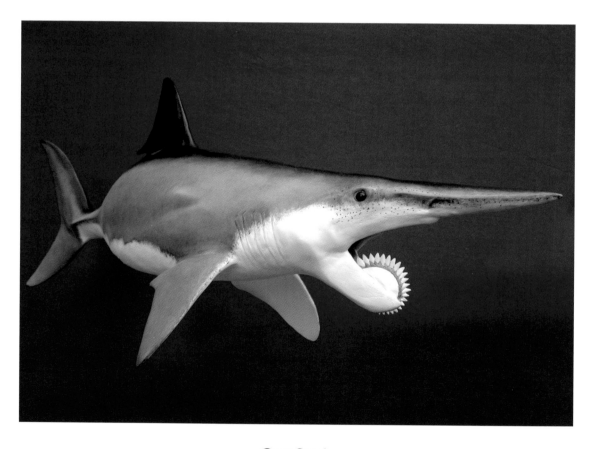

Gary Staab
Helicoprion
Cast resin, 30 × 14 inches
Courtesy of the artist

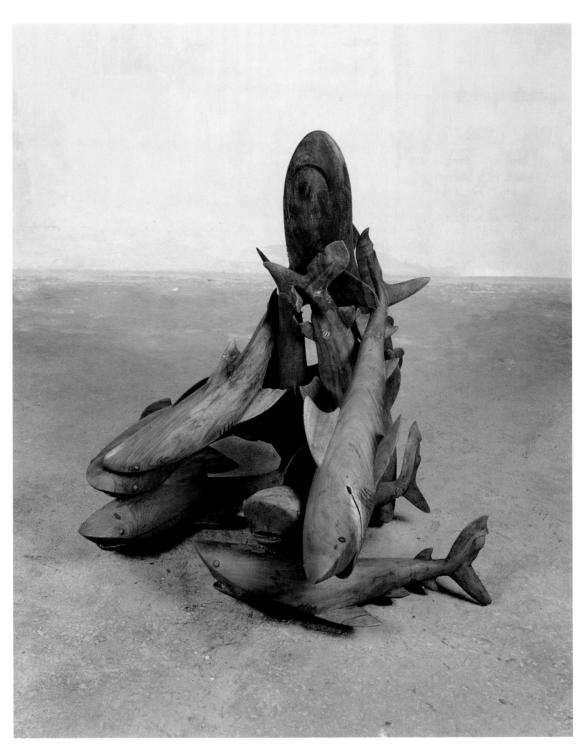

Kcho
La Familia (El niño), 2006
Wood, 33⅞ × 31⅞ × 32¼ inches
Courtesy of the Marlborough Gallery, NY

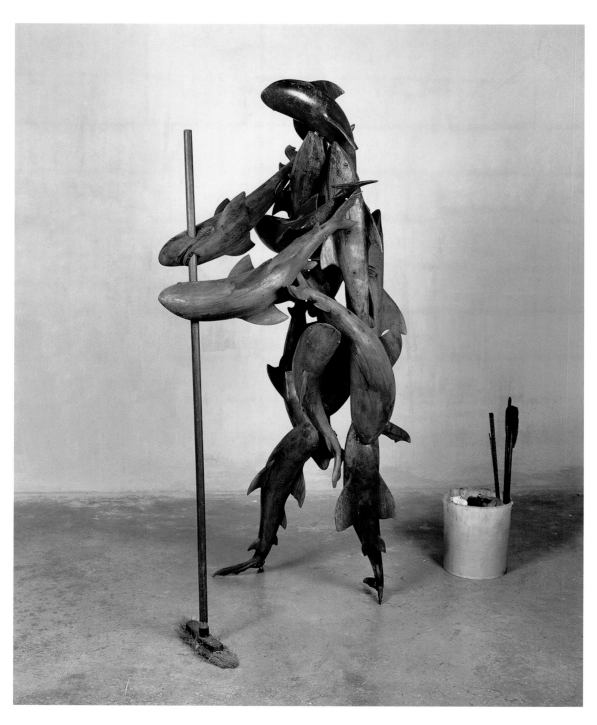

Kcho
La Familia (La madre), 2006
Wood and plastic, 65 × 39 ⅜ × 25¼ inches
Courtesy of the Marlborough Gallery, NY

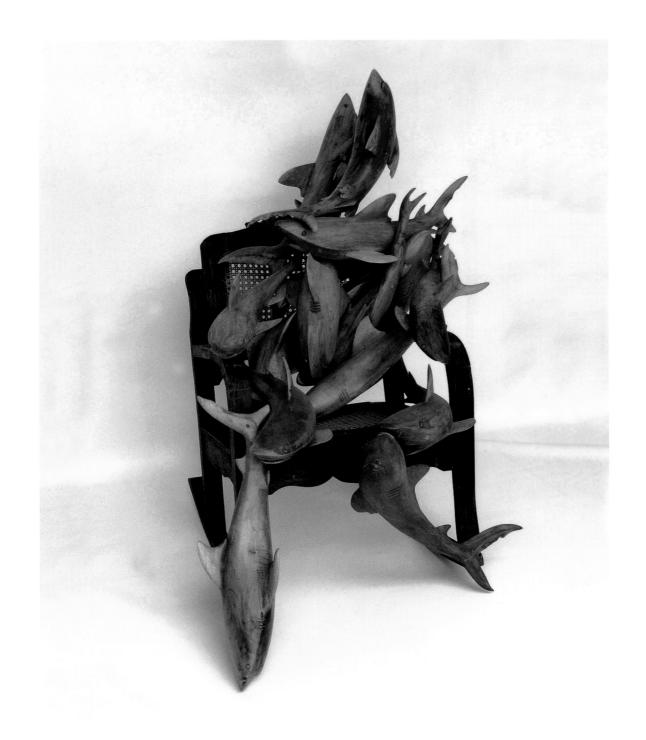

Kcho
La Familia (El padre), 2006
Wood, 50 × 39³/8 × 41 inches
Courtesy of the Marlborough Gallery, NY

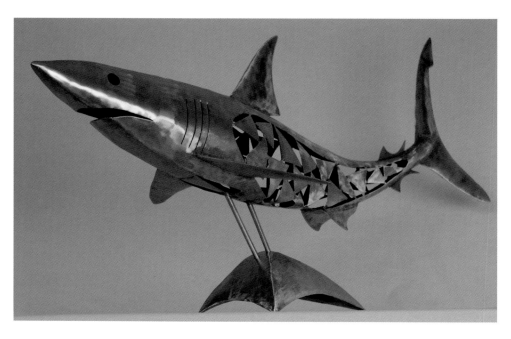

Stuart Peterman
Stainless Steel Shark, 2011
Stainless steel, 42 × 27 × 21 inches
Courtesy of the artist

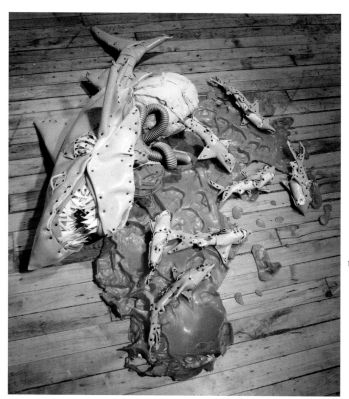

Johnston Foster
Catch and Release, 2009
Plywood, vinyl flooring, baby pool, plastic
trash can, vacuum hose, plastic table cloth,
vinyl, racket ball, marbles, and screws,
19 × 52 × 75 inches
Courtesy of Johnston Foster and RARE
Gallery, NY

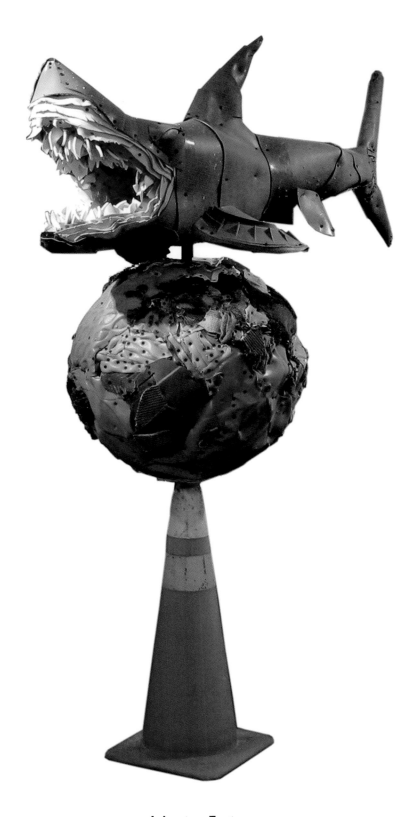

Johnston Foster
Life Psychotic II, 2009
Mixed media found materials including traffic cones, plastic, wood, carpet,
textiles, and rubber, 78 × 60 × 24 inches
Courtesy of Johnston Foster and RARE Gallery, NY

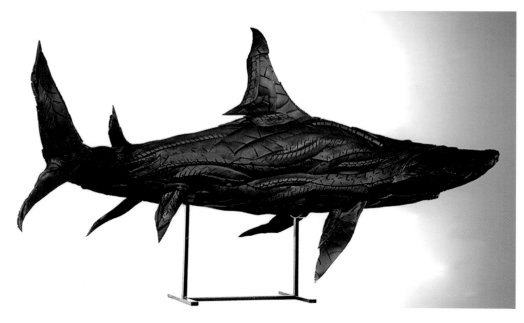

Yong Ho Ji
Shark, 2007
Car tires, glass, and metal, 88 × 64 × 23 inches
Courtesy of the Gana Art Gallery, Seoul, South Korea

Bruce Gray
Shark Table, 1993
Painted steel, 25 × 27 × 56 inches
Courtesy of the artist

Damien Hirst
Dark Rainbow, 2009
Resin, 22 × 15¾ inches
Collection of the Museum of Art | Fort
Lauderdale, Nova Southeastern University

Rinaldo Frattolillo
$5.99 Shark from Ebay, 2007
Toy shark suspended in acrylic, 5½ × 5 × 10 inches
Courtesy of the artist and Jim Kempner Fine Art, NY

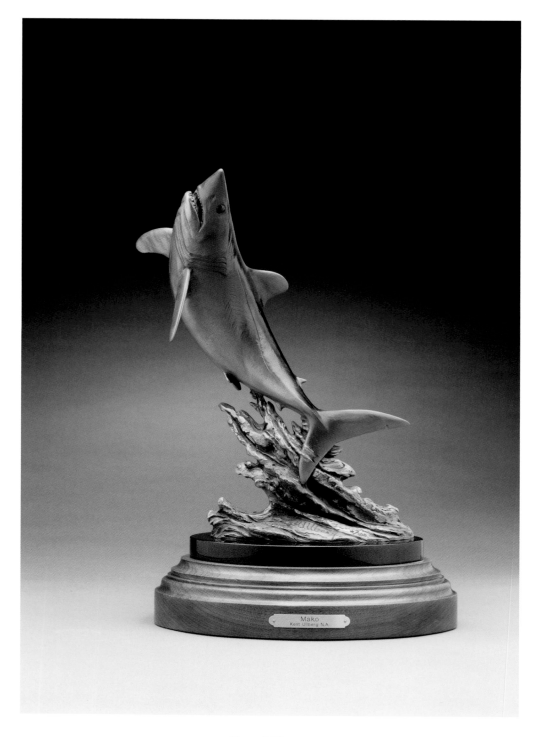

Kent Ullberg

Maquette of *NSU Mako*

Bronze, 18½ × 16 × 8 inches

Collection of Dr. George Hanbury II

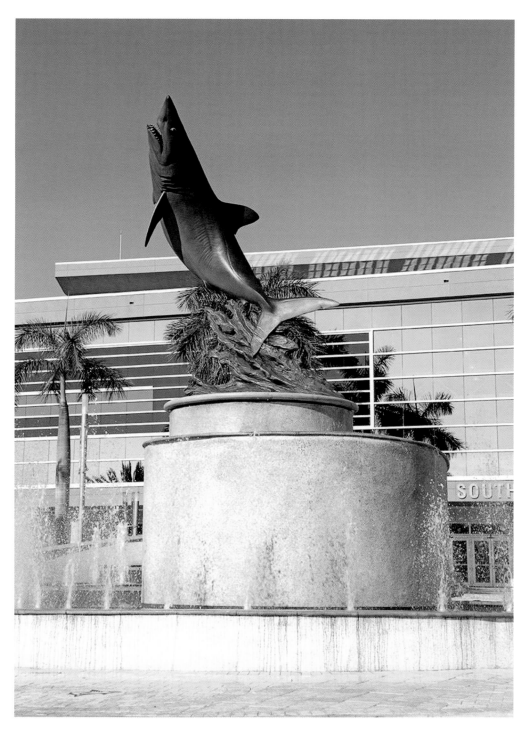

Kent Ullberg
Mako Fountain
Nova Southeastern University
Fort Lauderdale, Florida

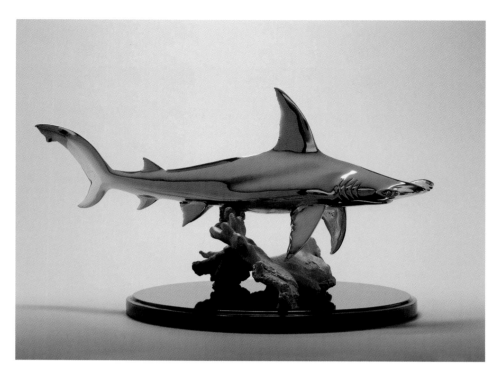

Victor Douieb
Hammerhead, 2008
Bronze, 26 × 18 × 13½ inches
Courtesy of the artist

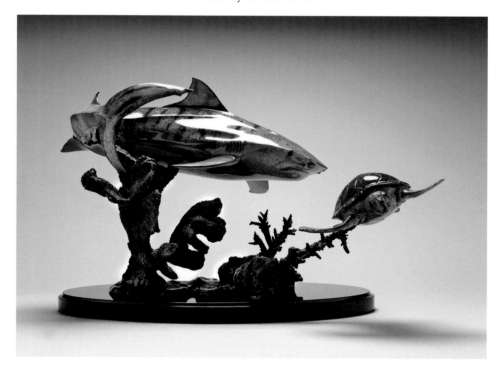

Victor Douieb
Tiger Shark with Turtle, 2010
Bronze, 27 × 22 × 16 inches
Courtesy of the artist

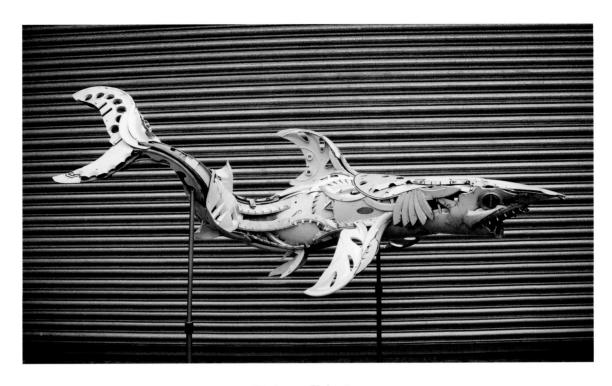

Ptolemy Elrington
Great White Shark, 2007
Hubcaps, 77 inches
Collection of Creatively Recycled Empire Ltd., London, UK

Eddie Borgo
Horror Necklace
Polished steel, 15 inches in diameter
Courtesy of Bradbury Lewis Gallery

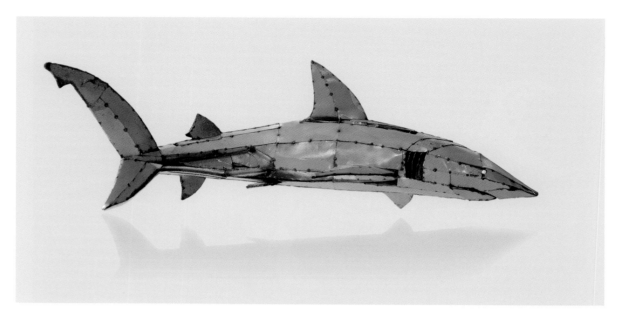

Kitty Wales
Hotpoint, 2011
Steel and appliance parts, 90 × 54 × 29 inches
Courtesy of the artist

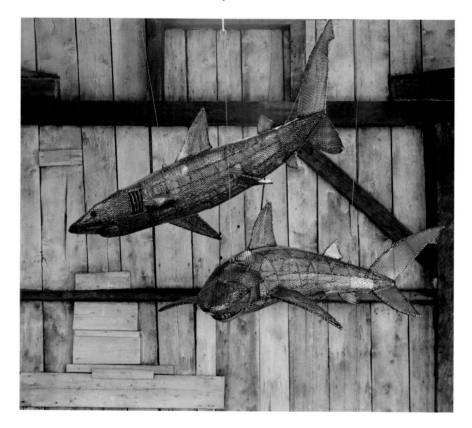

Kitty Wales
Stella and Maris, 2011
Steel and expanded metal, 64 × 38 × 27 inches
Courtesy of the artist

Don Straus
Shark Mask, 1991
Carbon fiber, Kevlar, titanium, closed cell foam urethane, and paint,
13 × 10 × 8¾ inches
Photo courtesy of the artist

Nana Montgomery
Undertow, 2003
Cotton quilt, 44 × 46 inches
Courtesy of the artist

Nootka Shark Mask
Wood, pigment, string, bark, and bone, 13 × 18 × 52 inches
American Museum of Natural History, 16/1947

Ijo, or Abua Igbo, Nigeria
Head crest, not dated, wood, fiber, glass, 28½ inches
Collection of the Museum of Art | Fort Lauderdale, Nova Southeastern University
Gift of Dr. and Mrs. E. Zimmerman

Tommy Joseph
Tlingit-style Shark Helmet, circa 2004
Carved wood, 12 × 12 × 16 inches
Collection of Ray Troll

Robin Lovelace-Smith
Modern Northern Tlingit
Shark Mask
Wood, 10¾ × 5½ × 3¼ inches
Courtesy of the artist

Robin Lovelace-Smith
Sharkey
11 × 5½ × 7 inches
Courtesy of the artist

Ken Thaiday, Sr.
Beizam (Hammerhead Shark Dance Mask), 2005
Plywood, bamboo, cockatoo feathers, string, plastic, and enamel,
39 × 50 × 25 inches
Courtesy of Ipswich Gallery, Brisbane

Mort Kunstler
MAD *magazine,* January 1976
Courtesy of Jim Beller, The *Jaws* Collection

Photos by David Doubilet

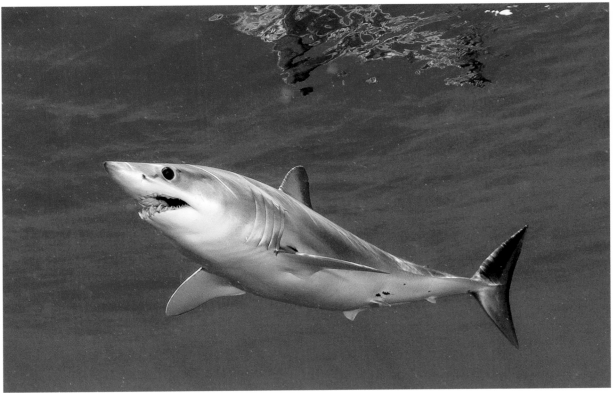

Photos by Chris Fallows

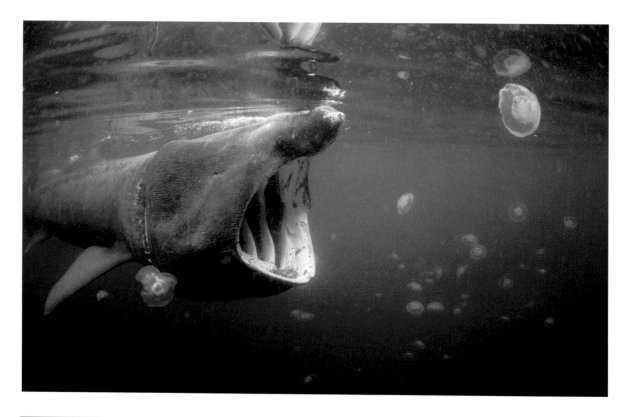

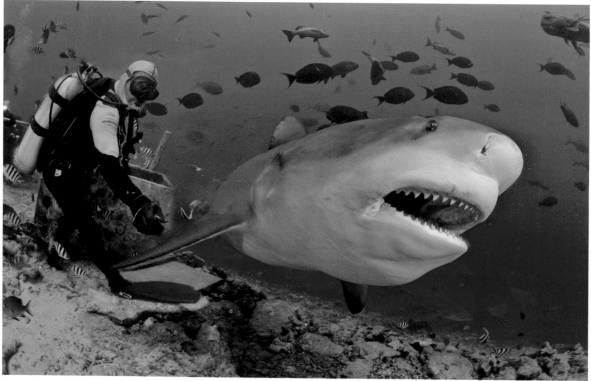

Photos by Douglas Seifert

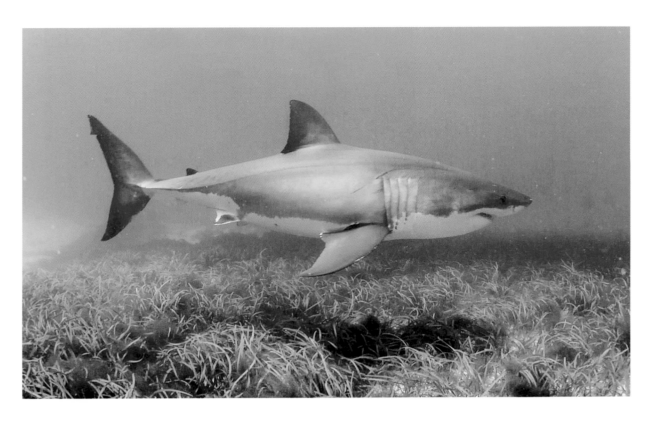

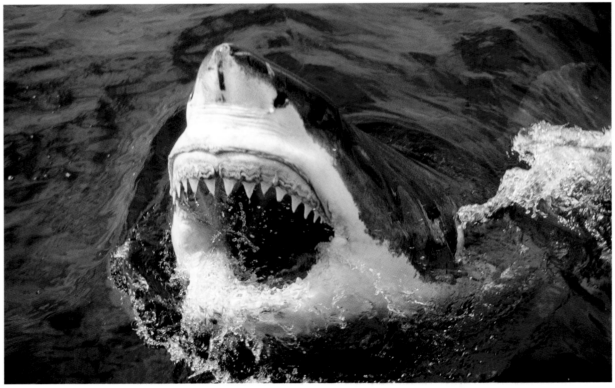

Photos by Rodney Fox

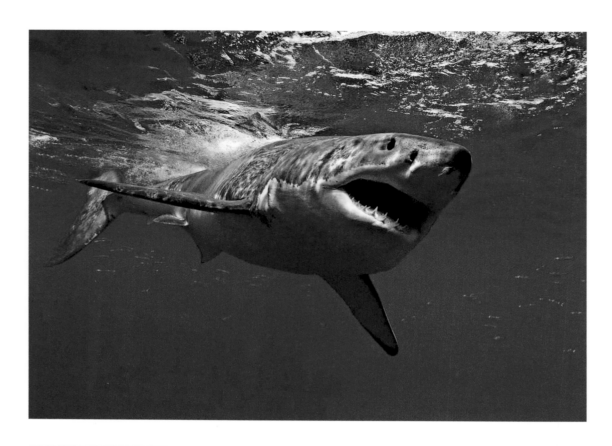

Photos by Ron and Valerie Taylor

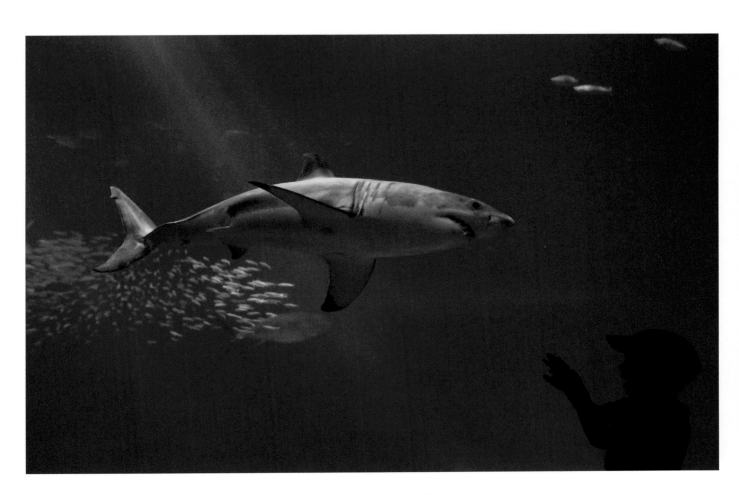

Captive Juvenile White Shark
(Still from the video)
Monterey Bay Aquarium

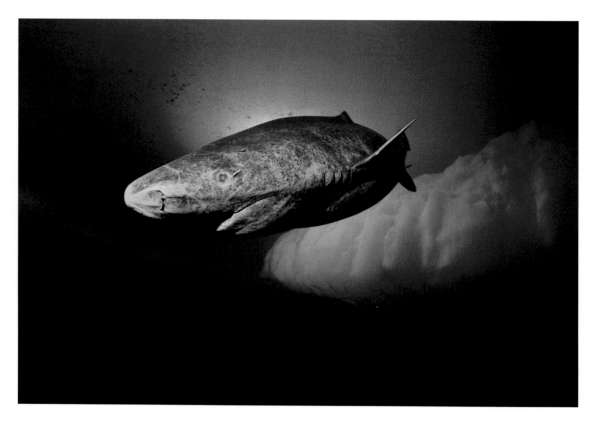

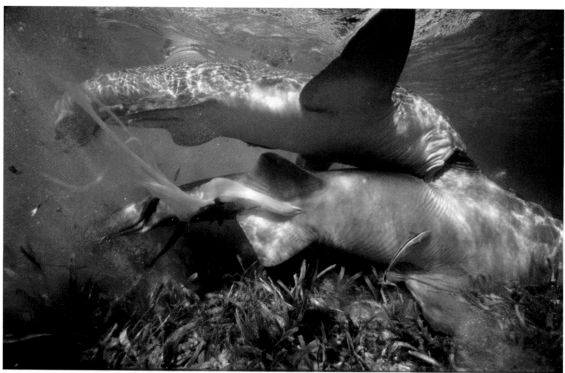

Photos by Nick Caloyianis

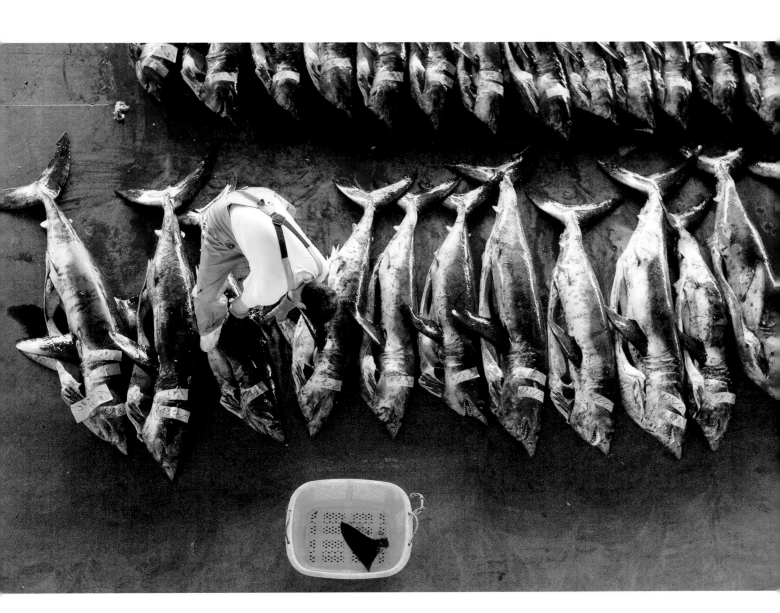

Photo by Alex Hofford

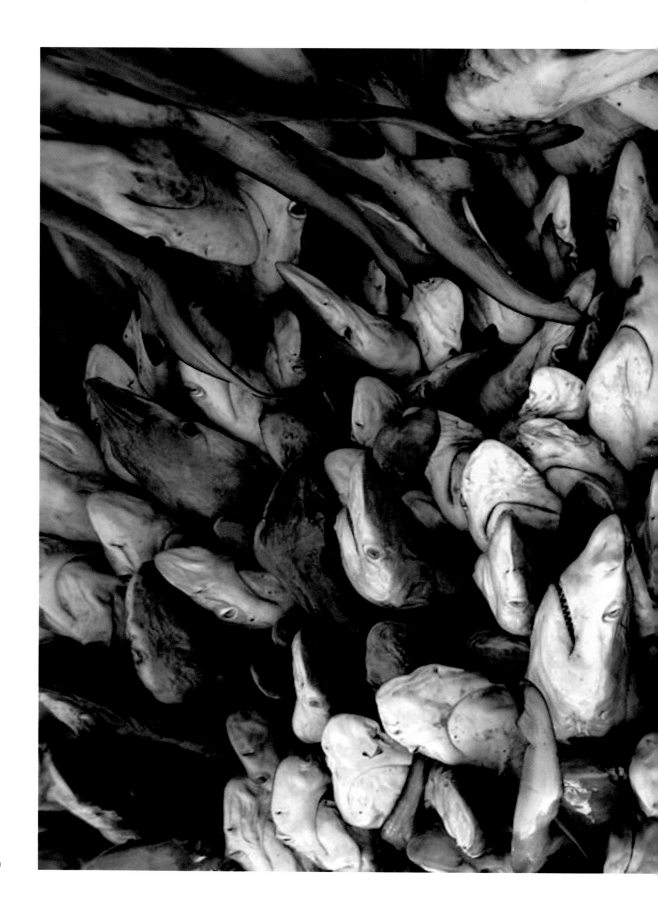

Photo by
Paul Hilton

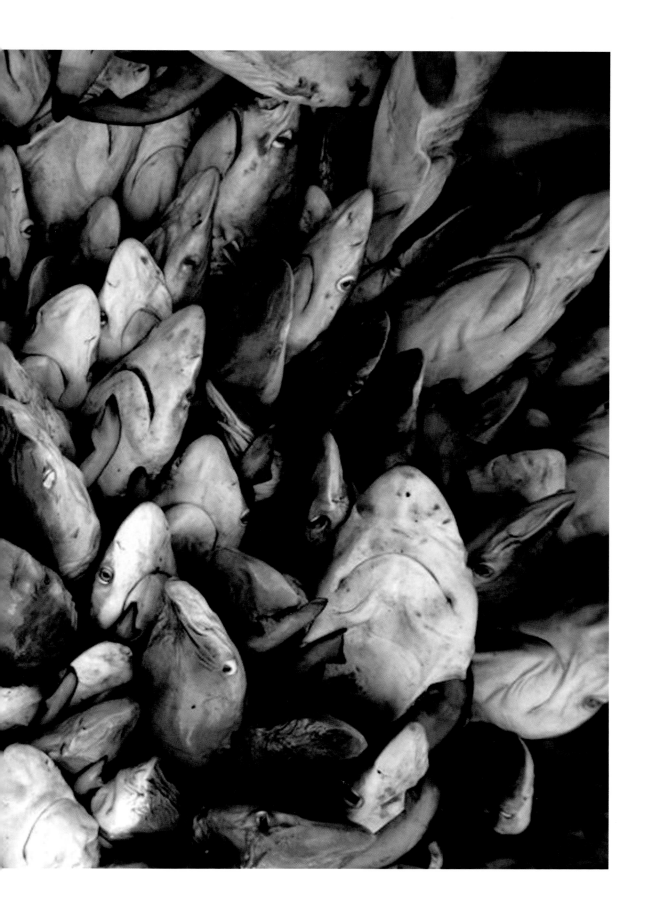

Jim Toomey

Cartoon Panels

Phil Watson

Cartoon Panels

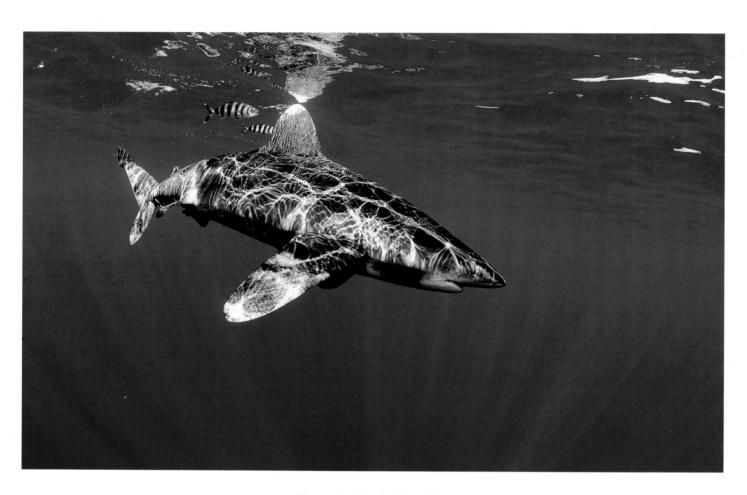

Photo by Daniel Botelho

Photo by Daniel Botelho

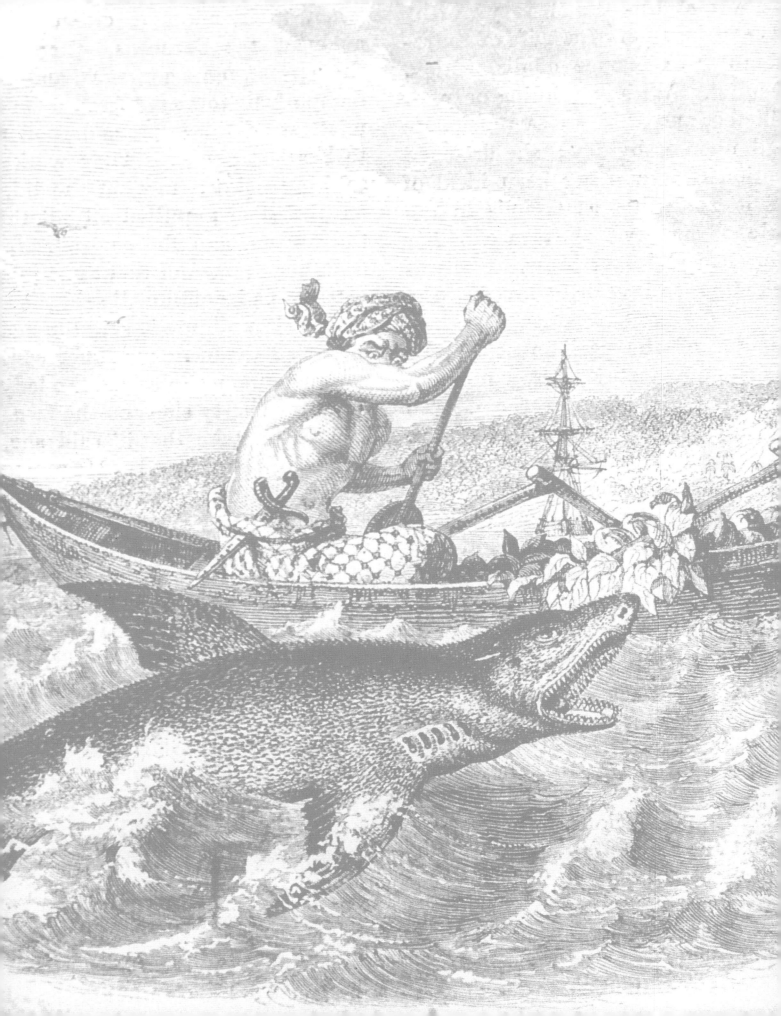

THE ARTISTS

Joe Alves

Joe Alves, born in 1936, in San Leandro, California, is an American film production designer best known for his work on three of the *Jaws* films. Educated in art, architecture, drama, and motion picture design, Joe was recruited by Disney Studios' animated special effects department right out of school. He later moved to Universal Studios' art department and progressed through the ranks as a set designer, art director, and production designer. In his early years at Universal he had the opportunity to work with such legends as Stanley Kramer and Alfred Hitchcock. Alves designed three features for Steven Spielberg: *The Sugarland Express, Jaws,* and *Close Encounters of the Third Kind.* He designed the three mechanical sharks for *Jaws,* with mechanical-effects man Bob Mattey supervising their physical construction in California. After the sharks were completed, they were trucked to the shooting location in Martha's Vineyard, Massachusetts, but unfortunately they had not been tested in salt water, causing a series of delays that have become legendary over time. Alves worked on *Jaws 2* in 1978 as both production designer and as second unit director. After John D. Hancock, the initial director of *Jaws 2,* was sacked, it was suggested that Alves co-direct it with Verna Fields (the editor of the original *Jaws*), but Jeannot Szwarc, a French-born television director, was hired to complete the film. Alves directed *Jaws 3-D* in 1983. He was nominated for an Academy Award and won the BAFTA for Best Art Direction for his work on *Close Encounters of the Third Kind* and worked on such classic films as *Forbidden Planet,* Walt Disney's *Sleeping Beauty,* and *Torn Curtain.* The model of New York that he created for John Carpenter's 1981 *Escape from New York* has been described as "memorably derelict." Joe Alves lives in Woodland Hills, California. *Photo courtesy of Joe Alves*

Robbie Barber

Robbie Barber was born in 1964 in Williamston, North Carolina, and raised on a farm near the Roanoke River in Martin County. He received his BFA degree from East Carolina University in Greenville, North Carolina, and his MFA degree from the University of Arizona in Tucson. He is currently an associate professor of art at Baylor University in Waco, Texas, teaching sculpture and three-dimensional design. Barber, who has earned critical acclaim for his sculpture, which utilizes a variety of media, is also the recipient of numerous awards. Among them are a North Carolina Arts Council Fellowship and a Southern Arts Federation/NEA Fellowship in sculpture. His work has also been exhibited at Redbud Gallery in Houston, Texas; Socrates Sculpture Park in Long Island City, New York; the Roswell Museum and Art Center in Roswell, New Mexico; the Rocky Mount Art Center in Rocky Mount, North Carolina; and Grounds For Sculpture in Hamilton, New Jersey, among others. Found objects are at the core of his work, both physically and conceptually. He regularly visits flea markets, junkyards, and thrift stores and has built a library of objects that he uses as raw material for the creation of his work and as inspiration for new ideas. The sharks in this exhibition are from an installation titled *The Reef*, created in 1992 in Roswell, New Mexico. This installation included sharks made from golf bags and wood, and crabs made from steel and toasters. The reef itself was made from discarded cement. There is no denying the humor in this ten-shark installation, but Barber was specifically thinking about the effects of humans on the environment and how animals have to deal with our trash-dumping tendencies. *Photo courtesy of Robbie Barber*

José Bedia

José Bedia was born in Havana, Cuba, in 1959. He studied at the Alejandro Fine Arts Academy and completed his advanced degree in fine arts specializing in painting at the Instituto Superior de Arte in Havana. He left Cuba in 1991, first going to Mexico and then to Miami in 1993. A gifted and compelling artist, Bedia approaches his subjects with the

social awareness of an anthropologist. The universalism of his work is the result of synthesizing and blending diverse elements drawn from ancient, geographical, historical, and cultural themes. Bedia says of his work, "It is an attempt at communication and community between the material and spiritual universe of 'modern' man and that of 'primitive' man." In *Fragment of Journeys*, Bedia paints powerful, animistic, and metaphorical images often featuring Afro-Cuban deities. Throughout this series, Bedia's symbolic animal and human-animal figures are presented in visual narratives that explore the effects of socio-political considerations and consequences on our societies. Bedia's work is provocative and profoundly beautiful. Bedia has exhibited in important museums throughout the world and received a Guggenheim Fellowship in 1994. His work can be found in both international private and public collections, including the Museum of Modern Art in New York; the Whitney Museum of American Art, New York; the Tate Gallery, London; the Hirschorn Museum and Sculpture Garden, Washington, D.C.; Centro Cultural de Arte Contemporaneo, Mexico City; Miami Art Museum; Museo de Bellas Artes, Caracas, Venezuela; and the Los Angeles County Museum of Art and many others. In 2010, He won the First Prize of Excellence in Painting at the IX Beijing Biennial. Bedia works and resides in Miami, Florida. *Photo courtesy of José Bedia*

Julie Bell

Julie Bell, born in 1958 in Beaumont, Texas, is a fantasy and wildlife artist, as well as a former bodybuilder and fantasy model for her husband, painter Boris Vallejo. She has painted covers for about one hundred fantasy/science fiction books and magazines since 1990. She has also painted covers for video games and best-selling trading cards for the superheroes of Marvel and DC. She designed the award-winning *Dragons of Destiny* sculpture series, *Mistress of the Dragon's Realm* dagger series, and the *Temptation Rides* sculpture series produced by the Franklin Mint. She and her husband have done many paintings for advertising campaigns such as Nike, Coca-Cola, and Toyota. She has painted the covers for two albums by rocker Meat Loaf: *Bat Out*

of Hell III: The Monster Is Loose and *Hang Cool Teddy Bear*. "Beauty and the Steel Beast" was the cover illustration for the January 1992 issue of *Heavy Metal* that featured a portfolio of her fantasy paintings. *Photo by Boris Vallejo*

Jim Beller

Jim Beller, forty-six, tells the story of his first recollection of the movie *Jaws*:

When I was a kid I was a big fan of monster films. I remember on the last day of school in 1975 seeing a copy of Time *magazine with the "Super Shark" cover on my teacher's desk. When I asked her what it was she told me that it was a movie about a monster shark eating people while at the beach. Well, that was it. I ran home after school and begged my parents to go see it. My mom told me that she was going to see it that night with my dad and she would see. The next weekend she took my friends and me to see it in Boston and I've been an avid* Jaws *fan and collector ever since.*

And what a collection! Since that fateful day in 1975, Jim has amassed the largest collection of *Jaws* memorabilia in the world. It's not just the obvious, like posters, T-shirts, caps, shark tooth jewelry, rubber sharks, puzzles, mugs, and games, but he also has every book mentioned or shown in the movie; dozens of original newspaper articles from the local Martha's Vineyard newspapers during the 1974 production; a schematic used in the cage attack scene of "Bruce" the mechanical shark; a color copy of Joe Alves's storyboard book; original production crew T-shirts; a number of scrapbooks including production notes and letters; the set-used screenplay by Carl Gottlieb; and a couple of original teeth from Bruce the mechanical shark. (You can see his entire *Jaws* collection at his website Jawscollector.com.) In June of 2011, with author Matt Taylor, Beller published the critically acclaimed and highly successful coffee-table book *JAWS: Memories From Martha's Vineyard*. After the exhibition of some elements of his collection at the Museum of Art Fort Lauderdale, Jim hopes to be able to found his own *Jaws* museum on Martha's Vineyard. *Photo courtesy of Jimmy Jawz*

Eddie Borgo

Jewelry designer Eddie Borgo was born in 1979 in Atlanta. He studied art foundation at Virginia Commonwealth University and costume theory at the Art Institute of Atlanta. In 1998 he moved to New York City to continue his studies at Hunter College and also worked at Barney's and the visual arts department of Donna Karan. His love of sculpture has inspired his jewelry design, and his arrival on the scene came at the moment that fashion editors and retailers recognized the need for innovative and exciting new talent. In his work, Borgo combines the traditions of American costume jewelry, the history of rock and roll, and the heritage of New York City to produce a new jewelry line that infuses a fresh perspective and energy to these established themes. His interest lies somewhere between the bold shapes and geometric forms of modern architecture and sculpture and the emotive energy of post-punk beauty Siouxsie Sioux and the Rolling Stones. His work offers both a clean aesthetic and clarity of form, even through the use of unexpected and suggestive materials. Borgo's jewelry gives the impression that he is a creature of city streets, a downtown kid, a New Yorker, and while he is all those things, he'll also tell you about the genteel metalsmithing tradition of Providence, Rhode Island, where he produces his eponymous jewelry line, and how it became a center of costume jewelry manufacturing. In 2010 he was nominated for the CFDA's Swarkovski Award for Accessory Design, and was runner-up in the CFDA/Vogue Fashion Fund. Borgo says that the "horror collar" featured in this exhibit, was inspired by the mayor of Halloween Town from Tim Burton's 1993 *The Nightmare Before Christmas*. Of the mayor, Borgo says "His wild mood swings made his cone head spin around from a happy face to a scary one. It's a figurative representation of a two-faced politician." To those of us with an interest in sharks, the silver-plated brass and crystal necklace looks a lot more like the shark in *Jaws* than the mayor of Halloween Town. *Photo by Derek Kettela*

Daniel Botelho

Daniel Botelho, born in Brazil in 1981, is an award-winning photojournalist, specializing in underwater photography. His connection with nature dates back to his childhood, as he grew up between the sea and the rainforest in Rio de Janeiro, Brazil. His spectacular photographs can be seen in a hundred advertising campaigns, and he contributes to publications in more than twenty countries, including *National Geographic, Africa Geographic, Ocean Geographic, Time, BBC Wildlife, Plongeur, Shark Diver Magazine,* and *Mergulho,* Brazil's biggest dive magazine. Concerned with ocean devastation, Daniel has become a warrior against the massacre of whales and sharks, carried out through unsustainable practices that are bound to lead these animals to extinction. As he writes, "It is not about the eyes, camera or lenses; I take photos with my heart. I am in love with the subjects I capture and I want to spread that love through my images. I hope you enjoy browsing my website [www.danielbotelho.com] and please help me spread the word. It's the only way to save our seas. Respect and love the oceans!" For three months of the year, Daniel is based in Rio, but for the rest of the year, he is on the road in pursuit of his subject matter. *Photo courtesy of Daniel Botelho*

Nick Caloyianis

Nick Caloyianis, born in Connecticut, is considered one of the top underwater filmmakers in the world. His expertise in underwater imaging is sought after by feature film and IMAX projects, television commercials, and documentaries. His company also produces and directs natural history documentaries. His work has been recognized by numerous awards including an Oscar, Primetime Emmys, Gold and Special Jury by Festival of the Americas, Golden Cines, Earthwatch, and a Gold Communicator Award. Nick is also known for his artistic imagery of shark behavior and for spearheading groundbreaking film research projects with scientists on sharks, including the first-ever filming and

still photography in 1995 of free-swimming Greenland sharks in the high Arctic. Trained in shark biology under Dr. Eugenie Clark at the University of Maryland, Nick is passionate about educating the public through visual means, and about helping audiences around the world better understand sharks and the need to conserve them. A consultant to many shark research filming projects, he was one of nine shark attack survivors who, on behalf of the Pew Charitable Trust, lobbied nine US senators for support to help pass the Shark Conservation Act of 2009, which banned shark finning in all US waters. A naturalist, author, lecturer, and former educator, Nick's remarkable still images, including those of sharks, have been published in numerous books including, *TimeLife's Greatest Photographs of the 20th Century,* National Geographic's *Visions of Paradise*, and *The Shark Handbook*, as well as in numerous popular magazines such as *National Geographic* and *Smithsonian.* He is on the Board of Advisors for the Shark Education Research Foundation (SERF). Currently he is working on a basking shark research project.

Photo courtesy of Nick Caloyianis

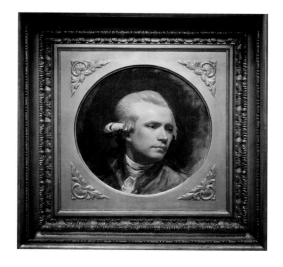

John Singleton Copley

John Singleton Copley (1738–1815), virtually self-taught as a portraitist, was the foremost artist in colonial America. He emigrated to London in 1774, where he began to specialize in narrative scenes from history and joined the influential artistic institution, the Royal Academy of Art. Among his better-known works are *The Death of Major Peirson, Defeat of the Floating Batteries at Gibraltar, The Boy with the Squirrel,* and the portraits of John Hancock and Paul Revere. *Watson and the Shark* was inspired by an event that took place in Havana, Cuba, in 1749. Fourteen-year-old Brook Watson, an orphan serving as a crew member on a trading ship, was attacked by a shark while swimming alone in the harbor. His shipmates, who had been waiting on board to escort their captain ashore, launched a

valiant rescue effort, and he was plucked from the jaws of death by his stalwart companions. He lost a leg, but went on to become the Lord Mayor of London. Copley painted three versions of this painting. One is in the National Gallery in Washington, the second is in the Boston Museum of Fine Arts, and the third is in the Detroit Institute of Art. Ours is a contemporary copy, loaned by the Metropolitan Museum of Art in New York. *Photo courtesy of the National Gallery*

Judy Cotton

Born and raised in Australia, Judy Cotton moved to the United States in 1971 and now divides her time between New York and Connecticut. "A passionate observer of the natural world, both in the wilds of America and in her native Australia, Cotton has long been drawn to the lives and movements of animals, plants, fires, floods, rivers and skies to life in flux," writes the critic Sebastian Smee. What initially appears as an idyll in her work is undercut by contemporary dystopian disquiet and malaise, a sense that natural life is heading toward extinction. Smee calls Cotton's paintings "powerfully haunted by life . . . informed by tremendous technical confidence. . . . The confidence matters because behind it is a bracing willingness to take risks, and a love of that tradition of truth-telling immediacy in paint that runs from Velasquez and Hals, to Manet, Soutine, and Bacon." An internationally recognized artist, Cotton has had thirty solo shows and over sixty group exhibits in the United States, Australia, Great Britain, Japan, South Korea, and Hong Kong. Her work is in numerous collections worldwide, including the Metropolitan Museum of Art, the Phillips Gallery, the National Gallery of Australia, and the Florence Griswold Museum. A ten-year survey of her work traveled in museums throughout Australia in 2002–2003. Her painting "Shark Fin Soup" was done specifically for this show. *Photo by Yale Kneeland III*

Marc Dando

Marc Dando completed an honor's degree in Zoology at Nottingham University and moved into a career as a graphic designer. After many successful years in commercial graphics, an opportunity occurred to work on various natural history projects, initially in design, but finally into his passion for wildlife illustration. Because of his scientific and commercial graphics background, his work is varied. Dando works with a variety of mediums—pencil, pen and ink, watercolor, computer graphics or combinations of these. His realistic style and unerring eye for overall graphical composition have often led to publication. However, in response to demand for his work, he has begun to produce more artistic pieces that work on many different levels, creating graphic shapes and movements from a distance while containing intricate detail on closer examination. His inspiration is always from nature. Marc lives and works in Cornwall, England. *Photo by Julie Dando*

David Doubilet

David Doubilet, generally regarded as the best underwater photographer in the world, was born in New York in 1946, and holds a degree from Boston University in film and broadcasting. At the age of twelve, he took his first underwater shots with a Brownie Hawkeye camera encased in a rubber anesthesiologist's bag from his father's hospital. From the age of fifteen until he graduated from college in 1970, he spent nearly every summer in the Bahamas, working as a general factotum and then as a diving instructor. For two summers he worked as a diver/photographer at the Sandy Hook Marine Lab; it was in the murky waters of the New Jersey shore that he took his first underwater shark photographs. Doubilet helped pioneer the split-lens camera,

which allowed him to take pictures above and below the surface simultaneously. His goal as a photographer is to "redefine photographic boundaries" every time he enters the water. In order to capture images of underwater wildlife, he takes several cameras with him on each of his trips. He has photographed nearly seventy stories for *National Geographic* and authored many of them. With Genie Clark, he has worked in the Red Sea, Australia, Taiwan, Japan, and Isla Mujeres, Mexico, where his photographs of "sleeping" sharks demonstrated undeniably that sharks did not have to keep moving to breathe. He also photographed the 1987 *National Geographic* story on South Australia, text by Richard Ellis, and the 2000 story on the white sharks of South Africa, text by Peter Benchley. He has published numerous books incorporating his text and photographs, including *Water, Light, Time*; *Fishface*; *Light in the Sea*; *The Red Sea*; *Australia's Great Barrier Reef*; *Pacific Undersea Journey*; and *Face to Face with Sharks*. He has received many awards for his work, such as the Academy of Achievement Award, the Explorers Club's Lowell Thomas Award, and the Lennart Nilsson Award for scientific photography. He is a member of the Royal Photographic Society and the International Diving Hall of Fame, and is a Founding Fellow of the International League of Conservation Photographers. Long a resident of New York City, Doubilet now lives in Clayton, New York, a small town near the St. Lawrence River, with his wife and underwater diving partner, Jennifer Hayes. They have a second home in the coastal town of Dekelders, South Africa. *Photo by Jennifer Hayes*

Victor Douieb

Victor Douieb was born in Tunisia in 1962; his parents moved to Paris when he was six months old. He now lives and works in Los Angeles. As a youngster, his interest in the sea was sparked by *Le Monde du Silence (The Silent World),* the 1956 French documentary co-directed by the famed French oceanographer Jacques-Yves Cousteau. "Before sculpting my first shark," Victor explains, "I had been a dental ceramist and technician, giving me the knowledge and experience that later made sculpting very natural for me. One day while at work, I suddenly got the urge to sculpt a little shark out of silver, not realizing that twenty years later, sculpting would become my profession." He is also a certified personal

fitness trainer, which helped him to understand the anatomy and dynamic movements of the body. It was a simple translation of the muscles and bones to the overlying surface of the sharks and other animals. Victor has been passionate about sharks since his first deep-sea dive when he was eighteen years old. Victor Douieb has traveled the world to see and experience his subject matter "up close and personal." Only a dedicated artist would free-dive (no cage) with tiger sharks, to get, as he phrases it, "the true feeling of the great tiger shark underwater." Victor's love and admiration for his subject matter is evident in every piece. Through his patination, Victor Douieb has managed to communicate color, texture, skin, muscle, and most difficult of all, flickering light coming through the water. Victor's bronzes gleam with energy, none more so than his stainless-steel sharks, which are simultaneously solid, liquid, modern and ancient. Victor began sculpting sharks as a means of expressing his appreciation of the sharks' simplicity of form and function, but also to help bring attention to the impact that overfishing and the needless slaughter by the shark fin industry is posing to shark populations worldwide. Through his passionate and innovative work, Victor Douieb has placed himself at the top of a very small group of artist-conservationists whose art is created not only for the art lover, but also for the sake of the very animals they depict. *Photo by Brian Buel*

Richard Ellis

Born in 1938 in New York City, Ellis is a graduate of the University of Pennsylvania. After college and the US Army (serving in Hawaii), Ellis began work as an exhibit designer at the Academy of Natural Sciences of Philadelphia. He then joined the staff of the American Museum of Natural History in New York, where, among other things, he designed the Hall of the Biology of Fishes and the life-sized blue whale model. His paintings of sharks, whales, and fishes hang in numerous galleries, museums, and private collections around the world. One hundred and six of his paintings were selected by the Smithsonian Institution to form a traveling exhibit of the marine mammals of the world, and these paintings are now in the permanent collection of Whaleworld, a museum in Albany, Western Australia. In 2005, in conjunction with the publication in Italian of his *Encyclopedia of the Sea*,

Ellis was given a one-man show of his drawings at the Museo del Mare in Genoa. He is the author (and sometimes illustrator) of more than one hundred magazine articles and twenty-three books, including *The Book of Sharks* (1975), *The Book of Whales* (1980), *Dolphins and Porpoises* (1982), *Men and Whales* (1991), *Great White Shark* (with John McCosker, 1991), *Physty, the True Story of a Young Whale's Rescue* (1993), *Monsters of the Sea* (1994), *Deep Atlantic* (1996), *Imagining Atlantis* (1998), *The Search for the Giant Squid* (1998), *The Encyclopedia of the Sea* (2001), *The Empty Ocean* (2003), *Tuna: A Love Story* (2008), *On Thin Ice: The Changing World of the Polar Bear* (2010), *The Great Sperm Whale* (2011), and this one.

Photo by Rick Edwards, American Museum of Natural History

Ptolemy Elrington

Ptolemy Elrington was born in Watford, London, in 1965. In his late teens, he experimented with various life choices, but by his twenties he focused on art and studied art and design at Bradford & Illkley Community College in West Yorkshire. Before he developed his personal form of expression, he worked for seven years on community projects and festivals. "Messing about" with found materials attracted enough attention so that he decided to try to earn a living with his art. Early on, he just gave his creations to family and friends but soon learned that people were willing to pay for them. "I like to work with reclaimed materials," he says, "to show that what is one person's junk is another man's treasure." From junkyards and roadsides, he gathers the materials to fashion dogs, dolphins, fishes, rhinos, warthogs, birds, dragons, insects, lizards, toucans, sheep, sharks, and other animal forms. His material of choice is the reclaimed or recycled hubcap; he prefers those from luxury cars such as BMW and Mercedes because of their quality and flexibility. Originally made of chrome-plated steel, hubcaps are now made of different kinds of plastic, so Elrington's tools are knife and hacksaw. After college he stayed in Bradford, but he now maintains a studio in Brighton, a resort city in Southern England. Because so much of his work uses reclaimed hubcaps, he has named his website and business "Hubcap Creatures." *Photo courtesy of Ptolemy Elrington*

Chris Fallows

African-born Chris Fallows is an expert on great white sharks and their hunting habits. He has amassed the world's largest database of predatory events involving great white sharks from False Bay, South Africa. Frequenting various game reserves, Fallows has a fascination with wildlife that stretches back to his childhood. After moving to the coast at the age of twelve, his fascination with the ocean and marine wildlife grew. At the age of sixteen Fallows coordinated a tag and release program in his hometown. His efforts, with the cooperation of local beach net fishermen, saw the tagging, documenting, and releasing of more than fifteen hundred sharks and rays. In 1992 Fallows was at the forefront of great white shark tourism when he started working and doing research with the White Shark Research Institute at Dyer Island off Gansbaai. He worked there until 1996, when he co-founded African Shark Eco-Charters in False Bay. Along with a colleague he then discovered the breaching white sharks that have been made famous by the *Air Jaws* movies. In 2000 Fallows formed Apex Shark Expeditions with his wife, Monique. Fallows has worked with *National Geographic*, the BBC, *Planet Earth*, and the Discovery Channel, and helped produce the *Air Jaws* series of shark documentaries. Fallows has written scientific papers on the breaching behavior of great whites when hunting, as well as a book titled *Great White: The Majesty of Sharks*, which incorporates his astonishing photography. The book has sold more than 25,000 copies. To show that great whites are not seagoing homicidal maniacs, for the 2011 Shark Week, Fallows paddle-boarded next to a free-swimming great white shark. He said, "I have free-dived, paddle-boarded, body-boarded, and kayaked with them, as well as being dragged on a sled less than fifteen feet from a breaching great white. In essence, I have done pretty much everything that a shark is likely to encounter in the form of a human. In virtually all instances the sharks chose to ignore me, and it was often a battle to get them to come close." That's good for Fallows and, of course, good for the reputation of the sharks. *Photo by Monique Fallows*

Johnston Foster

Johnston Foster, born in South Boston, Virginia, in 1978, was educated at Virginia Commonwealth University (BFA), the Skowhegan School of Painting and Sculpture, and Hunter College, New York (MFA). He brings a long-lost sense of hand-craftedness to his sculptures, demonstrating the sheer joy of fashioning something wonderful out of what has been thoughtlessly thrown away, thus opening a window onto humankind's obsessions and follies. His signature style is to create work out of the debris he finds strewn across highway medians, tossed into dumpsters, and abandoned in alleys. Johnston lets his surroundings dictate the materials he will use and the sculpture he will create. This strategy results in work that reflects the physical environment and the social, political, and cultural climate in which it was made.

Johnston gathers not only things, but also ideas that he translates into three dimensions and informs with his unique, rough-hewn style. From our cultural detritus, he takes an alchemist's approach to creating work with open-ended narratives and imagery that at once celebrate, critique, and question the fragility and transitory nature of beauty and order in our world. In a recent show, sharks, tigers, hornets, unicorns, and a pizza populated RARE, the New York City gallery that has represented the artist over the last decade. The Keeper, a monumental work that was the centerpiece of the 2010 exhibition, is typically constructed out of plastic traffic barrels, bicycle spokes, garden hose, plastic cutting board, plastic tablecloths, rubber, PVC, glass, wire, plastic ties, hot glue, and screws.

Johnston's hybrid mutant creatures are not just the visually compelling products of an impulsive and shocking imagination, but also a representation of the will to survive, an interesting idea for trash to possess. *Photo courtesy of Johnston Foster*

Rodney Fox

Born in 1940, Rodney Fox is considered one of the world's foremost authorities on the great white shark, but he came by his knowledge the hard way. In December 1963, while participating in a spearfishing tournament off Aldinga Beach, south of Adelaide, South Australia, he was attacked by a great white shark and his upper body torn open. His abdomen was fully exposed and all the ribs on his left side were broken. His diaphragm was punctured, his lung ripped open, his spleen uncovered, and his veins were minutes away from collapsing because of the huge amount of blood lost. When he tried to push the shark away, his right hand was badly lacerated, and he still has part of a great white tooth embedded in his wrist. It took 462 stitches to sew him back together. Fox went on to design and build the first underwater observation cage to dive with great whites, and for more than forty years has led major expeditions to film and study his attacker. He arranged and hosted the very first white shark expedition for sport divers, and has run hundreds of expeditions over three decades. He has been involved in some way with most of the great white shark films made in the twentieth century, including *Blue Water, White Death* and *Jaws*. Fox has hosted expeditions for more than one hundred major features and documentaries with filmmakers and researchers from a dozen different countries. Disney, Universal Studios, IMAX, the Cousteau Society, and the National Geographic Society have enlisted his help to film and study the great whites from his cages. Rodney's talks and films on the great white have educated swimmers and divers to the realistic potential of shark attack. He positions the great white as an important "keystone predator" directly controlling the diversity and abundance of other species in the ocean's web of life. With his son Andrew, Rodney runs Great White Shark Expeditions, a shark cage-diving operation to view great white sharks in the waters of southern Australia. The operation also acts as a platform for much needed further research of great whites as well as encouraging quality natural history documentaries on the species. With shark researcher Dr. Rachel Robbins, he and Andrew founded the Fox Shark Research Foundation (FSRF), which is devoted to the study and conservation of the great white shark. In 2009 Fox was nominated for the 2010 Indianapolis Prize, the world's largest individual monetary award for animal species conservation. After forty years of diving, Rodney has amassed one of the most comprehensive collections of photographs of *Carcharodon carcharias*, the shark that nearly killed him. He lives in Adelaide, South Australia.

Photo by David Doubilet

Rinaldo Frattolillo

Born in New York City in 1933, Rinaldo Frattolillo attended P.S.1, and studied at the Parsons School of Design, the School of Visual Arts, and the Art Students League. He studied graphic design, art history, advertising communications, industrial design, interior design, and painting. In 1980, Harcourt Brace published *American Grilles*, a book of the photographs of Rinaldo Frattolillo and Steve Salmieri. Frattolillo was an associate creative director at J. Walter Thompson Advertising and opened his own advertising agency in 1982. He designed a line of furniture for Cavalon Incorporated and started a design firm that marketed design items to museum stores across the country. Since 1995 he has concentrated on his art. As a conceptual artist his thinking is similar to that of Ed Ruscha, Robert Gober, Sherrie Levine, and others influenced by Marcel Duchamp. He writes:

> *My work is about counterpointing a word, a thought or a material, in order to visualize an idea. It becomes the process of how that concept will be executed. I then select mediums that will work for the visual requirements, and use any combination of elements including bronze, Belgian linen, acrylic, corrugated steel, photography, wood, barbed wire, and granite. The point is for the viewer to rethink their original observation, and see the irony, amusement or controversy.*

Frattolillo's work has always been characterized by a sense of humor and a willingness to poke fun at the art establishment. His *Nude Descending a Staircase* is a photograph of a woman descending a staircase sitting in a mechanical chair for invalids, and his *Nothing is Written in Stone* is a polished granite block with those very words engraved into it. (Does that remind you of Magritte?) When he learned that Damien Hirst's shark-in-formaldehyde had sold for $12 million, he made his version, a ten-inch long block of acrylic with a little plastic shark suspended in it, called *$5.99 Toy Shark From eBay*.

Rinaldo's work has been exhibited at the International Design Center (New York City), the Wilson Arts Center (Rochester, New York), the Silvermine Art Center (Silvermine, Connecticut), New York University, the New Museum (New York City), the Studio Transfer Gallery (Miami), the Museum of History and Industry (Seattle), the Stuart Levy Gallery (New York City), and the Very Venice Gallery (Venice, California). He is represented by Kempner Fine Arts in New York City. *Photo courtesy of Rinaldo Frattolillo*

Bruce Gray

Sculptor Bruce Gray was born in 1956 in Orange, New Jersey. He moved around quite a bit as a child, and lived in several places including Madison, New Jersey; Brussels, Belgium; and Bridgewater, Massachusetts. After high school, Bruce spent four years in the Coast Guard as an electronics technician, and was stationed at Governors Island, New York; Cape Sarichef, Alaska; and Jupiter, Florida. After his four-year enlistment, Bruce went to college on the GI Bill and received a BFA in design from the University of Massachusetts in 1983. After graduation he moved to Boston and started work as a photographer and photo printer, then worked as an art director at Allied Advertising until 1988. In 1989 he moved to Los Angeles and started working as an artist full time. His work includes kinetic art, such as rolling ball machines, mobiles, stabiles, and suspended magnetic sculptures. He also works with found objects to create sculptures as varied as a life-size motorcycle constructed from train parts, and giant objects such as a large aluminum wedge of Swiss cheese and giant high-heeled shoes. Gray's work has been displayed at many museums and art galleries, and is included in more than 1,200 corporate and private art collections. His sculptures can be seen in the Little Rock National Airport, Edwards Air Force Base, Vanderbilt University, University of Pittsburgh Medical Center, Children's Hospital Boston, the Academy of Motion Picture Arts and Sciences, A&M Records, Network Solutions, and the Rolling Ball Museum Permanent Collection in Seoul, Korea. His work has appeared in numerous films and television shows including *Charmed, Austin Powers, Meet the Fockers, Batman Forever, Sleeping with the Enemy, Six Feet Under, Seinfeld, Star Trek, Friends, Frasier, Roseanne, Murphy Brown*, and *NYPD Blue*. He lives and works in Los Angeles.

Photo courtesy of Bruce Gray

Todd Michael Guevara

Todd Michael Guevara, born in 1967, calls himself "The Fish Man." In his studio in Costa Mesa, California, he creates dramatic, anatomically correct fiberglass models of sharks, gamefish, whales, dolphins, and turtles. The process to create each sculpture is complicated, meticulous, and time-consuming. First, he makes a rough draft of foam. Once perfected, he seals the foam with a fiberglass resin, thus creating a hard object from which to work. He pays attention to detail while shaping, sanding, and filling in the original to produce a flawless sculpture. Approximately three to six coats of primer filler are used to create a smooth, seamless finish. He then pries apart the mold by hand (in pieces) using high pressure air blowers to release the original, which is often destroyed. Once he takes the mold apart and releases the original sculpture, he preps the mold (cleans it of debris) to create a reproduction of the original piece in fiberglass. The inside of each mold piece is then gel-coated, matted, and "fiberglassed." He then "bolts" the pieces together creating several flanges, or seams, and leaves them to dry for several hours. Once the bolts are released (taken apart), there remains a 100 percent fiberglass reproduction of the original. Before painting, all the flanges from the seams must be ground down, sanded, filled in, and smoothed out to an even surface, thus eliminating any signs of the seams. He makes the teeth, eyes, and some fins separately and then installs them on the piece. He applies three to six coats of filler primer with a high-power paint gun to fill in any flaws. He sands the surface again until smooth. Finally, he applies the base color, followed by the tack coat, which is basically a light clear coat. He then shapes the flame pattern with fine pin-striping tape. The negative, or outside, of the flame is then filled in with paper and tape. Next, he sprays an opaque white over the base flame for true color clarity of the three flame colors, which are then applied and blended. The tape is removed and the edges are sanded before being clear coated to create the shiny, wet look that Guevara calls "Fire on Water." He wet-sands and buffs each coat to achieve a flawless finish. In all, each sculpture is meticulously layered with up to sixty coats of pearls, candies, and clears. The strength, grace, and speed of the shark are epitomized in these unique and powerful works. *Photo courtesy of Todd Michael Guevara*

Don Ed Hardy

Born in Iowa in 1945 and raised in Corona del Mar (Newport Beach), California, Don Ed Hardy attended the San Francisco Art Institute and graduated with a BFA in printmaking. He was a student of the legendary tattoo artist "Sailor Jerry" Collins, and, through this association, was able to study tattooing in Japan in 1973 with the Japanese classical tattoo master Horihide. Hardy became recognized for incorporating the Japanese tattoo aesthetic and technique into his own American style of work. Over the last forty years, Hardy has revolutionized and revitalized this ancient tradition, bringing fresh energy to painting, printmaking, and ceramics. His mesmerizing imagery has created an indelible style not only in tattoo art but in fashion and contemporary art as well. In 1982, Hardy and his wife, Francesca Passalacqua, formed Hardy Marks Publications. Under this imprint, they published the five-book series Tattootime. Hardy Marks has gone on to publish more than twenty books, including catalogs of Hardy's work and that of Sailor Jerry Collins. Today, Hardy is retired from tattooing. In 2000, he was appointed by Oakland mayor Jerry Brown to that city's Cultural Arts Commission, and awarded an honorary doctorate by the San Francisco Art Institute. He still oversees and mentors the artists at his San Francisco studio, Tattoo City. Since the 1960s, he has concentrated heavily on non-tattoo-based art forms, especially printmaking, drawing, and painting. From June 9 to August 25, 2011, the Fort Mason Artist's Gallery of the San Francisco Museum of Modern Art staged an exhibit entitled "The Unruly Art of Don Ed Hardy," which included cast resin work layered with vintage Hardy acetate tattoo stencils, porcelain pieces with cobalt handwork, original prints, and large-scale original brush paintings. As the museum noted, "Also included [was] a replica tattoo shop in a tiny closet space in the gallery: Much like ones he observed in the 1950s complete with sheets of "flash" (painted designs), ink, and tattoo machines, it will reanimate the aura of that art in a bygone era." *Photo © Bud Shark 2007, Courtesy of Shark's Ink, Lyons, CO*

Guy Harvey

Guy Harvey was born in 1955 in Bad Lippspringe, West Germany, while his father was serving as a gunnery officer in the British Army. He grew up in Jamaica, West Indies. Harvey is a tenth-generation Jamaican of English heritage, as his family immigrated to Jamaica in 1664. He attended Aberdeen University in Scotland, graduating with highest honors in marine biology in 1977. He then obtained a PhD degree in fisheries management from the University of the West Indies in 1982. His paintings of game fish such as swordfish, sailfish, and especially marlins, are very popular with sport fishermen and have been reproduced in prints, posters, T-shirts, jewelry, clothing, and other consumer items. His work in the field of game fish conservation led to his nomination for the International Game Fish Association Hall of Fame. He is also a very vocal and active advocate for marine conservation, having established the Guy Harvey Research Institute (GHRI) at Nova Southeastern University in Fort Lauderdale, and the Guy Harvey Ocean Foundation, an organization that funds scientific research and educational initiatives. *Photo courtesy of Guy Harvey*

Paul Hilton

Born in England in 1970 and raised in Australia, Paul Hilton is a Hong Kong–based photojournalist who specializes in highlighting global environmental and conservation issues. His efforts to bring about urgent change in the way we treat our surroundings have taken him to all parts of the globe. As a commercial, editorial, portrait, and assignment photographer, he has covered Macau, Southern China, and Asia. He has collaborated with Greenpeace International on myriad marine issues, from illegal shark finning to satellite tagging of humpback whales in the Pacific. His work has been published in the *New York Times, International Herald Tribune, National Geographic, Newsweek,*

and *Time* magazine, among other leading media. In early 2009, he traveled to Sri Lanka, where he reported on a newly discovered blue whale migration from the Bay of Bengal to the Horn of Africa in the Arabian Sea. Paul has received numerous awards for his conservation photography including Asian Geographic Best of the Decade series for conservation photography and photojournalism. He has also won the coveted Ark Trust Award for his exposé of bear-bile farming in China, and his photographs of the horrendous misuse of animals in China were an important part of the 2005 book by Ben Davies, *Black Market: Inside the Endangered Species Trade in Asia.* Working with the Guy Harvey Research Institute, he is investigating the use of gill-rakers in traditional Chinese medicine. Paul Hilton lives in Big Wave Bay, Hong Kong, with his wife and two daughters. *Photo courtesy of Paul Hilton*

Damien Hirst

Damien Hirst was born in 1965 in Bristol, England. In 1988, a year before he graduated from Goldsmith's College in London, he curated the widely acclaimed exhibition "Freeze", which launched the careers of many British artists, including his own. The exhibition is widely believed to have been a defining moment in kick-starting cutting-edge British contemporary art. Hirst's work confronts the scientific, philosophical, and religious aspects of human existence and includes sculpture, painting, drawing, and printmaking. One of the world's most famous living artists, he has exhibited widely and was awarded the Turner Prize in 1995 for *The Physical Impossibility of Death in the Mind of Someone Living.* In 2004, Hirst collaborated with Sarah Lucas and Angus Fairhurst in an exhibition at Tate Britain, under the title "In-a-Gadda-da-Vida." In 2006, the Serpentine gallery, London, exhibited works from the artist's murderme collection: "In the darkest hour there may be light." Hirst's work can be found in several important collections worldwide, including Tate, London, UK; British Council, UK; MoMA, New York; Hirshhorn Museum and Sculpture Garden, Washington, D.C.; National Galleries of Scotland, Edinburgh, UK; Broad Art Foundation; Centraal Museum, Utrecht, Netherlands; Neue Galerie Graz, Austria; and State Museum of Berlin, Germany. *The Physical Impossibility of Death in the*

Mind of Someone Living, a twenty-two-ton sculpture of a dead tiger shark in a tank of formaldehyde, is owned by American collector Steven Cohen, who bought it in 2004 for a reported $8 million, one of the highest prices paid for a piece of contemporary art at the time. In 2009, Hirst exhibited a series of large paintings called "No Love Lost: Blue Paintings," many of which incorporated a shark jaw, a human skull, and occasionally, an iguana. In this show, we are exhibiting one of Damien Hirst's multiples (art made as a limited edition) known as *Dark Rainbow*. It is a resin cast of a tiger shark jaw, fitted with rainbow-colored teeth. According to Hirst's London gallery, which is selling the multiples for £11,500 apiece, "They are signed on underside of jaw in pencil and silkscreened in ink with title, date and 'Other Criteria' on base of stand. The shark's jaws we see numerously in Hirst's paintings are manifested here in 3 dimensions, the colored, resin teeth lending a cartoon element to *Dark Rainbow*. The piece is in part a trophy against fear and threat and in many ways comical and alluring." *Photo by Anton Corbijn*

Alex Hofford

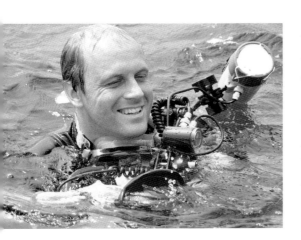

Alex Hofford was born in 1970 in Cambridge, UK, educated at the Leys School in Cambridge, and then Kingston University in London. He holds a master's of journalism (MJ) degree from the Journalism & Media Studies Centre (JMSC) of the University of Hong Kong. He has lived in Hong Kong for more than a decade, using the city as a base to cover stories in China and the region. Much of his work focuses on environmental issues. Alex recently spent four months in the Pacific Ocean for Greenpeace International covering the problems of marine plastics pollution, shark finning, over-fishing, and illegal coastal development. Since establishing his company in Hong Kong in 1998, Alex has carried out many editorial assignments in the region, having worked mainly in Asia, but also in the Middle East and Africa. In 2008, Alex covered the Sichuan earthquake and the Beijing Olympic Games for the European Pressphoto Agency (EPA), and in 2010 he documented the massive industrial shark-finning operation in the northern Japanese fishing port of Kesennuma, which was destroyed by the tsunami and earthquake. The following year, he covered the devastating earthquake, tsunami, and subsequent nuclear catastrophe in Japan. He is currently working on toxic e-waste, air pollution, and solar power issues in China. Alex Hofford is on the

board of directors of the Hong Kong Shark Foundation, which, as the name suggests, is focused entirely on sharks and shark finning in Hong Kong and China. He is also a director of MyOcean, a non-profit that focuses on the broader marine conservation issues facing the greater China region. He lives in Hong Kong with his wife and two children. *Photo courtesy of Alex Hofford*

Winslow Homer

Winslow Homer (1836–1910) was an American landscape painter and printmaker, best known for his marine subjects. He is considered one of the foremost painters in nineteenth-century America and is a preeminent figure in American art. Largely self-taught, Homer began his career working as a commercial illustrator but then turned to oil painting, producing major studio works. He also worked extensively in watercolor, creating a fluid and prolific body of work, primarily chronicling his working vacations. In the 1880s he moved to Prout's Neck, Maine, and began painting scenes of the sea and coast. While his early work captured the horror of the Civil War, toward the end of his life his work focused on the power and majesty of the oceans of the Maine coast. He died on September 29, 1910.

Photo from The Life and Works of Winslow Homer, *by William Howe Downes, 1911*

Sebastian Horsley

Sebastian Horsley was born on August 8, 1962 in Holderness in the East Riding of Yorkshire. He attended Pocklington School and then applied to Edinburgh University before ending up at St. Martin's School of Art in London. He was thrown out for forging a document to gain a grant, but he said he didn't mind too much, because he was afraid that such an institution might "normalize" him. As a painter, he never

wanted to paint things as they were, but the way he felt and sensed they were, and the only way to achieve this was through first-hand experience. In order to paint great white sharks, he descended in a cage off South Australia and looked them in the face. For the catalog of his shark paintings, exhibited in May of 1997 in a one-man show at Grosvenor Gallery in London, he wrote,

> *In my paintings I wanted to capture their beauty—a beauty like the first touch of terror. I wanted to distill that haunting moment where violence and beauty merge, to paint a vision of the abyss, or the sense of the void which has always been my central vision, or the knife-edge balance between being and nothingness, to show how form emerges out of darkness and melts back into it. I think it is only in extreme situations that ultimate realities reveal themselves. Alone in the cage, as night falls, and the great predators silently circle, the sensation of life comes across in its most acute and violent forms.*

In August 2000 Horsley travelled to the Philippines to experience a crucifixion, so he could prepare for a series of paintings on the topic. Refusing painkillers, he was nailed to a cross and, not surprisingly, passed out. The foot rest broke and he only avoided serious injury by being caught by onlookers. Rachel Campbell-Johnston, an art writer who was his girlfriend at the time, did not discourage him: "I admired him for doing something that most people wouldn't have dared to do and I was proud of him for sticking to his ideals in the face of disapproval and ridicule. I believed there was something pure amid all his complicated motivations." In September 2007, the Spectrum London gallery staged Hookers, Dealers, Tailors, a retrospective by Horsley. The show documented his diving in Australian shark-infested waters and copiously ingesting dangerous drugs. Horsley was denied entry into the United States in March 2008, after arriving at Newark Airport for a book tour, when immigration officers claimed issues of moral turpitude. After eight hours of questioning, he was placed on a plane and sent back to London. Horsley was found dead at his London home on June 17, 2010 of a heroin and cocaine overdose. His funeral took place on July 1, 2010, at St James's, Piccadilly, and was attended by more than four hundred mourners. Rachel Campbell-Johnston has generously loaned her Horsley painting to this exhibition. *Photo by Gabriella Meros*

Yong Ho Ji

Born in South Korea in 1978, Yong Ho Ji received a BFA in sculpture from Seoul's Hongik University in 2005 and an MFA from New York University in 2008. Adopting tires as his signature material, he based his art on domesticated and wild animals, coupled with his desire to make art about humanity's responsibility to nature, via subject matter as well as recycled materials. Non-biodegradable rubber tires are piling up in landfills the world over. In Ji's hands, tires, which are made from natural rubber liquids, can also be reborn as other forms of life. "Rubber is very flexible, like skin, like muscles," he explains. This quality gives him more freedom to capture the animals' expressivity—the horse's wistful glance, a snarling lion, the threatening, life-sized head of a rhinoceros. To Ji, rubber symbolizes mutation. He says, "The product is from nature, but the sap of latex trees is white. Here it's changed. The color is black. The look is scary." Ji transforms this versatile material into a series of jaw-dropping (and frightening) sculptures, which he dubs Mutant Myths. These fabulous pieces consist of layers of used tire strips bound together by synthetic resins on supporting frames of steel, wood, or Styrofoam. The mutants are constructed with a surgeon's precision, employing classic sculptural techniques to achieve the levels of the "intense, abnormally muscular form" he strives for. He sculpts his initial forms out of wire and clay, builds plaster molds, and makes resin forms around which he wraps rubber tire sliced with mat-knives. Various types of tires—motorcycle tires, bicycle tires, and tractor tires—are used to create different muscles and muscle tension, or to give each sculpture the effect of skin or fur. This laborious process can take two to three months per mutant, but it enables the artist to more closely emulate Rodin's perfection of "powerful and exaggerated posture" to convey his subjects' emotional states. His pieces often demonstrate zoology gone awry, and the cosmic order undermined, while voicing the artist's personal concern that our ability to produce something against nature is alarmingly near. In his ongoing shark series, Ji builds his sharks with the muscular forms of land animals in mind, enlarging fins, stomachs, and backs to make his mutants appear more aggressive. They have become archetypical animals that thrill the viewer by

capitalizing on a deep-seated, death-based fear of gargantuan, predatory ocean creatures lurking in the depths. Yong Ho Ji lives in Korea. *Photo courtesy of Bong Lee*

Tommy Joseph

Born in 1964 in Ketchikan, Tommy Joseph lives and works in Sitka, Alaska. He is of the Eagle Moiety, Kaagwaantaan Clan. Tlingit, meaning "The People," are divided into moieties, which means "each of two parts." There is the Eagle Moiety and the Raven Moiety. To keep the bloodlines separate, Tlingit people must marry the opposite moiety. They are a matrilineal society, so their moieties are determined by their mothers. Joseph has been actively engaged in Northwest Coast carving since the 1980s as an instructor, interpreter, demonstrator, and as a commissioned artist. He creates hybrid carved wooden totems that are imaginative interpretations of various creatures—fish, mammal, bird, or human. He uses stylistic and formal elements drawn from his Tlingit heritage as inspiration to create innovative reinterpretations that comment on contemporary community life. He has produced a wide range of artwork including thirty-five-foot totems, smaller house posts, intricately carved and inlaid masks, and a wide range of bentwood containers. He also has replicated Tlingit ceremonial treasured objects and armor. Since the early 1990s, he has been in charge of the carving shop at the Southeast Alaska Indian Cultural Center in Sitka, demonstrating and interpreting Northwest Coast art for the many thousands of tourists who visit during the summer months. In addition, he has been employed by the National Park Service to restore and replicate some pieces in the park's extensive collection. Tommy Joseph was commissioned to carve a pole in 2010 for the American census of that year. The pole traveled through many communities in Alaska during the census data collection process. It was finally raised at the Census Bureau's headquarters near Washington, D.C., in August 2010. On May 15, 2011, the town of Sitka held a pole-raising in Sitka National Historic Park to inaugurate Tommy Joseph's thirty-five-foot pole, which includes images of an eagle, a raven, and a buffalo, the emblem of the National Park Service. The pole also has images of Alaskan plants, the devil's club, and skunk cabbage. The raising was the culmination of a year of events that marked the hundredth year of Alaska's oldest national park, including a presentation in 2010 of a Ravenstail robe by Tlingit artist Teri Rofkar. *Photo by Kristina Cranston*

Roger Kastel

Roger Kastel was born in 1931 in White Plains, New York. He began his art career while still in high school, commuting into Manhattan to study at the famed Arts Students League, whose notable alumni include Frederick Remington, Georgia O'Keeffe, and Winslow Homer. Roger returned home after serving in the Navy during the Korean War to became a professional artist doing freelance work for various studios and ad agencies throughout New York. After putting in a full day's work on storyboards, mechanicals, and layouts, he continued his education at the Arts Students League in the evenings. Much of his training came from one of the most respected teachers of his era, Frank Reilly, who had earlier been an apprentice to Dean Cornwell. Roger also studied with Edwin Dickinson, Sidney E. Dickinson, and Robert Beverly Hale.

In the 1960s, while still a student, Roger had his first paperback book cover published by Pocket Books (Simon and Schuster). Roger estimates that he has done more than a thousand illustrations for various publishers to date. Also in the 1960s, Roger won first prize from the National Fire Underwriters for one of his paintings, which was subsequently made into a fire safety poster and used for many years thereafter.

By the 1970s Kastel had become one of the most respected illustrators in the business, working for every major publishing house in New York. If his work was not yet recognized globally that was about to change when he accepted the challenge of illustrating the paperback cover of Peter Benchley's bestselling classic *Jaws* for Bantam Books. Universal Studios was so impressed by the work, it purchased the right to use the image as the poster for the movie. This was the first time that a poster image became a merchandising product in itself. Forty years later Roger's illustration is still as instantly recognizable throughout the world as when it first exploded onto the scene.

Roger's reputation as a top-tier illustrator also made its way across the country to Hollywood, and he was asked to paint the movie poster for *The Empire Strikes*

Back. This poster also became an instant classic, and it is considered one of the most influential movie posters ever produced.

Kastel's work is recognized in the prestigious books *200 Years of American Illustration*, and *The Illustrator in America*. Kastel is a long-time member of the Society of Illustrators; some of his work is in the society's permanent collection. Roger is also a member of the Artists Fellowship, the Kent Art Association, and the Portrait Society. His paintings are found in both private and corporate collections, and he currently works doing fine art and commissioned portraits. Roger Kastel lives in Lagrangeville, New York. *Photo courtesy of Roger Kastel*

Kcho

Born Alexis Levya Machado in 1970 in Nueva Gerona, Cuba, Kcho (pronounced "Katcho") is a 1990 graduate of the Academia de Artes Plásticas San Alejandro in Havana. In 1996 he began exhibiting his work at the National Centre of Contemporary Art (Montreal, Canada), the Los Angeles Museum of Contemporary Art, and the Reina Sofia National Museum in Madrid. In 1992 Kcho was made a member of the Jury of the National Salon of the National Museum Palace of Fine Arts, Havana; in 1994 he received a scholarship by the Ludwig Foundation; and in 1995 he received the UNESCO Prize for Promotion of the Arts. Kcho is known for creating works based on the forms of boats, which he often fashions from scavenged or improvised materials, and he incorporates iconography and items from everyday life in Cuba into his art. He is known for his carefully detailed paintings and drawings, and also for his large-scale, site-specific installations. Migration is a major theme in his work, and boats, oars, docks, and water are recurrent symbols. The recipient of numerous awards, Kcho has had several significant solo shows and his work is in collections internationally. *Photo courtesy of the Marlborough Gallery, New York*

Charles R. Knight

Charles Robert Knight was born in 1874 in Brooklyn, New York, and died in 1953 in Manhattan. He was best known for his influential paintings of dinosaurs and other prehistoric animals. His works are currently on display at several major museums in the United States, including the American Museum of Natural History in New York, the Carnegie Museum in Pittsburgh, the Smithsonian, and Yale University's Peabody Museum of Natural History. While making murals for museums and zoos, Knight continued illustrating books and magazines, and became a frequent contributor to *National Geographic*. He also wrote and illustrated several books of his own, such as *Before the Dawn of History* (1935), *Life Through the Ages* (1946), *Animal Drawing: Anatomy and Action for Artists* (1947), and *Prehistoric Man: The Great Adventure* (1949). Additionally, Knight became a popular lecturer, describing prehistoric life to audiences across the country. He was one of the few artists ever to attempt to paint the great megalodon, extinct for 500,000 years. *Photo courtesy of Rhoda Knight Kalt/Richard Milner*

Charles Lawrance

Charles Lawrance was born in 1970 in Yonkers, New York, and schooled in Mahopac. He studied painting and illustration at the Maryland Institute College of Art and received a BFA in 1993. Growing up in the outdoors and embracing nature inspired his lifelong obsession for expression through art. A fisherman and naturalist at heart, Charles's adventures bring him above and below the surface, creating a rich diversity to draw from. Using a painterly realism, he renders his canvases and walls into a contemporary mixture of knowledge and spirit. Paintings are done in oil and acrylic, commissioned canvases may be either. In more than fifty exhibitions, Lawrance has shown his work in galleries such as the Baltimore Life

Gallery; the Society of Illustrators in New York City; the Carefree Theatre Gallery in West Palm Beach, Florida; the Maryland Art Place; and the Meyerhoff Gallery in Baltimore. He has completed numerous murals for interior and exterior spaces in New York, Florida, the U.S. Virgin Islands, and his adopted state of Maryland, where his marine mural at the Boomerang Pub in Baltimore is that city's largest indoor mural. As a career artist, Charles Lawrance has achieved regional and national recognition in books, magazines, CDs, newspapers, lithographs, and set design (the Lyric Opera of Baltimore). AgoraGraphics; A&M, Island, and Polygram Records; Red Bull Energy Drink; *Baltimore* magazine; and *Fishing and Hunting Journal* feature his innovative and provocative images. The critic Lori Lothan wrote, "The contemporary work of Charles Lawrance is fiercely provocative and delightfully disturbing. Cultures tribal and modern, beings human and animal, meet on canvas and invite the viewer to draw conclusions about the surreal nature of reality. At times playful, and other times profoundly mystical, Lawrance manages to capture imagination in the net of his palette and brush. Not for the pastoral minded, this artist's Daliesque view of the world makes for art that rivets and challenges." Lawrance lives and works in Fells Point, Baltimore. *Photo courtesy of Charles Lawrance*

Pascal Lecocq

Born in June 1958, in Fontainebleau (Seine et Marne, France), Pascal Lecocq has a PhD in arts from Paris VIII University. From 1985 to 1996, he designed sets and costumes for operas in France and Belgium. He moved to Normandy in 1982, and opened his own gallery in Honfleur six years later. Lecocq is the author of a hundred articles on painting and opera, concentrating on the ancient masters and anatomy. He is a regular contributor to the magazines *Techniques des Arts* and *Artistes et Techniques* (1986–1990), and the author of several books about painting techniques. His pictorial research and color work betray his great admiration of Van Eyck and Vermeer and his landscapes show the influence of Dali. His paintings are smooth, bright, and delicate. Although his work also includes surreal landscapes and opera decors, he is best known for his images of divers in surreal situations floating in his trademark blue vistas.

Pascal Lecocq is a storyteller. His characters evolve in a natural but surrealistic environment in which the spectator dives with the artist: This is the source of

the magic. Whether it is a diver "bullfighting" a great white shark, or a group of divers playing leapfrog or basketball, we are amused, but at the same time, we do not doubt the dignity of the characters. In each of his paintings, Pascal places a tiny "frogman" character, which he equates to Charlie Chaplin's "Little Tramp." The Pascal Lecocq Foundation for the Arts and Environmental Education was formed to encourage children to express themselves by painting and demonstrating their concern for the environment. Lecocq has had regular exhibitions since 1977, including more than two hundred solo exhibitions in the US, France, England, Germany, Japan, and of course, at dive shows around the world. He was DEMA (Diving Equipment and Marketing Association) Artist of the Year in 2001. Since then, he has been working in Fort Lauderdale, Florida. *Photo courtesy of Pascal Lecocq*

Robert Longo

Robert Longo was born in 1953 in Brooklyn, New York, and raised on Long Island. He began college at the University of North Texas, in Denton, but left before completing a degree. In 1972 Longo received a grant to study at the Accademia di Belle Arti in Florence, and after returning to New York, he enrolled at Buffalo State College, where he received a BFA in 1975. While in Buffalo, Longo and his friends established an avant garde art gallery in the Essex Art Center, a converted ice factory, which became Hallwalls Contemporary Art Center. Around 1976, Longo moved to New York City to join the underground art scene. Although he studied sculpture, drawing remained Longo's favorite form of artistic expression. To create his works, he first projects photographs of his subjects onto paper and traces the basic contours of the figures in graphite, omitting all details of the background. Then his long-time illustrator, Diane Shea, works on the figure, filling in the details. Finally Longo goes back into the drawing, using graphite and charcoal to provide "all the cosmetic work." He continues to work on the drawing, making numerous adjustments until it is completed.

Longo produced a series of blackened American flags (*Black Flags*, 1989–91) as well as oversized handguns (*Bodyhammers*, 1993–95) that illustrate themes of

power and authority. In 2002 and 2004 he presented *Monsters*, renderings of massive breaking waves, and *The Sickness of Reason*, baroque renderings of atomic bomb blasts. It seems almost inevitable that Longo would turn to sharks, particularly the great white.

Longo has had retrospective exhibitions at the Museu Berardo, Lisbon; Musee d'art Moderne et D'art Contemporain, Nice; Hamburger Kunstverein and Deichtorhallen; the Menil Collection in Houston; the Los Angeles County Museum of Art; the Museum of Contemporary Art in Chicago; the Hartford Athenaeum; and the Isetan Museum of Art in Tokyo. Group exhibitions include Documenta (1987 and 1982); the Whitney Biennial (2004 and 1983); and the Venice Biennale (1997). His work is represented in collections of the Museum of Modern Art, the Guggenheim Museum, and the Whitney Museum of American Art in New York; the Art Institute of Chicago; the Los Angeles County Museum of Art; the Walker Art Center in Minneapolis; the Stedelijk Museum in Amsterdam; the Centre Georges Pompidou in Paris; the Albertina in Vienna; and the Ludwig Museum in Cologne. He is a recent inductee into the French Academy of Arts and Letters and was the recipient of the Goslar Kaiserring in 2005. Robert Longo is represented by Metro Pictures in New York City; Galerie Hans Mayer in Düsseldorf, Germany; and Galerie Thaddaeus Ropac, Paris. He is a co-founder and member of the band X PATSYS (with Barbara Sukowa, Jon Kessler, Anthony Coleman, Knox Chandler, Sean Conly, and Jonathan Kane). Robert Longo lives with his wife, Barbara Sukowa, and their three sons in New York. *Photo courtesy of Robert Longo Studio*

Sandra Ramos Lorenzo

Sandra Ramos was born in 1969 and educated in Havana. Ramos began her art studies at age twelve in Havana's Escuela Elemental de Artes Plásticas and then studied at the prestigious San Alejandro Academy and at Instituto Superior de Arte under the tutelage of the talented "1980 generation" artists like José Bedia, Leandro Soto, and Carlos Cárdenas—all now exiled in the United States. Her first solo show in the United States was entitled *Heritage of the Fish,* which was inspired by a soulful poem penned by the late exiled Cuban writer Gastón Baquero, *Testamento del pez* (The Fish's Last Will and Testament), in which a fish professes his devotion to the

city he's abandoned. Using sculpture, photographic self-portraits, video, and lots of water in five installations, Ramos offers her comments on the losses fueled by exodus after exodus from the island. "Water is a symbol of the situation in Cuba, of the sadness of separation, of the impotence we feel before things that happen and we cannot change," Ramos says. "I've always used water in my work in some form, but lately, it has evolved from a secondary role to being a fundamental and symbolic element." Much of her art is focused on her island home; *La Balsa* ("the raft") shows a Cuba-shaped balsa raft with the Cuban flag flying, but surrounded by sharks, suggesting the difficulties of leaving the island.

Ramos first made her mark on the international art scene in the mid-1990s by participating in and curating several Havana biennials. International curators and art gallery owners who came to Cuba saw her work and began showing it in their galleries and promoting her abroad. Her pieces also have been exhibited at Art Basel, Art Miami, and Art Chicago. "She's an artist who surrenders her biography, her most intimate feelings, and her own body to discuss social, political, and cultural problems," wrote Cuban art critic and curator Gerardo Mosquera. "She uses her portrait to personify the Cuban flag, the island, establishing a parallel between her personal situation and the suffering of her own country." Ramos's art, which has attracted attention from Mexico to Tokyo and has been acquired by the Museum of Modern Art in New York, is remarkable enough on its artistic merit alone. But it is made even more remarkable because she's a vanguard artist living inside Cuba, part of a generation that in the past decade has protested the constraints of censorship and made art, music, movies, and written works that address the starkness of Cuban reality. Ramos lives in the once-grand neighborhood of Vedado in an old house that she and her husband had restored from shambles and furnished with antiques other Cubans sold to them. "There's an entire part of my life in Cuba up to 1994 that has all left, that is here now," Ramos says. But leaving the island is not for her. "Do you think that if you leave Cuba your art would suffer?" someone in the art gallery audience asked her one evening during a lecture. "Yes," she readily answered. "My work is too related to my life there and my life would change a lot if I left. Maybe someday I need to change, but not now." *Photo courtesy of Alida Anderson Art Projects*

Robin Lovelace-Smith

Robin Lovelace-Smith is a Tlingit sculptor and carver born in Sitka, Alaska, in 1970. The main focus of her research is Taku River Tlingit Yanyeidí clan carvings, stories, songs, and regalia. She has been meeting with elders, documenting stories and photographs, and compiling a clan history/family tree. She sees and hears clues everywhere in the artwork and oral tradition of her Tlingit forebears. As she says, "I believe our ancestors left directions and hints in their stories and artwork as avenues to understand ourselves and our roles in today's world." One of her pieces is a guardian spirit fashioned out of gleaming steel. Although this tradition was once silenced, Lovelace-Smith's mastery of metal speaks volumes about her passion for culture. She has spent the last ten years training under, studying, and collaborating with Frank Perez, David Boxley, Larry Ahvakana, Pat Stone, and Nathan and Stephen Jackson. She was apprenticed to Stephen Jackson when he created *Nearing Completion*, the Kaats housepost for the Burke Museum (Seattle) in 2005, and worked with Tommy Joseph in Sitka during the summer of 2011. While Lovelace-Smith honors tradition, she feels that it's vitally important for Northwest Coast art to be viewed as highly evolved and therefore ever-progressing. "My artwork is a vital part of my own self-determination and I create objects of power and wealth to help foster my people's cultural pride," says Lovelace-Smith. "It is my goal and desire to pass down my knowledge and skills to future generations." Sharks play an important role in Tlingit legend. Typically it is the dogfish, or mud shark, that is represented on pipes, masks, and helmets. Lovelace-Smith resides in Anchorage with her husband and three children.

Photo by Carmen Bydalek

Stanley Meltzoff

Stanley Meltzoff was born in New York City in 1917 and died in 2006. He attended the Massachusetts Institute of Fine Arts, NYU, and the Art Students League. During World War II, he was a correspondent for *Stars and Stripes*, the legendary military publication that introduced Bill Mauldin and Andy Rooney, among others, to the world. As an illustrator, he brought to life the news of the day and created visuals for *Puptent Poets*, a small paperback that featured soldiers' verse. He became a full time painter in 1949, painting covers and interior spreads for *Life*, *National Geographic*, *Saturday Evening Post*, *The Atlantic*, and many others. He painted sixty-five covers in all for *Scientific American*. In the 1960s, he began painting saltwater game fish in their undersea environments, attracting the attention of *Sports Illustrated* and later virtually all outdoor media. He painted all the major big-game species, but not fresh-water species, finding them easier to see and thus less interesting to paint. His art ran in almost every major outdoor publication, including *Field & Stream*, *Gray's Sporting Journal*, *Outdoor Life*, *Sporting Classics*, *Sports Afield*, and *Wildlife Art*. Today his art hangs in the National Gallery (Smithsonian), Getty Museum, and many other world-class institutions.

Photo courtesy of Mike Rivkin

Nana Montgomery

Nana Montgomery, an artist who makes contemporary quilts, was born in 1961 in San Francisco. Her canvas is the quilt, onto whose surface she creates her pictorial compositions with fabric. Frequently her quilts feature the shape of a house, a symbol that represents the different places where we live, both physically and emotionally. Her work seeks to express both the universal and the personal experience of these places. Montgomery constructs her quilts in a traditional manner, with cotton fabrics and filling. Paint and any other embellishments are applied after the quilt is fully constructed to enhance the surface design and add an important

spontaneity to the work. Nana holds a master's degree in fine art from San Francisco State University where she focused on merging her quilts with painting and developing her own artistic style. Her art quilts have been shown throughout the Bay Area, including several juried shows at the San Jose Museum of Quilts and Textiles. As a surfer in the San Francisco area, she has a particular interest in sharks, as shown in *Undertow*, her contribution to this show. Nana lives in Santa Cruz where she runs her own graphic design business, Blue Shark Design Company.

Photo courtesy of Nana Montgomery

Stuart Peterman

An internationally known artist who specializes in metal sculptures, hand-crafted metal jewelry, and abstract paintings, Stuart Peterman was born in 1959 in Minneapolis, Minnesota, and holds a bachelor's degree from the University of Wisconsin, Eau Claire. He has been a full-time metalsmith since 1994. As he puts it, "I started my art career as a metalsmith, creating unique hand-crafted jewelry. Fueled by a love of larger-scale art and experience working with textures, lines, and shapes, I began experimenting with their relationship in my metal sculptures. My creations are inspired by nature; it is not meant to mimic nature, rather to create beauty from the combination of natural forms and structured shapes. My goal is to captivate the viewers while invoking feelings of intimidation and fear or awe and wonder. I make sculptures of many different kinds of fish: marlin, tuna, swordfish, tarpon, grouper, and others, but among my favorites is the shark. Sharks have an instantly recognizable form and create an immediate response. Because they can be mysterious and dangerous, they are fascinating to observe and universally appealing. Using metal to form a shark sculpture requires many hours of hand hammering to create the compound curves necessary for the sleek, powerful appearance." His unique and dramatic pieces have found their way to collectors, galleries, restaurants, and private homes around the globe. He lives in Tampa, Florida. *Photo courtesy of Stuart Peterman*

Ila France Porcher

Ila France Porcher grew up in British Columbia, Canada. She spent much of her life as a wildlife artist under the name Ila Maria. She is renowned for her wildlife art, her activism in behalf of sharks, and her new discoveries that illustrate the little-known intelligence and kinder nature of sharks. From 1995 until 2009, she established an utterly unique intimacy with the reef sharks of Tahiti in French Polynesia. Her experience learning about these fascinating creatures of the deep is chronicled in a memoir entitled *My Sunset Rendezvous*, published in 2010. Her true story takes place underwater and her characters are the sharks, each carefully identified by its unique appearance and markings. In her book, Porcher leads readers from one new discovery to another and, consequently, to greater intimacy with each of the sharks, all set within the unparalleled beauty of a coral lagoon. There is the unfortunate misconception that sharks are mindless, vicious creatures that we all should fear and avoid. *My Sunset Rendezvous* debunks these myths. She hopes that animal lovers who had not considered sharks before will now realize the true nature of these animals that are worth studying and saving. With the publication of the book, she joined the very special fraternity of shark artists who write as well as paint. Throughout her years of study, Porcher has had many strange and startling experiences with sharks, which she's shared with other scientists across the world, comparing her observations and conclusions while accumulating evidence about sharks that transcends common beliefs. She and a scientific colleague, Arthur A. Myrberg Jr., found the first evidence that sharks can think and the degree to which they are social creatures. Professor Myrberg died before their paper on cognitive thinking in sharks could be published; she honors him by including his last scientific article in her book. Porcher was also a contributor on shark cognition and social intelligence for the documentary *Sharks: Size Matters* for Discovery Channel's Shark Week. New Zealand filmmaker Alan Baddock said of her book: "Your clarity of intent is stunning and beautiful. As a wordsmith, I recognize and acknowledge rare mastery. As a traveller who has picked up and cast aside the best of world literature in a thousand hostelries on half a dozen continents and countless islands, I recognize a book I would share with people I considered friends. . . . Three chapters into a subject I am not especially interested in, I am waiting with a low, gnawing hunger for more. That alone tells me I have found something special."

Photo courtesy of Ila France Porcher

Don Ray

Born in 1958 in Akron, Ohio, Don Ray is a self-taught artist whose work is enjoyed and collected by fishermen around the world. He has a tremendous love for fine art, and his intensive study of marine environments, including collecting wild specimens and diving with them in their habitat, are evident in his oil paintings. Foremost is his desire to balance artistic expression and realistic interpretations of life and light underwater. His art can be found on the covers of many books, magazines, and catalogs such as *Field & Stream*, *Outdoor Life*, *Marlin*, *Game Fish* (France), *Cabela's*, *Penn Reels*, *Saltwater Sportsman*, and the International Game Fish Association World Record books. His paintings have won first place for the Florida State Lobster Stamp for three consecutive years, 1990 to 1992. In 1992 his entry won him first place in the Florida Snook Stamp competition as well, the state's first double winner. In 1995 Don again won the snook stamp and print competition. He was chosen to paint the Coastal Conservation Association stamp and print in 1994 and again in 1999. Don was selected to paint the Texas Saltwater Fishing stamp and print for 1996, 2004, and 2009. His paintings have also been selected by the International Game Fish Association for numerous covers on their annual *World Record Game Fishes* book, which is seen by fishing enthusiasts the world over. Don's painting appeared on *Marlin* magazine's thirtieth anniversary cover in 2011. Don was chosen to be the featured artist for Florida's Coastal Conservation Association 25th Anniversary in 2011. He is a member of Society of Animal Artists and a recipient of the society's Award of Excellence. He lives in Florida with his family, where he is better able to "immerse" himself in the subjects that he loves to paint. *Photo courtesy of Don Ray*

Alexis Rockman

Alexis Rockman, born in New York City in 1962, is an American contemporary artist known for his paintings that provide often disturbing depictions of future landscapes as they might exist with impacts of climate change and evolution influenced by genetic engineering. He studied animation at the Rhode Island School of Design

(1980–1982), and continued his studies at the School of Visual Arts in Manhattan, receiving a BFA in 1985. In his work, Rockman uses the language of natural history to examine our relationship to it as a culture. Early influences for Rockman included the artwork and dioramas of the American Museum of Natural History, and Charles R. Knight influenced Rockman's development, as he almost single-handedly created the genre of reconstructions of extinct ecosystems. Many of Rockman's works have been inspired by his travels around the world, including visits to Costa Rica, Brazil, Madagascar, Guyana, Tasmania, and Antarctica.

His paintings are an expression of the hopes and popularly held fears about scientific progress and the wide-ranging effects that human intervention can have on animal species, ecosystems, and the natural world. We look upon a future world that is both surreal and unsettlingly familiar: mutant animals, geometric landscapes, alternative environments either sterilized by science or despoiled by pollution. He writes, "My position is one of ambivalence as the horse is already out of the barn so to speak; it is not biotechnology that is the problem but corporate America or globalism or colonialism. The implications of using this technology are far more devastating because of the unknowable effects. This is something that is very disturbing and visually compelling to me."

In the *Biosphere* series, Rockman alludes to the Biosphere 2 project in Arizona and envisions an Earth that has become so toxic for human life that it can exist only in strange and mutated forms inside geodesic-dome structures. *Biosphere* draws references from science fiction cinema, especially the opening scene of the 1971 film *Silent Running*, as well as Stanley Kubrick's *2001* and Ridley Scott's *Alien*. *Biosphere: The Ocean* (1994) is influenced by H. R. Giger's work and depicts a shark with a long, bionic, sawfish beak that allows it to tear through food.

In the mid- through late-1980s, Rockman began exhibiting his work at the Jay Gorney Modern Art Gallery in New York City; he has also had exhibitions at galleries in Los Angeles, Boston, and Philadelphia. He has exhibited in the United States since 1985, including a 2004 exhibition at the Brooklyn Museum, and internationally since 1989. From November 2010 to May 2011, Alexis Rockman: A Fable for Tomorrow was featured at the Smithsonian American Art Museum. The exhibition, the first to survey Rockman's career, presented forty-seven paintings and works on paper. (The title of the exhibition refers to the title of the first chapter of Rachel Carson's 1966 book *Silent Spring*.) Alexis Rockman lives in New York City and works out of a studio in the city's TriBeCa neighborhood.

Photo courtesy of Alexis Rockman

Douglas Seifert

For the past twenty years, Douglas Seifert has worked professionally as a writer and award-winning photographer specializing in the marine environment and its inhabitants. Formerly senior contributing editor of *DIVE* magazine in the United Kingdom, he has written and published more than eighty articles over the past fifteen years. Seifert's photographic imagery has appeared in the *New York Times, Australian Geographic, Reader's Digest, Esquire, Outside, BBC Wildlife, National Wildlife, Skin Diver, Sport Diver, Mondo Marino, Plongeurs International, Mundo Submerso,* and numerous books, magazines, and newspapers around the world. His images of a family of sperm whales in the Azores were awarded a bronze medal by the United Nations Environmental Program in 2000, and he was grand prize winner of the 2000 Papua New Guinea Underwater Photographic Competition. His work has been awarded many times by the prestigious British Wildlife Photographer of the Year Competition. For the summer 2003 "Shark" issue of *DIVE* magazine, Seifert photographed spawning whale sharks ("the first photographer to record this remarkable event"), reef sharks, bull sharks, white sharks, and hammerheads. He accompanied Ron and Valerie Taylor to the Caribbean where they were going to test a stainless steel chain-mail diving suit to ascertain if it could protect divers from shark bites. He wrote:

> *He raked a hunk of bleeding tuna over his forearm as a Caribbean reef shark approached, and succeeded—if that's the right word—in getting the shark to bite him. As the shark began shaking him, trying to remove a piece of his arm, he did not struggle, but remembering the advice that Ron and Valerie had given him, he went limp. The shark seemed uninterested in a flaccid piece of chain-mail-wrapped meat, and released him. So it was either the suit or the advice that protected him.*

If you had to follow the advice of anybody about what to do when a shark has engulfed your arm, it would be Ron and Valerie Taylor. *Photo courtesy of Douglas Seifert*

Gary Staab

Gary Staab was born in 1967 in Hays, Kansas. He earned a degree in art/biology at Hastings College (Nebraska) and interned at the Smithsonian Institution and the British Museum of Natural History. His work and eclectic studio skills demonstrate a flair and passion for natural forms both past and present. He was employed by the Denver Museum of Nature and Science as a sculptor for seven years, where he still holds a position as research associate. Staab also works as a freelance sculptor for such institutions as the National Geographic Society, the Smithsonian's National Museum of Natural History, the Carnegie Museum of Natural History, and the Miami Science Museum, among many others.

Staab produces natural history and prehistoric life models for museums, publishing, and film. His re-creations and sculptures can be found in the halls of the Smithsonian, the British Museum of Natural History, the American Museum of Natural History, the BBC, and many others. His work has also been featured on the Discovery Channel, in *National Geographic* magazine, and through Dorling Kindersley Publishers. He has received the prestigious John Lanzendorf Paleoart award for sculpture, presented by the Society of Vertebrate Paleontology, four times. Staab lives with his wife, Lissi, and two sons, Max and Owen, on a lake near Kearney, Missouri.

For this exhibition, Gary Staab contributed a model of *Helicoprion,* a 300-million-year-old extinct shark that sports perhaps the most unusual tooth arrangement in history. (*Helico* is a spiral or curl, and *prion* is a saw, so *Helicoprion* actually means "circular saw.") *Helicoprion* had flat, crushing teeth in its upper jaw, and a circular-saw blade made of teeth somehow inserted into its lower jaw. To date, nobody knows how the tooth whorl might have been used, or, for that matter, where on (or in) the shark it went. The nineteenth-century Russian paleontologist Karpinsky "spent years in futile attempts to restore the position of the whorl. He placed it in the tail, on the dorsal fin, and in the upper jaw." Later analyses have come no closer to placing it or describing its function. Because of the mystery that surrounds the perfect logarithmic spiral of the teeth, *Helicoprion* is one of the most intriguing and enigmatic creatures of all time. In the Hall of Vertebrate Origins in the American Museum of Natural History, the tooth spiral is labeled, "What is this fossil?" *Photo courtesy of Gary Staab Studio*

Adam Straus

Born in Miami Beach, Florida, in 1956, Straus's education includes a 1976 BA from Miami-Dade Community College; a 1978 BS in mathematics from the University of Florida, Gainesville; and a 1982 MFA from Florida State University, Tallahassee. Straus began his artistic career as a sculptor and photographer but was always intrigued by the creative process. In New York he frequented the Metropolitan Museum of Art to observe the work of Monet and artists from the Hudson River School. It was through observing these great masters that he found the basis for his art and became a self-taught painter. His paintings of skylines, seascapes, fields, and mountains are very seductive and gloomily romantic. They invite the viewer to get lost in the breathtaking beauty of the image, only to be roughly reminded of the cruel reality of our impact on the planet. In his oils, Straus represents the struggle and survival of mankind and mankind's effect on nature. He praises the human race for surviving while condemning it for destroying the environment. His paintings, however, are not completely pessimistic. Despite his critique of our behavior, he offers an optimistic point of view by including humor in his work. He hopes that we are left with a feeling that it is possible to turn the world into a better place. Straus has exhibited extensively throughout the United States as well as internationally. His works can be seen in such collections as the City of Orlando, Florida; the Mead Art Museum, Amherst, Massachusetts; the Art Museum at Florida International University in Miami; American Express; Fidelity Investments; and the Lavandoo Corporation of Geneva, Switzerland, among others. Besides winning numerous prizes in juried competitions, Straus received a grant from the Southern Arts Federation and a painting fellowship from the National Endowment for the Arts. He moved to New York in 1990 and has been affiliated with the Nohra Haime Gallery there ever since. He currently lives and works in Riverhead, New York. *Swimming with Sharks* is a perfect exemplar of everything Adam Straus wants to accomplish with his art. When you notice the tiny human figure on the horizon, you understand that this is not simply a picture of sharks dappled by sunlight flickering through the water; it is a vivid commentary on man's somewhat precarious place in the natural world.

Photo courtesy of the Nohra Haime Gallery

Don Straus

Born in Kitchener, Ontario, in 1962, Don Straus spent most of his youth travelling around North America with his father Bert, a legendary drag racer, and now a member of the Canadian Motorsports Hall of Fame. At racetracks around the country, Don entertained himself by sketching and refining his artistic skills. His early adult years were split between auto-racing mechanics, photography, and art-related pursuits. In the late 1980s, he began thinking about a new design for the ice hockey goaltender's mask. From his experience in the automotive racing field, he drew design concepts and materials, and after about a year of development, Straus stepped away from automotive pursuits and put the Armadilla Mask into production. It was a huge improvement over previous goalie masks: lighter, better impact protection, more comfortable, and with better sightlines that enabled the goalie to spot the puck flying at him. It was the first mask of its kind to be approved for use in the Canadian minor-league hockey association, but when Straus visited the yearly spring hockey manufacturer's trade show in Montreal and saw the San Jose Sharks' colors, he knew what his next project was. He drew the first design on a cocktail napkin at a Montreal jazz club, but kept the drawing on a shelf for six months before he tracked down Brian Hayward, the Sharks' goalie, and showed him the "shark mask." Within a week, the mask was cast, built, painted, and delivered to Hayward in time for the start of the season's training camp in California in 1991. The "shark mask" immediately became a press and fan favorite, and evolved into one of the most replicated mask concepts—perhaps the most popular mask design in the history of the game. After a fifteen-year run with the Armadilla Mask, manufacturing was halted, and Don shifted back into the automotive-racing world to concentrate on the design and painting of NASCAR drivers' helmets under the banner of Tonto Design. He still lives and works in Kitchener, Ontario, with his wife, Krista, and a bull terrier named Memphis.

Photo courtesy of Don Straus

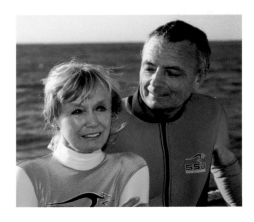

Ron and Valerie Taylor

Ron Taylor (born March 1934) and his wife Valerie (born November 1935) are Australia's reigning shark and underwater experts. Ron began diving in 1952, becoming interested in spear fishing and underwater photography. Valerie won Australian ladies' championships in both spear fishing and scuba, but they decided to switch from killing to filming after becoming so deeply involved with marine life. They married in December 1963, the year they made their first film, *Playing with Sharks*, which was shown on Australian and American television. In 1970, Ron and Valerie joined Peter Gimbel's *Blue Water, White Death* expedition to search for and film white sharks around the world. With Gimbel and Stan Waterman, they left the protection of the cages to film a frenzy of sharks feeding on a whale carcass off Durban. (Eventually, Gimbel found the sharks he was seeking off South Australia, exactly where the Taylors had said they would be.) In 1973, when the producers of *Jaws* wanted footage of real great white sharks trying to get at divers in a cage, they contracted Rodney Fox and Ron and Valerie, who got the dramatic (and nearly fatal) shots of sharks tangled in the cage lines off South Australia. The Taylors also did the underwater photography for the 1980 Brooke Shields film *The Blue Lagoon*, and the shark sequences for the film *Orca*. (Although the film was nominally about killer whales, the fishermen start out hunting great white sharks.) Valerie appeared on the cover of the June 1973 *National Geographic*, diving on the Great Barrier Reef. Together, Ron and Valerie have authored a number of books that feature their spectacular photography: *Sharks: Silent Hunters of the Deep*, *Great Shark Stories*, *Ron and Valerie Taylor's Underwater World*, *Realm of the Shark*, and *Blue Wilderness*, which was derived from a documentary film that included shots of Ron and Valerie swimming among great white sharks without a cage. During more than fifty years underwater, Ron and Valerie have collected awards in conservation and photography too numerous to mention. Ron is a member of the Order of Australia; in 1986, Valerie was nominated to receive the Order of the Golden Ark, an award established by Prince Bernard of the Netherlands for major contributions to nature conservation. Ron and Valerie Taylor are still active, spending months each year on expeditions to remote corners of the earth to be with the sharks they have learned so much about. They live in Sydney, Australia. *Photo courtesy of Ron and Valerie Taylor*

Ken Thaiday Sr.

Ken Thaiday Sr. was born in 1950 on Erub (Darnley) Island in the Torres Strait, the 93-mile-wide body of water that separates the Cape York Peninsula (the northeastern tip of Queensland, Australia) from Papua New Guinea. Thaiday is a senior indigenous artist whose dance masks, or "dance machines," have garnered him much acclaim. His father was a dancer, utilizing the sculptural headdresses that continue to not only play an important role in traditional Torres Strait Islander ceremonies but influence Thaiday's work as well. Islander dance performance utilizing dance paraphernalia is one of the most powerful visual expressions of indigenous culture in Australia. Thaiday's keen eye for contemporary aesthetics combined with the cherished traditions of his homeland convey the resilience of Torres Strait Islanders, who have a long history of ingeniously incorporating diverse ideas, events, and materials into their culture. Thaiday is inventive in his use of materials, too, pairing modern plastic components, plywood, and paint with natural materials such as feathers and bamboo. His work typically revolves around native fish and birds, but his more famous pieces are his shark headdresses. The shark is a key totemic animal, and in the island culture certain sharks are representative of law and order; consequently respect plays an important role in the inspiration for his headdresses. The hammerhead shark headdress is also worn during traditional dances. By manipulating strings, the dancer is able to control the movement of the shark and open and close the jaws. White feathers around the jaws represent the explosion of foam generated by the shark's mouth as it feeds, portraying dramatic movement and power.

Photo courtesy of the Ipswich Gallery, Brisbane, Australia

Jim Toomey

Jim Toomey was born in Alexandria, Virginia, in 1969. For nearly two decades he has been writing and drawing the daily comic strip *Sherman's Lagoon,* which is syndicated to more than 250 newspapers in North America, including the *Washington Post,* the *Chicago Tribune,* the *San Francisco Chronicle,* and the *Toronto Star.* It also appears in more than thirty countries, in French, Portuguese, Spanish, Norwegian, and Swedish. Jim has just completed his eighteenth book, published by Andrews McMeel. *Sherman's Lagoon* combines two of Toomey's passions: art and the sea. He is also active in marine conservation, and this conservation message, evident in his comic strip, earned him the Environmental Hero Award first in 2000, presented by NOAA on behalf of Vice President Al Gore "for using art and humor to conserve and protect our marine heritage," and again in 2010. His comic characters and other illustrations appear in educational materials published by the NOAA, the UN, and a variety of non-profit organizations for the purpose of raising awareness of the oceans. Jim brings his message directly to the public in other ways, too. He routinely speaks in front of younger audiences at aquariums and conferences, using live drawing and humor to convey the importance of protecting our oceans. In April 2010 he was invited to join a group of noted marine biologists, Hollywood celebrities, and business leaders in an ocean-themed TED conference in the Galápagos. He has given similar talks at a variety of venues, such as the Royal Society in London, Harvard University, the Monterey Bay Aquarium, and his daughter's kindergarten class. Jim has been featured in many of his client newspapers, *Wired* magazine, National Public Radio, and Discovery Channel's Shark Week. He holds a bachelor of science in mechanical engineering from Duke University, a master of arts from Stanford University, and recently returned to Duke to earn a master's in environmental management. Jim Toomey currently lives in Annapolis, Maryland, with his wife and two children.

Photo courtesy of Jim Toomey

Ray Troll

Ray Troll was born in Corning, New York, on March 4, 1954 (a Pisces, of course), and moved to Kansas as a teenager when his father, a lifelong Air Force officer, took a job there after retiring from the service. Troll earned a BA degree from Bethany College in Lindsborg, Kansas, in 1977 and moved to Seattle, where he worked at various odd and arty jobs. He applied to the MFA program in studio arts at Washington State University in Pullman in 1981 and invented the unique drawing style that characterizes his work today. His sister Kate had migrated to Ketchikan, Alaska, so Ray headed up there after school, worked in her retail fish store and in a cannery, and became utterly besotted with the life and wildlife of southeast Alaska. (He lives in Ketchikan to this day.) He says that his art has been shaped by the work of R. Crumb, Gaylen Hansen, Edward Gorey, William Blake, Magritte, Escher, Gauguin, Karl Bodmer, Rousseau, Charles R. Knight, Hieronymus Bosch, and Pieter Bruegel the Elder, but the influences of Northwest Coast Indian Art and *Mad* magazine are also strong. Although salmon predominate in his paintings, drawings, T-shirts, murals, coffee cups, mouse pads, and lunch boxes, he is also devoted to chimaeras, the deep-water relatives of sharks known as ratfishes, to the extent that his pickup truck proudly sports the license plate "RATFISH," and his band is called the Ratfish Wranglers. He even has a species named after him: *Hydrolagus trolli*.

With author Brad Matsen, Troll produced lit-art collaborations such as *Shocking Fish Tales; Planet Ocean: Dancing to the Fossil Record;* and *Raptors, Fossils, Fish and Fangs: A Prehistoric Creature Feature*; and with Denver paleontologist Kirk Johnson, *Cruisin' the Fossil Freeway*. On his own, Troll has written and illustrated *Something Fishy This Way Comes* and *Sharkabet: A Sea of Sharks from A to Z*, which demonstrates yet another aspect of his oeuvre, a fascination for prehistoric sharks. His paintings and drawings have been exhibited at museums around the world, and he has produced striking murals for museums, businesses, and a fish-packing plant in Sitka. In 2005 he was awarded the Excellence in Public Outreach National Award from the American Fisheries Society; the Alaska Governor's Award for the Arts in 2006; a Gold Medal for Distinction in Natural History Art from the Academy of Natural Sciences, Philadelphia; and in 2011, he received a Guggenheim Fellowship and a Rasmuson Foundation Distinguished Artist award. Ray Troll's art is not

only about T-shirts and bad puns: He did the cover illustrations for ichthyologist Ted Pietsch's monumental monograph, *Oceanic Anglerfishes;* and in 2004, the University of California Press published what amounts to a monograph on the artist: *Rapture of the Deep: The Art of Ray Troll.* *Photo courtesy of Ray Troll*

Kent Ullberg

Born in 1945 in Sweden, Kent Ullberg is recognized as one of the world's foremost wildlife sculptors. He studied at the Swedish Konstfack University College of Art in Stockholm and at museums in Germany, the Netherlands, and France. He lived for seven years in Botswana, Africa, serving for the last four as curator at the Botswana National Museum and Gallery. He now lives on Padre Island, Corpus Christi, Texas, and maintains a studio in Loveland, Colorado. Although he has completed hundreds of pieces on a small scale, he is perhaps best known for the monumental works he executed for museums and municipalities from Stockholm, to Cape Town. Two of his installations—*Sailfish Fountain* at the Fort Lauderdale convention center and *Spirit of Nebraska's Wilderness* in Omaha, Nebraska—are the largest wildlife bronze compositions ever done, spanning several city blocks. In 1993 and again in 2008, Ullberg received the Henry Hering Medal from the National Sculpture Society for outstanding collaboration between architect, sculptor, and patron in a monumental commission. Ullberg's work has been shown and can be found in major museums and corporate headquarters around the world, including the National Museum of Natural History in Stockholm; the Salon d'Automne in Paris; the National Gallery in Botswana; the National Geographic Society in Washington, D.C.; the Exhibition Hall in Beijing, China; the Guildhall in London; and many more. His work is also in the private collections of world leaders and celebrities. Ullberg is a major supporter of many wildlife conservation efforts, as attested by his *Mako Shark* monument at Nova Southeastern University (Fort Lauderdale) and *Sworddance* at the International Game Fish Association Hall of Fame and Museum in Dania Beach, Florida. He received the Rungius Medal in 1996, the highest honor bestowed by the National Museum of Wildlife Art, given to artists, authors, and conservationists who have made significant contributions to the interpretation and conservation of wildlife and its habitat. *Photo by Gray Photography, Corpus Christi, TX*

Kitty Wales

Kitty Wales was born in 1957 in Boston. A graduate of Boston University in sculpture and art education, she also holds an MFA in sculpture from the University of Arizona. For some time she has been working in and around the animal world exploring narrative installations, drawings, and prints. Wales travels the world to observe animals in their natural habitats and then returns to her studio to interpret her experiences in a variety of media. Her interest is in weaving a multi-layered context into a specific setting. She uses recognizable materials salvaged from everyday life to create sculptures whose visual narratives provide us with unexpected connections to the animal world. Abigail Satinsky, curator of the DeCordova Museum, described Wales's work: "Using detritus of everyday life as material for her installations—such as old sweaters, discarded tires, or mismatched silverware—Wales alters the gallery setting in surprising ways to create a psychological context for her immersive animal landscapes."

Wales's work has been variously inspired by wild dogs, feral goats, swine, and birds of prey. Her fascination with the sinewy form and fluid movement of sharks led her to participate in shark dives in the Bahamas, where she was able to sketch the predators on a plastic drawing slate as they swam above her. *Pine Sharks*, an installation created for the DeCordova Sculpture Park in Lincoln, Massachusetts, includes three sharks that closely resemble the flesh-and-blood models in size, anatomy, and deadly posture as they "swim" above the visitor. These sculptures, however, are not without humor. The *Pine Sharks* are fabricated from discarded appliances—an oil burner, a refrigerator, and an avocado-green stove—and other debris that inspired their individual names: American Standard, Maytag, and Hotpoint. The *Pine Sharks* are thus not only studies of magnificent sharks, but also a wry commentary on the environment, recycling, and our consumerist culture.

Wales has work in the permanent collections of the DeCordova Museum and Sculpture Park, the Duxbury Art Complex Museum, the New England Bio Lab in Beverly, Auburn Park in Cambridge, the Meditech Corporation, the Fuller Craft Museum, and the South Shore Conservatory in Hingham, Massachusetts. She was the 2007 recipient of the Virginia A. Groot award for sculpture and

has received grants from the Massachusetts Cultural Council, the Coleman Foundation, the Elizabeth Foundation for the Arts, and the Berkshire Taconic Community Foundation. Kitty Wales currently teaches sculpture at Boston University. She lives and works in Wrentham, Massachusetts, and Vinalhaven, Maine. Represented by the New Era Gallery in Vinalhaven, her work has been widely exhibited in museums and galleries throughout the United States.

Photo courtesy of Kitty Wales

Phil Watson

Phil Watson was born in 1970, in the North Queensland town of Ingham, just a stone's throw from the Great Barrier Reef. He has a university degree in science, but cartooning and story-telling became his career. He worked for fifteen years as a freelance cartoonist, illustrating kids' educational material and telling original stories to school-children throughout the Sydney region. He also worked for the television show *Catch Phrase*; his animations were watched all over Australia every weeknight. In 2000 Phil started combining his love of the ocean with cartooning and developed his own series of shark cartoons. This casual hobby has now become the world's largest collection of single-panel shark cartoons and can be found at his dedicated website Shaaark.com. In 2005, Underwater Adventures Aquarium in Minneapolis, Minnesota, hired Phil to turn its mascot "Sharky" into a cartoon character. Phil then created some short animations of Sharky on his YouTube channel, and they have been viewed more than two million times. In 2011, Movie Extra helped turn his *Shaaark!* cartoons into an animated series, which is shown on its YouTube channel. These days Phil is passionate about his family, the ocean, and using pictures to tell stories to kids of all ages, either with a pencil and paper or using the latest digital techniques. He still tries to get in the surf as much as he can on the northern beaches of Sydney, Australia, where he lives and works.

Photo courtesy of Phil Watson

Mark Weinhold

San Francisco native Mark Weinhold was born in 1956. He received his first mask, snorkel, and fins at the age of six, and these, along with the 1950s television series *Sea Hunt*, spawned his fascination with the underwater world. Reinforced throughout the years by the Cousteau specials, his early life plan was to become a marine biologist. Sharks quickly became the main focus of Mark's passion; he saw them as the last dinosaurs. In 1975 Mark received his scuba diving certificate. While snorkeling the coral reefs of Bora Bora, he unintentionally swam into a school of blacktip reef sharks, an encounter that would re-light an old flame. Having dabbled in filmmaking, photography, and nightclub event productions, Mark tried his hand at fine art and found his niche. Early paintings made a point of showing man and shark in the same ocean without conflict, reflecting the reality of most encounters in the wild. It is Mark's desire to visually catalog sharks. He has gone to extremes, consulting marine biologists and traveling the world, photographing sharks so that he can paint them as true to life as possible. His more recent work maintains the same degree of accuracy but incorporates more movement and natural behavior. Mark's artistic goal is simply to share his love of sharks with others. "It's like going to Jurassic Park every time you dive with sharks," says Mark. When asked about the dangers of diving with sharks, Mark laughs and says, "It's not as dangerous as it looks. The trick is not to act like food."

To achieve his incredible photo-realistic effects, Weinhold says, "My paintings are all art acrylic/acrylic latex that is brushed in first, starting from the background and working my way to the foreground. I brush in all the hard edges and primary color patches. I create depth to the terrain by adding increasing amounts of ocean blue to the background colors. The initial image is somewhat of a high contrast representation of the image I ultimately want. Then, to bring life to the final painting, I use air-brush to soften edges, blend color, add contour and light accents to characters and terrain alike. This last step involves a lot of masking. In some spots I tape and spray, while in others I make use of custom cut cardboard holdouts. These are squares of cardboard with different curves and angles cut into the working edge. Using a block and spray technique, I work my way around the canvas

always keeping in mind where the sun is in reference to this particular piece. It is this last step that I believe truly brings life to the painting. At this point, every spurt of the air-brush encourages the next as the image becomes more and more real. I continue this process until I hear my dad telling me in the back of my head, 'The sign of amateur is overdone work.' When I consider it finished, I usually sit back and stare at it for a while; sometimes with a glass of tequila or a beer. I hope it's not too much ego, but I enjoy looking at my artwork. The idea of taking an image in your head and turning it into something others can see is very satisfying to me. Plus, I wouldn't have painted it if I didn't want to be there for a while."

Photo courtesy of Mark Weinhold

Bill Wieger

Bill Wieger was born on Christmas Day, 1966. Even as a child in Valley Station, Kentucky, he knew he was destined to be an artist. Influenced by films like *Jaws*, *Star Wars*, and *Alien*, he developed an interest in wildlife, science fiction, horror, fantasy, and special effects. He entered the University of Louisville in 1984 as a biology major in hopes of becoming a marine biologist, but never abandoned his interest in art, and changed his major to theater arts. He graduated in 1989 and took a course with Dick Smith, the special-effects wizard for films like *Amadeus*, *Little Big Man*, *The Exorcist*, and *Dark Shadows*. Wieger went to work for Chris Walas in Marin County, California, special-effects supervisor for the films *Gremlins* and *The Fly*. In Los Angeles, he worked on the films *Thinner*, *Blade*, *Steel*, *Space Truckers*, and *Titanic*. He changed directions from film to marine conservation, because, as he says, "I had an absolute love and passion for wildlife, science, nature, and the ocean, but even before *Jaws*, I loved sharks." He sculpts his sharks in clay and then molds them in silicone. They are then cast in resin, painted with acrylics, and clear-coated for permanence. Bill Wieger lives and works in Hollywood, Florida.

Photo courtesy of Bill Wieger

ACKNOWLEDGMENTS

Along with the exhibit itself, this catalog would not have been possible without the assistance (often at critical moments) of Tom Baione, Michael Beckmann, Julie Bell, Jim Beller, Wendy Benchley, Daniel Botelho, Nick Caloyianis, Marc Dando, Ana Maria de la Ossa, Rachel Diana, David Doubilet, Victor Douieb, Ptolemy Elrington, Chris and Monique Fallows, Johnston Foster, Rodney and Andrew Fox, Rinaldo Frattolillo, Bruce Gray, Jerry and Idaz Greenberg, Sonny Gruber, Todd Michael Guevara, Don Ed Hardy, Guy Harvey, Paul Hilton, Alex Hofford, Rachel Talent Ivers, Rachel Johnston, Freddy Jouwayed, Rhoda Knight Kalt, Roger Kastel, Anthony Lauro, Charles Lawrance, Pascal Lecocq, Bong Lee, Tony Leeds, Marie Levine, Irvin Lippman, Robin Lovelace-Smith, John McCosker, Joe Macinnis, Richard Milner, Nana Montgomery, Peter and Sue Ogilvie, Stuart Peterman, Ila France Porcher, Don and Loraine Ray, Mike Rivkin, Alexis Rockman, Doug Seifert, Jon Snow, Gary Staab, Don Straus, Pete Surace, Ron and Valerie Taylor, Jim Toomey, Ray Troll, Kent and Veerle Ullberg, Kitty Wales, Phil Watson, James Weiger, Barabara Weinberg, and all the other artists and photographers whose work is represented herein. In many cases, the artist's wives, husbands, partners, or assistants encouraged the artists—often a difficult and uncooperative lot—to submit artwork, photographs, biographical information, and other materials required for the exhibition and its attendant catalog. A very special note of thanks is due to Sean Gelb, a doctor, lawyer, and art collector from Miami who appointed himself adjunct curator for acquisitions and suggested (and often found) artists whose existence I was completely unaware of. The book that you hold in your hands could not have been brought to its sharky fruition without the enthusiastic cooperation of the staff at Pequot, particularly Janice Goldklang, who turned an unruly manuscript into what I hope is a coherent disquisition on a most unruly subject; and Ellen Urban and Cynthia Hughes, who diligently read—and often cleverly rearranged—all these words and pictures.

I dedicate this book to my friend, colleague, and mentor, Genie Clark, who, through her scholarship, courage, and dedication, has opened the sometimes murky, but always fascinating, world of sharks to millions of people, the most grateful of whom is me.

Klimley, A.P. and D.G. Ainley, eds. 1996. *Great White Sharks.* Academic Press.

La Gorce, J.O. 1952. *Marineland, Florida's Giant Fish Bowl.* In J.O. La Gorce, ed., *The Book of Fishes,* pp. 141–156. National Geographic Society.

Leopold, A. 1949. *A Sand Country Almanac.* Oxford University Press.

Lineaweaver, T.H. and R.H. Backus. 1973. *The Natural History of Sharks.* Anchor Doubleday.

Mattheissen, P. 1971. *Blue Meridian: The Search for the Great White Shark.* Random House.

Maunder, S. 1862. *A Treasury of Natural History.* Spottiswoode & Co. London

McCormick, H.W., T. Allen, and W. Young. 1963. *Shadows in the Sea: The Sharks, Skates and Rays.* Chilton.

Mundus, F. and B. Wisner. 1971. *Sportfishing for Sharks.* Macmillan.

Murdy, W.H. 1975. *Anthropocentrism: A Modern Version.* Science 187:1168–1172.

Musick, J.A. and B. McMillan. 2002. *The Shark Chronicles.* Times Books.

Myers, R.A. and C.A. Ottensmeyer. 2005. *Extinction Risk in Marine Species.* In E. Norse and L.B. Crowder, eds., Marine Conservation Biology, pp. 58–79. Island Press.

Myers, R.A. and B. Worm. 2003. *Rapid Worldwide Depletion of Predatory Fish Communities.* Nature 423:280–283.

———. 2005. *Extinction, Survival or Recovery of Large Predatory Fishes.* Philosophical Transactions of the Royal Society B. 360:13–20.

Norman, J.R. and F.C. Fraser. 1938. *Giant Fishes, Whales and Dolphins.* W.W. Norton.

Norman, J.R. and P.H. Greenwood. 1963. *A History of Fishes.* Hill and Wang.

Ostrander, G.K. and J. Harshberger. 2000. *Sharks DO Get Cancer.* Science 288(5464):259.

Owen, D. 2010. *Shark: In Peril in the Sea.* Allen & Unwin.

Pauly, D. and J. Maclean. 2002. *In a Perfect Ocean: The State of Fisheries and Ecosystems in the North Atlantic Ocean.* Island Press.

Pauly, D. and M.L. Palomares. 2005. *Fishing Down Marine Food Web: It Is Far More Pervasive Than We Thought.* Bulletin of Marine Science 76(2):197–212.

Pauly, D. and R. Watson. 2003. *Counting the Last Fish.* Scientific American 289(1):42–47.

Pauly, D., V. Christensen, R. Froese, and M.L. Palomares. 2000. *Fishing Down Aquatic Food Webs.* American Scientist 88(1):46–51.

Pauly, D., J. Alder, E. Bennett, V. Christensen, P. Tyedmers, and R. Watson. 2003. *The Future for Fisheries.* Science 302:1359–1361.

Pennant, T. 1776. *British Zoology.* Benjamin White. London.

Perkins, S. 2010. *Shark: In Peril in the Sea* [book review]. Science News 178(12):32.

Phillips, C. 1964. *The Captive Sea.* Chilton.

Pliny. n.d. Natural History. 10 Vols. Loeb Classical Library. Harvard University Press.

Poe, E.A. 1838. *The Narrative of Arthur Gordon Pym of Nantucket.* Harper & Brothers.

Raloff, J. 2002. *Clipping the Fin Trade.* Science News 162(15):232–234.

Randall, J.E. 1973. *The Size of the Great White Shark (Carcharodon)*. Science 181:169–170.

Renz, M. 2002. *Megalodon: Hunting the Hunter*. PaleoPress.

Ricciuti, E.R. 1973. *Killers of the Seas*. Walker.

Smith, J.L.B. 1968. *High Tide*. Books of Africa.

Stead, D.G. 1906. *Fishes in Australia*. Sydney.

———. 1933. *Giants and Pygmies of the Deep: The Story of Australian Sea Denizens*. Sydney.

———. 1963. *The Sharks and Rays of Australia*. Angus & Robertson.

Stevens, J.D., R. Bonfil, N.K. Dulvy and P.A. Walker. 2000. *The Effects of Fishing on Sharks, Rays, and Chimeras (Chondrichthyans) and the Implications for Marine Ecosystems*. ICES Journal of Marine Science 57:476–494.

Taylor, R., L.J.V. Compagno, and P.J. Struhsaker. 1983. *Megamouth—A New Species, Genus, and Family of Lamnoid Shark (Megachasma Pelagios, Family Megachasmidae) from the Hawaiian Islands*. Proc. Cal. Acad. Sci. 43(8):87–110.

Taylor, R. and V. Taylor. 1978. *Great Shark Stories*. Giniger/Harper & Row.

———. 1986. *Sharks: Silent Hunters of the Deep*. Reader's Digest.

———. 1997. *Blue Wilderness*. Ocean Realm.

Tedeschi, M. and K. Dahm. 2008. *Watercolors by Winslow Homer: The Color of Light*. The Art Institute of Chicago.

White, W.T. and S.P. Iglesias. 2011. *Squalus Formosus, A New Species of Spurdog Shark (Squaliformes: Squalidae), from the Western North Pacific Ocean*. Journal of Fish Biology doi:10.1111/j.1095–8649.2011.03068.

Wilkinson, D. 2004. *A Devastating Delicacy*. Shark Diver 6:32–35.

Wise, H.D. 1937. *Tigers of the Sea*. Derrydale Press.

Wong, E. H.-K., M.S. Shivji and R.H. Hanner. 2009. *Identifying Sharks with DNA Barcodes: Assessing the Utility of a Nucleotide Diagnostic Approach*. Molecular Ecology Resources (2009) 9 (Suppl. 1): 243–256.

Worm, B. M. Sandow, A. Oschlies, H.K. Lotze, and R.S. Myers. 2005. *Global Patterns of Predator Diversity in the Open Ocean*. Science 309:1365–1369.

Young, W.E. and H. Mazet. 1934. *Shark! Shark!* Gotham House.

Zamperini, L. (with D. Rensin). 2003. *Devil at My Heels*. Harper Perennial.

LE REQUIN.

Publié par Furne, Paris.